JETER
UNFILTERED

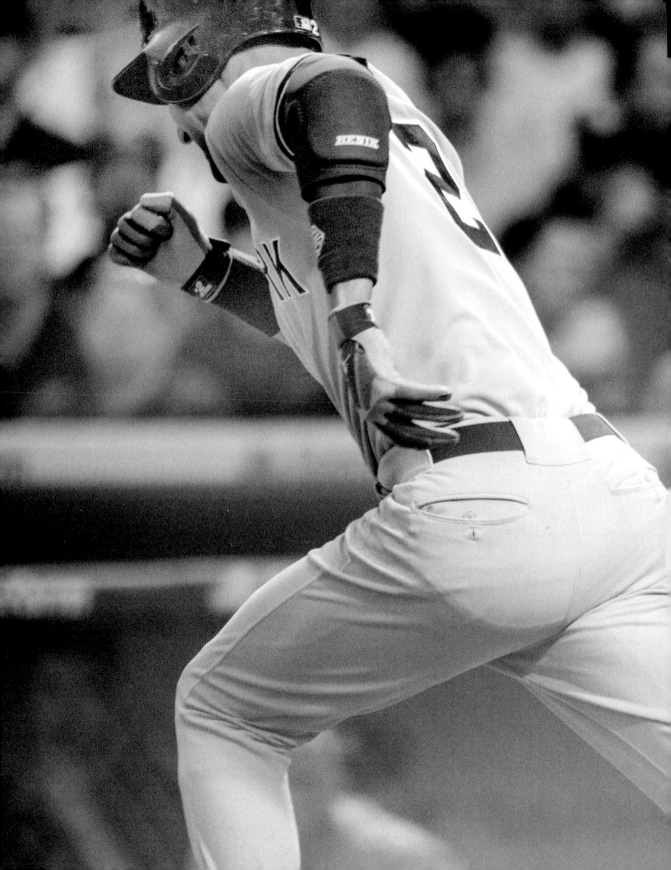

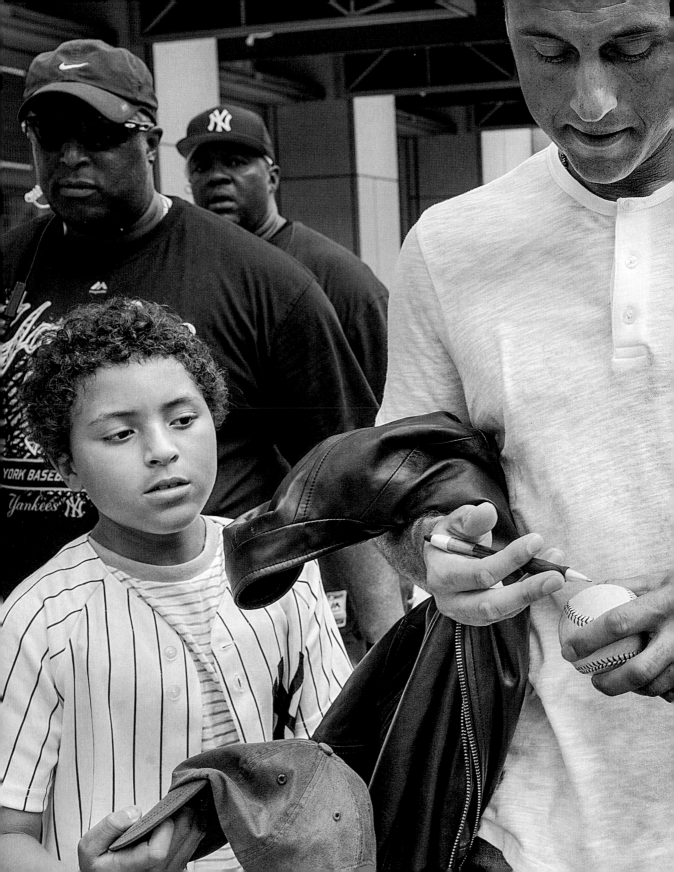

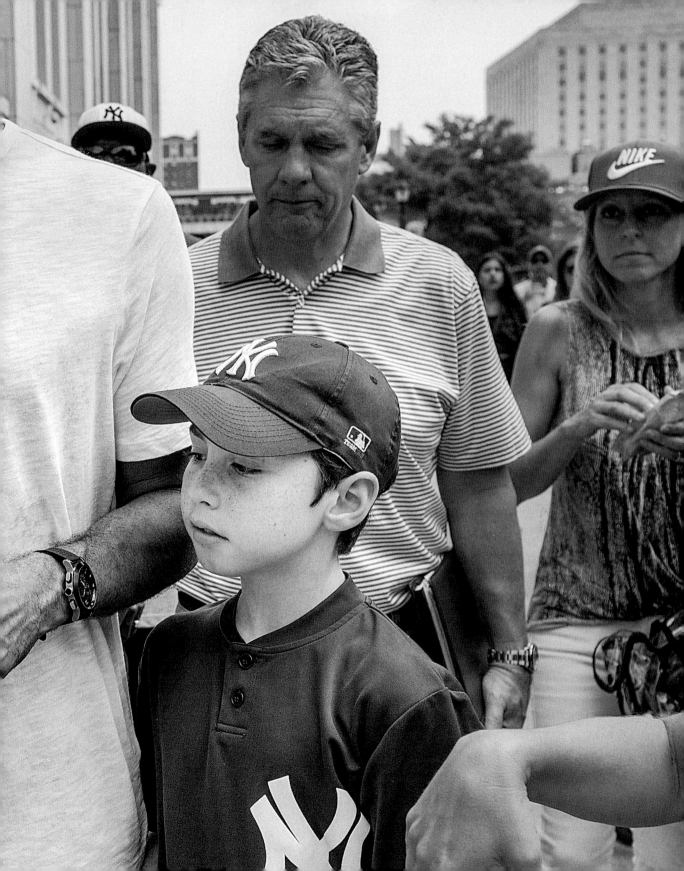

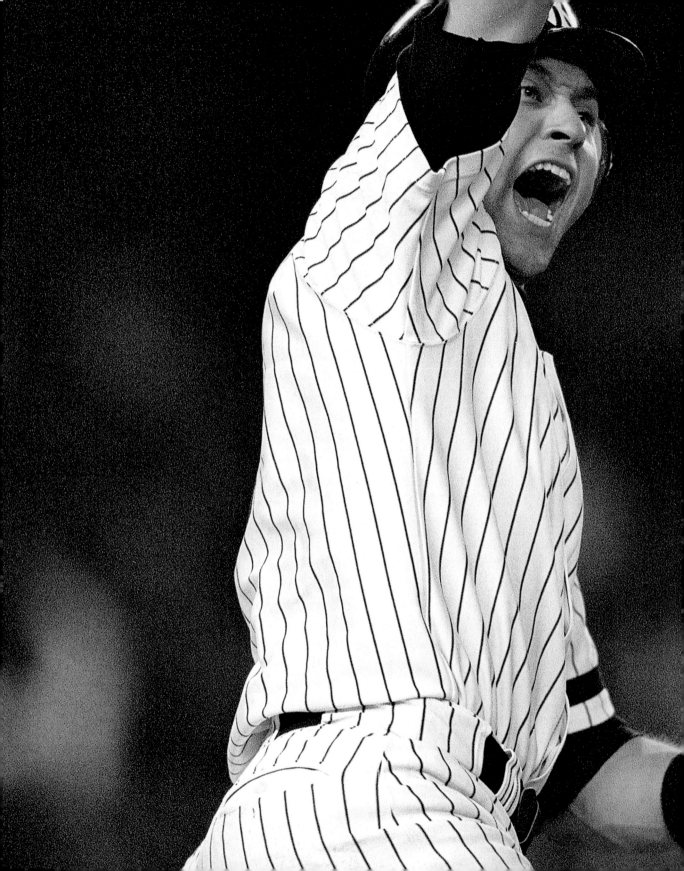

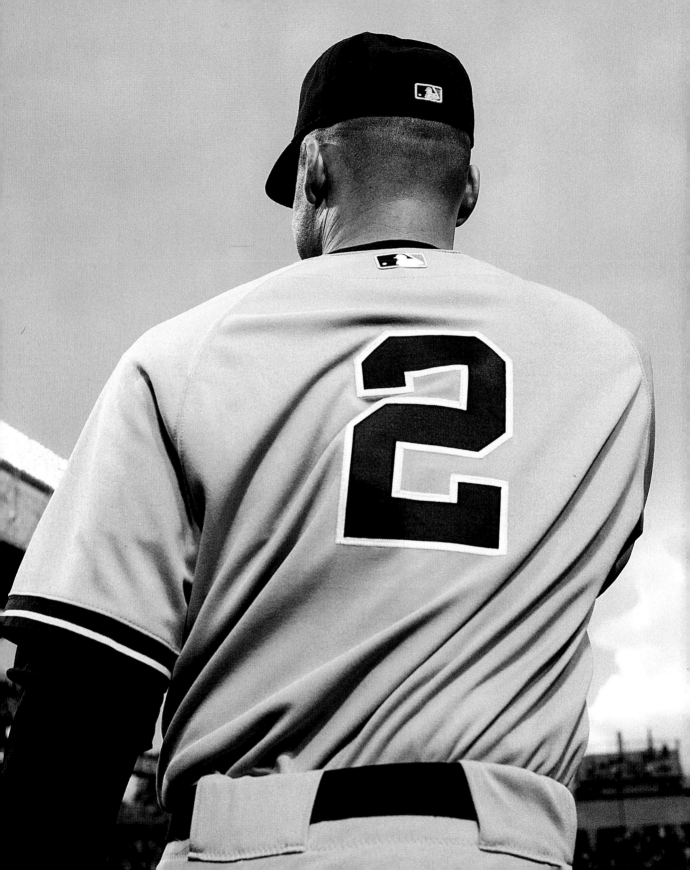

JETER
UNFILTERED

DEREK JETER

WITH
ANTHONY BOZZA

PHOTOGRAPHS BY
CHRISTOPHER ANDERSON

GALLERY BOOKS

JETER PUBLISHING

NEW YORK LONDON TORONTO SYDNEY NEW DELHI

Gallery Books
A Division of Simon & Schuster, Inc.
1230 Avenue of the Americas
New York, NY 10020

First Gallery Books hardcover edition October 2014

GALLERY BOOKS and colophon are registered trademarks of Simon & Schuster, Inc.

For information about special discounts for bulk purchases, please contact Simon & Schuster Special Sales at 1-866-506-1949 or business@simonandschuster.com

The Simon & Schuster Speakers Bureau can bring authors to your live event. For more information or to book an event contact the Simon & Schuster Speakers Bureau at 1-866-248-3049 or visit our website at www.simonspeakers.com.

Interior design by Nate Beale
Photo editor: Maureen Cavanagh
Jacket design by Jon Contino
Jacket art by Christopher Anderson

Manufactured in the United States of America

10 9 8 7 6 5 4 3 2 1

Library of Congress Cataloging-in-Publication Data

Jeter, Derek
 Derek Jeter: Jeter unfiltered/Derek Jeter with Anthony Bozza; photographs by Christopher Anderson.
 pages cm
1. Jeter, Derek, 1974– 2. Baseball players—United States—Biography. I. Title.
 GV865.J48B43 2010
 796.357092—dc23 [B] 2014033440

ISBN 978-1-4767-8366-6
ISBN 978-1-4767-8368-0 (ebook)

DEDICATION

To make a dream come true, you need a lot of help, and I was lucky enough to get more than my share. Start with a family that has always believed in me and never let me sell myself short on or off the field. Add to that a set of mentors who taught me what it means to wear the pinstripes and be a ballplayer for the greatest franchise in professional sports. There's the two decades' worth of teammates and brothers who played the game with me and left me with a bunch of rings to show for it.

Finally, there's the New York fans. They're as tough a crowd as you'll find anywhere but when they do give you their love, there's nothing else like it. The pictures in this book show a side of me that most of those fans have never seen. I hope you all enjoy it.

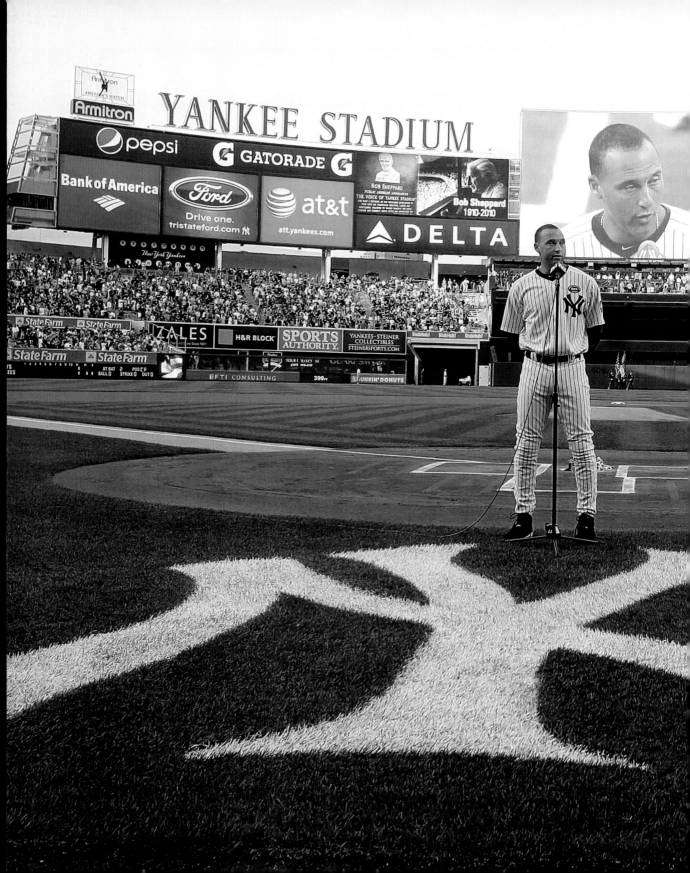

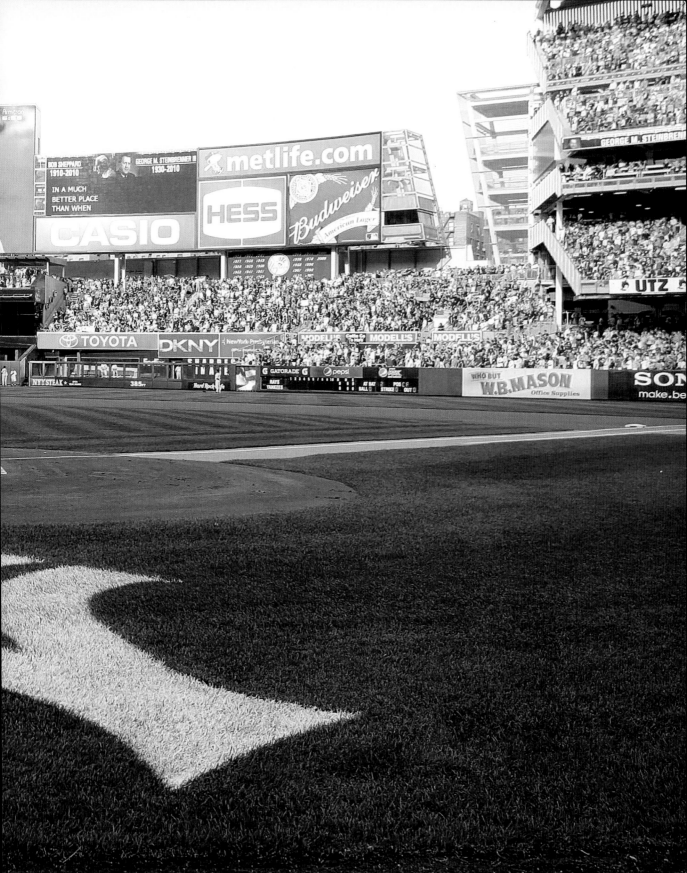

CONTENTS

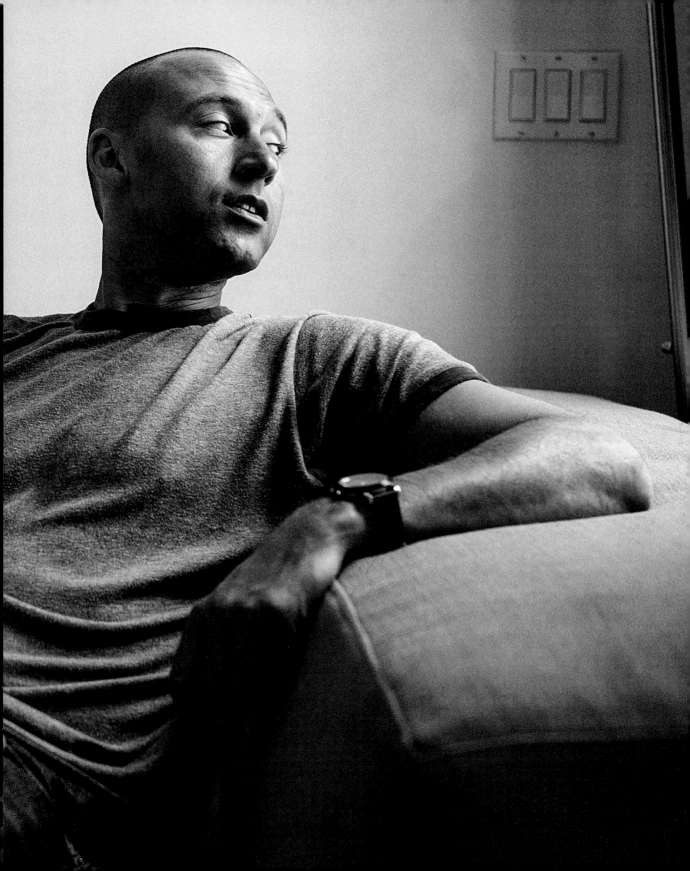

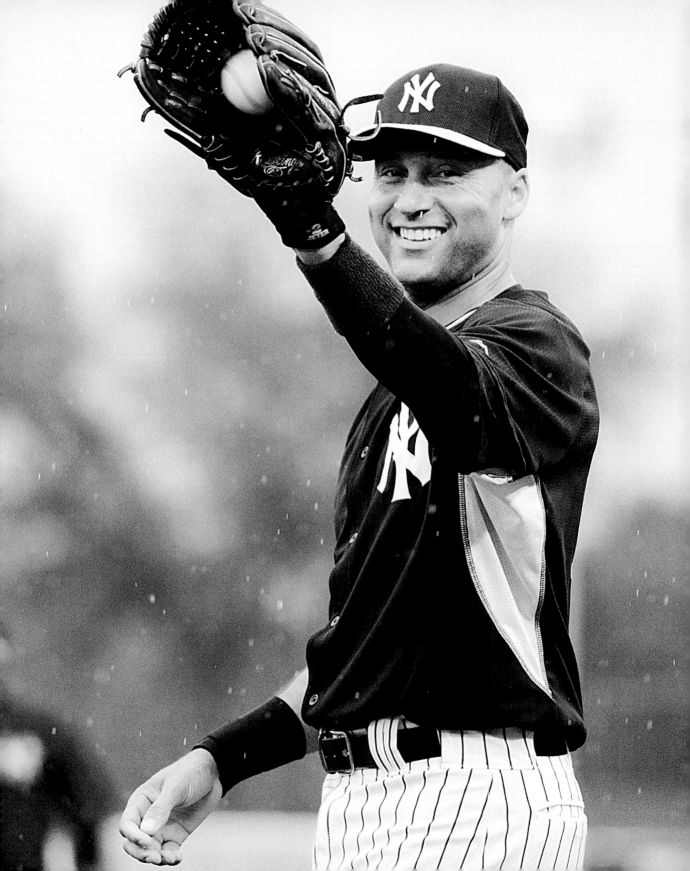

I want to start by saying thank you.

I know they say that when you dream you eventually wake up. Well, for some reason, I've never had to wake up. Not just because of my time as a New York Yankee but also because I am living my dream every single day.

Last year was a tough one for me. As I suffered through a bunch of injuries, I realized that some of the things that always came easily to me and were always fun had started to become a struggle. The one thing I always said to myself was that when baseball started to feel more like a job, it would be time to move forward.

So really it was months ago when I realized that this season would likely be my last. As I came to this conclusion and shared it with my friends and family, they all told me to hold off saying anything until I was absolutely, 100 percent sure.

And the thing is, I could not be more sure. I know it in my heart. The 2014 season will be my last year playing professional baseball.

I've experienced so many defining moments in my career: winning the World Series as a rookie shortstop, being named the Yankees captain, closing the old and opening the new Yankee Stadium. Through it all, I've never stopped chasing the next one. I want to finally stop the chase and take in the world.

For the last twenty years I've been completely focused on two goals: playing my best and helping the Yankees win. That means that for 365 days a year, my every thought and action was geared toward that goal. It's now time for something new.

From the time I was a kid, my dream was always very vivid, and it never changed: I was going to be the shortstop for the New York Yankees. It started as an empty canvas more than twenty years ago, and now that I look at it, it's almost complete. In a million years, I wouldn't have believed just how beautiful it would become.

So many people have traveled along this journey with me and helped me along the way: I want to especially thank the Boss, the Steinbrenner family, the entire Yankees organization, my managers, my coaches, my teammates, my friends, and of course, above all, my family. They taught me incredible life lessons and are the number-one reason I lasted this long. They may not have been on the field, but they feel they played every game with me, and I think they are ready to call it a career as well.

I also couldn't have done it without the people of New York. New York fans always pushed me to be my best. They have embraced me, loved me, respected me, and have always been there for me. This can be a tough, invasive, critical, and demanding environment. The people of this city have high expectations and are anxious to see them met.

But it's those same people who have challenged me, cheered for me, beat me down, and picked me back up all at the same time. New York made me stronger, kept me more focused, and made me a better, more well-rounded person. For that, I will be forever grateful. I never could have imagined playing anywhere else.

I will remember it all: the cheers, the boos, every win, every loss, all the plane trips, the bus rides, the clubhouses, the walks through the tunnel, and every drive to and from the Bronx. I have achieved almost every personal and professional goal I have set. I have gotten the very most out of my life playing baseball, and I have absolutely no regrets.

Now it is time for the next chapter in my life. I have new dreams and aspirations, and I want new challenges. There are many things I want to do in business and in philanthropic work, in addition to focusing more on my personal life and starting a family of my own. And I want the ability to move at my own pace, see the world, and finally have a summer vacation.

But before that, I want to soak in every moment of every day this year, so I can remember it for the rest of my life. And most important, I want to help the Yankees reach our goal of winning another championship.

Once again, thank you.

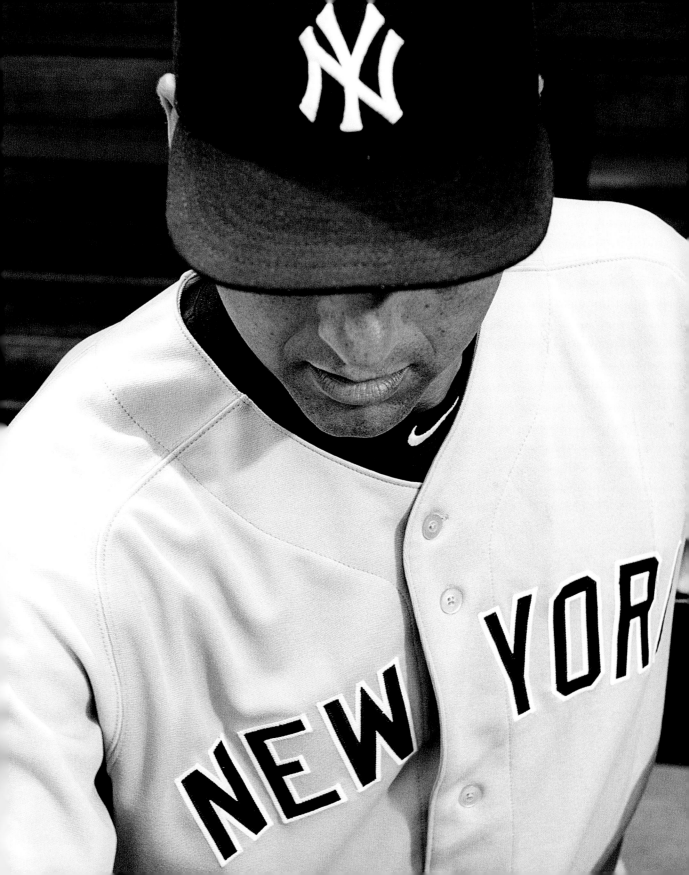

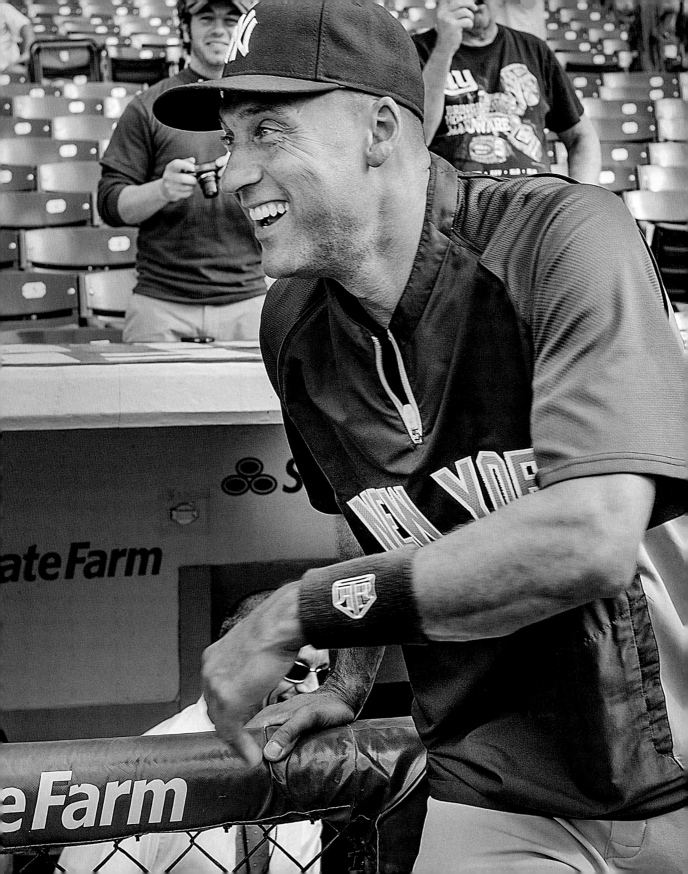

SPRING TRAINING

This spring training was different, because more than ever before, I focused on trying to enjoy it. When everyone shows up for spring training, all they look forward to is the end of it. Most guys just can't wait to get out there on Opening Day and start playing. A countdown begins—thirty days left, twenty days left, and so on—it's all the guys talk about. I've done that, too, in the past, but not this time. I went in and tried to enjoy every day, without thinking about the end of it. The end would come soon enough.

Welcome to the Big Time

I remember showing up for my first spring training at eighteen years old. It used to be held down in Fort Lauderdale, so Doug, who has been my friend since fourth grade, made the long drive with me from Kalamazoo in the first car that I'd bought, a red Mitsubishi 3000. I was nervous, I was intimidated, I was scared. After being a lifelong Yankees fan who had played most of his years with a friend at third base, throwing to another friend at first, and flicking it to a close friend at second, all of a sudden there I am with Don Mattingly at first base and Wade Boggs at third. Those are guys I grew up watching and idolizing, so it was intimidating, to say the very least.

Preemptive Strike

I don't have as much hair as I did when I first started playing professionally, so I like to keep it short now. It cuts down on my time getting ready. But I would just like people to know that this hairstyle is by choice, not necessity, okay?

To avoid injuries during the season, you have to stay limber during the off-season, and my masseuse, Nicole, makes sure of that. She comes over twice a week, and let me tell you, getting massages isn't as relaxing as one may think.

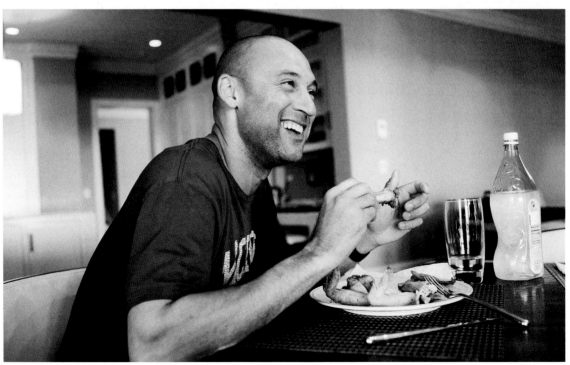

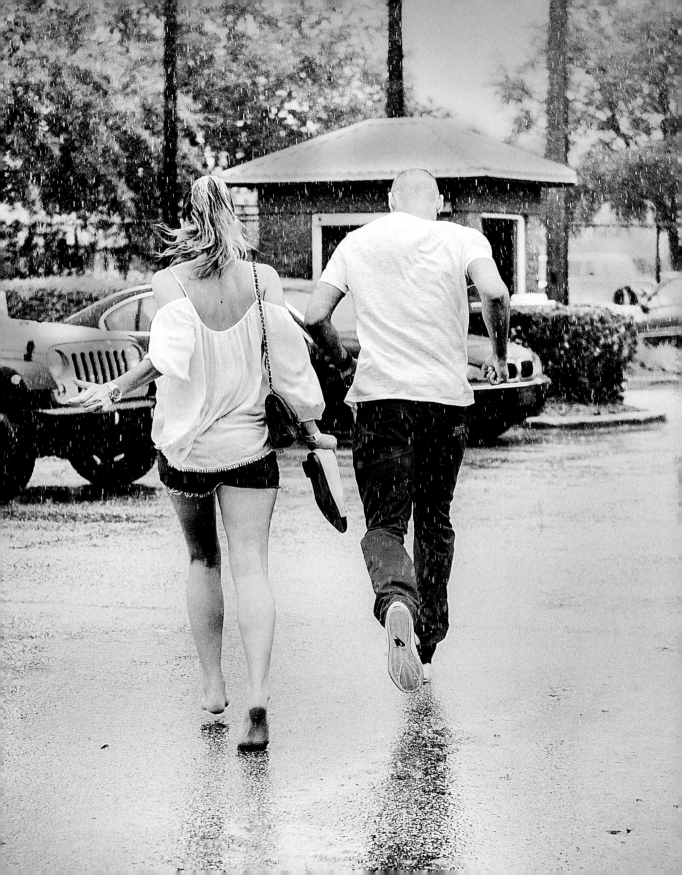

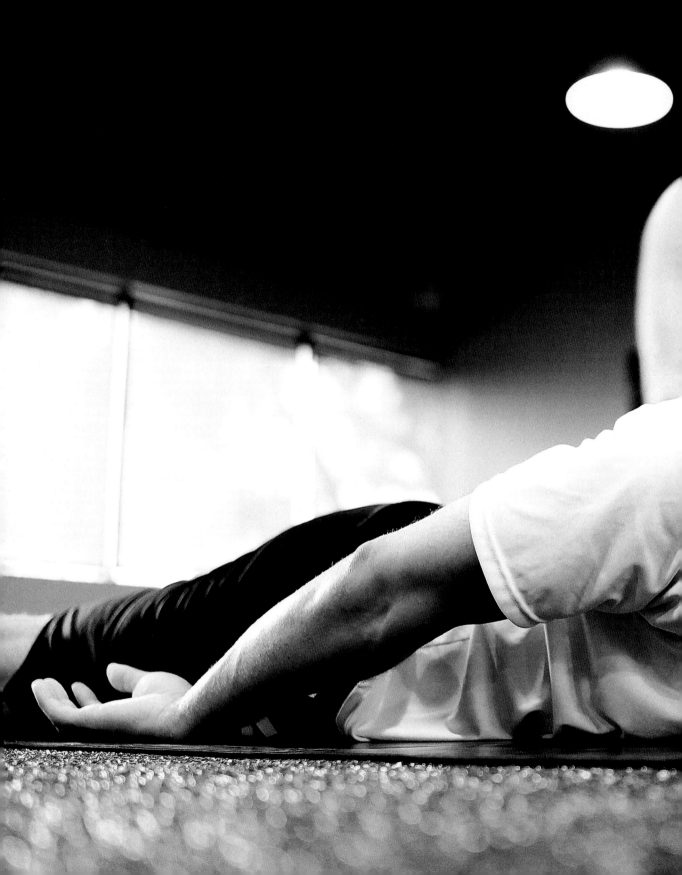

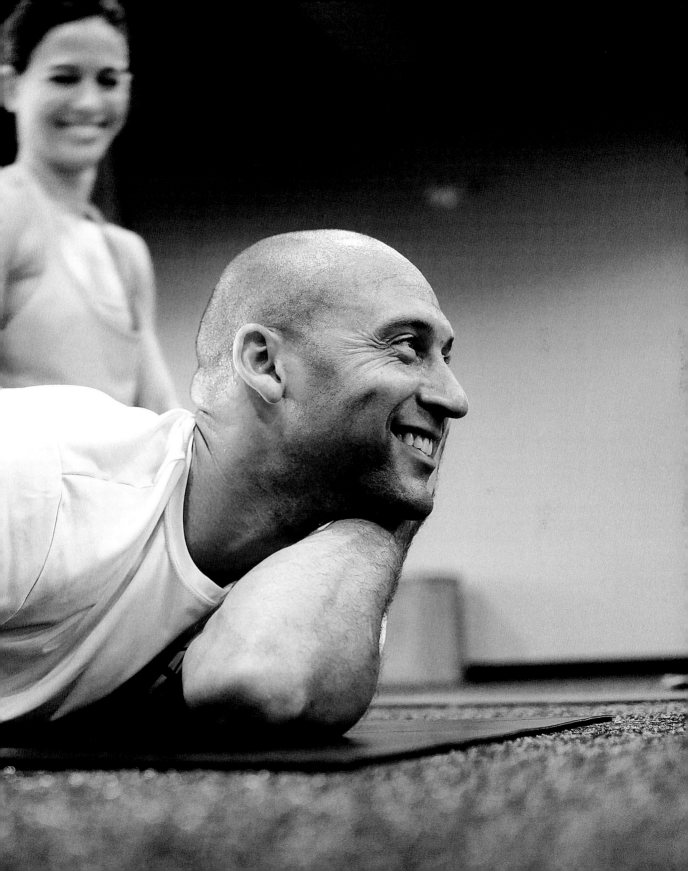

Old Dog, New Tricks

I started doing yoga about three years ago, and I really enjoy it. When you get a little older, it helps with your flexibility, so I do it once or twice a week with my teacher, Kelly. I really see a difference; I think if I'd done it earlier in my career, the moves and stances would be easier for me now, but it has served its purpose. People think yoga is easy. It's not, it can be quite difficult; but whenever I do it, afterward I feel a whole lot better—and a little sore.

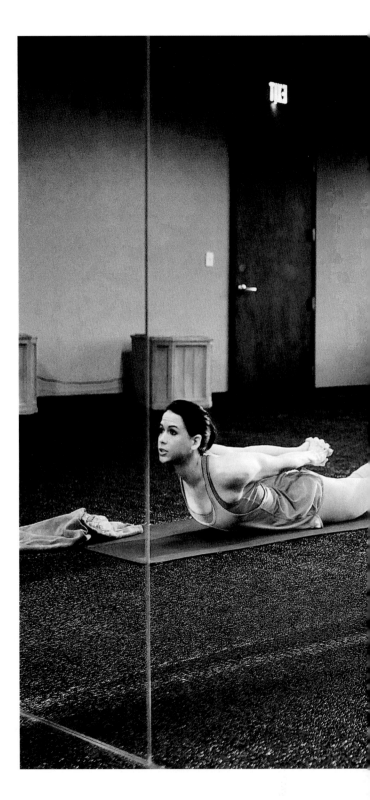

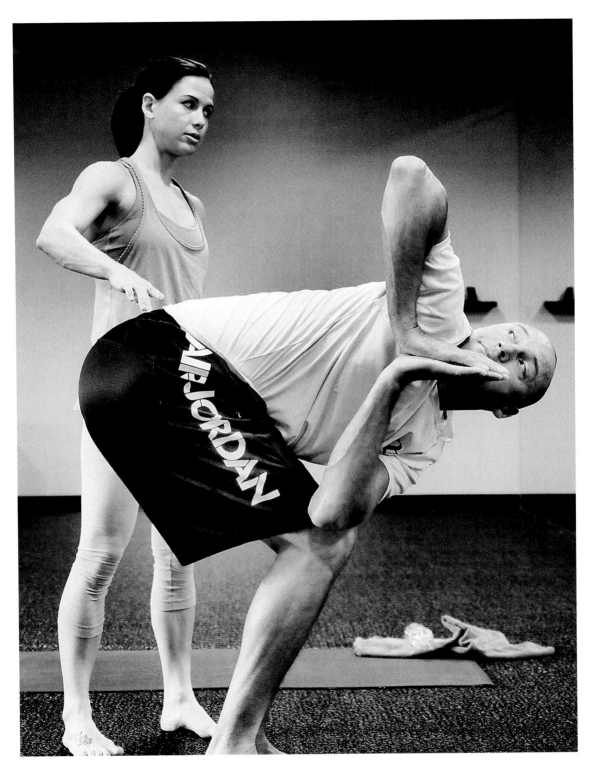

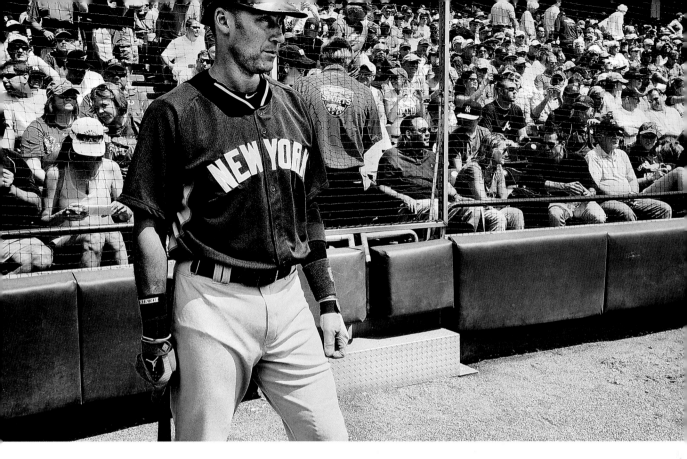

New Faces

I used to always look for Jorge Posada first when I showed up for spring training because he was my closest friend on the team. He and I had a spring training tradition: on the last day we would order a bunch of Hooters chicken wings, then we'd drive to Baskin-Robbins and get ice cream. Not exactly what a nutritionist would advise, but we weren't telling. Jorge has been retired for a few years now, and there are so many new faces in Tampa, so what I really look forward to when we all show up is getting to know all the new guys. I've always gone out of my way to try to get to know people's personalities, and before the season starts, when you're all there together getting ready, is the best time to do that. With the young guys, the future Yankees, I want to be able to say that I really knew them when.

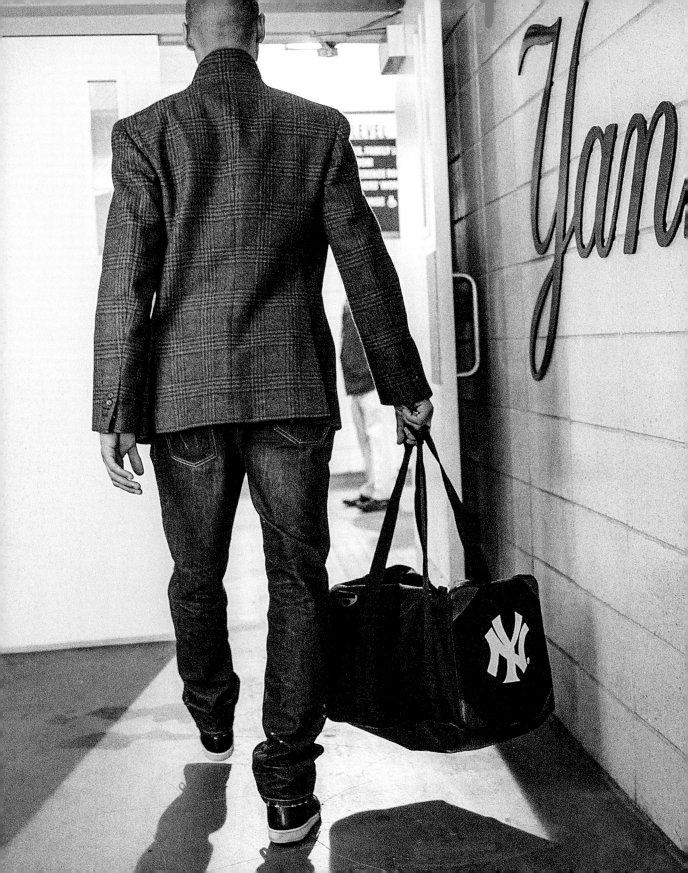

ANNOUNCING
MY FINAL SEASON

I've never doubted my decision to retire, not once. I used to wonder how I would know when it was time to retire. Older guys would tell me that I'd just know, and that didn't seem like much of an answer at the time—but they were right. I didn't want my teammates to have the distraction of facing questions about my future after every single game, and to be honest I didn't want to be asked about it thousands of times either, so I knew I had to reveal my decision before the start of the season. I spent a considerable amount of time on my letter that was posted on Facebook. There were just so many thoughts and thank-yous I wanted to convey and I wanted to get it right.

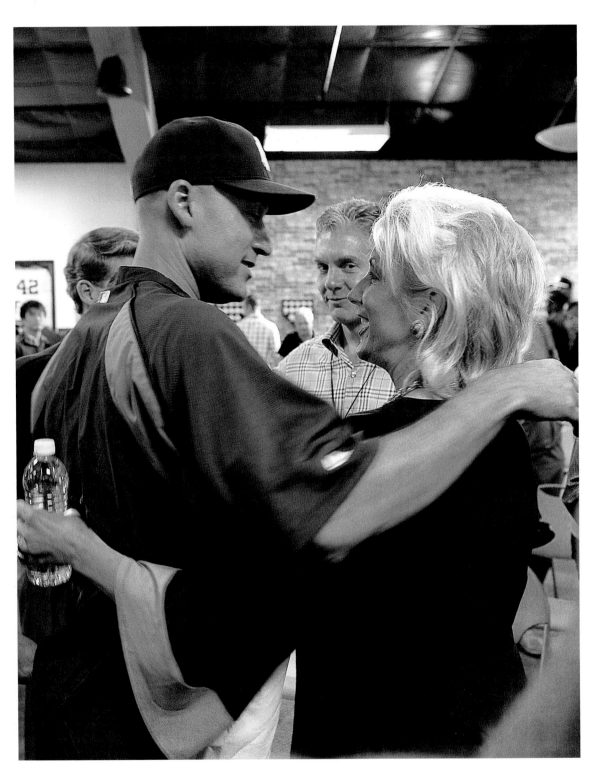

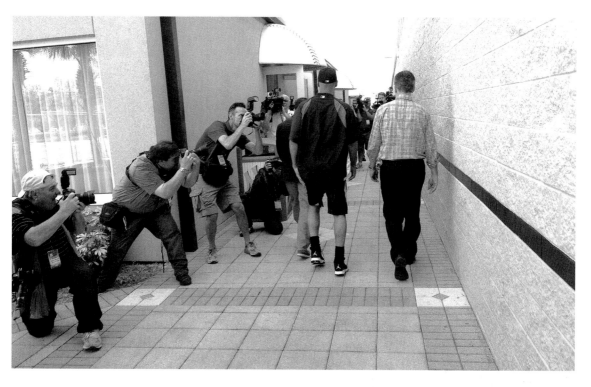

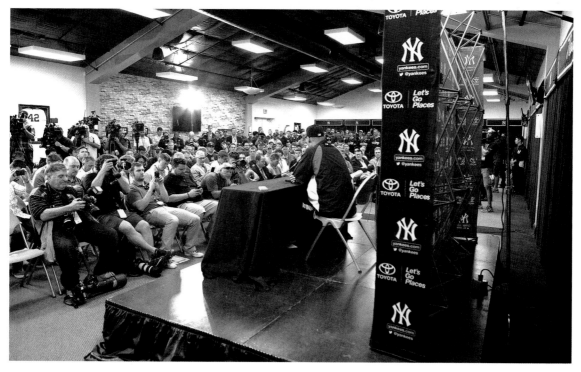

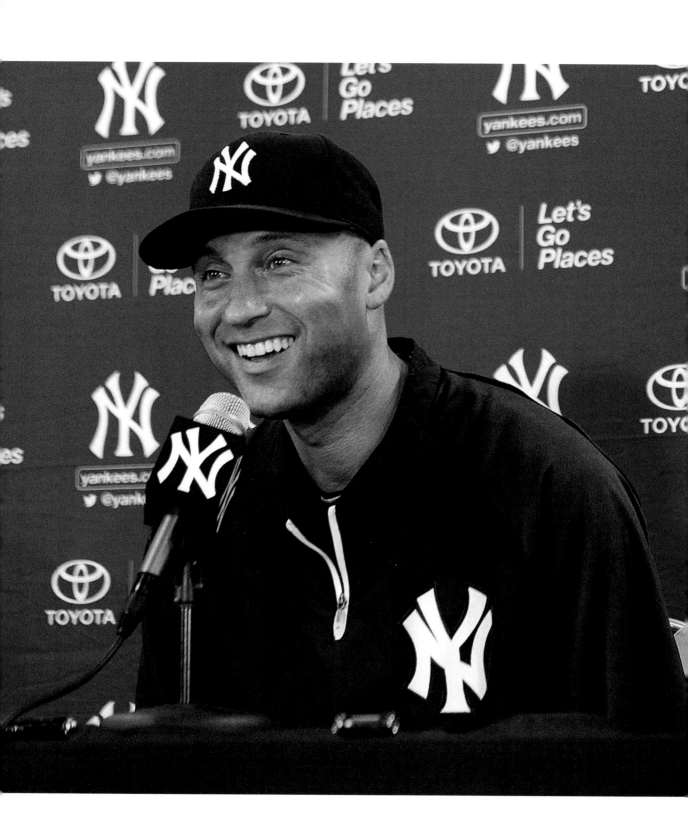

Time to Say Goodbye

I knew I was going to retire quite some time before I announced it at the start of the 2014 season, because I felt it in my heart. But family and friends told me to wait until I was completely healthy and sure of my decision. They didn't want an injury to sway me. I always knew deep down that it wasn't the reason, but I took their advice and waited anyway, just to be completely sure. They thought that when I felt good again I might decide that I wanted to play for a few more years, but that feeling never came. I've been playing ball for a long time— twenty years. And playing in New York? That's like dog years.

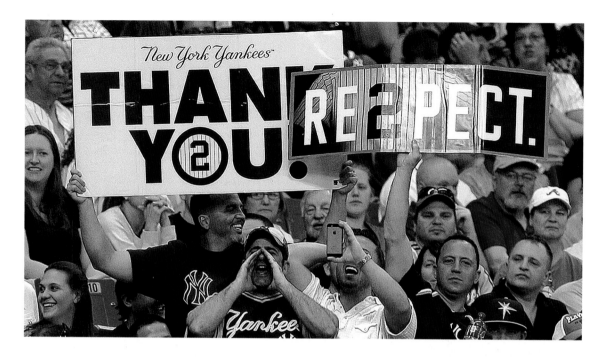

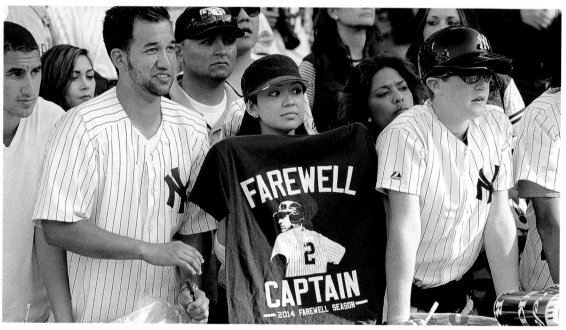

This Is the End

*I've been asked if I think I'll come back to play the game like other athletes
have, and to that, I can most definitely say no. I'm gone. This is it.*

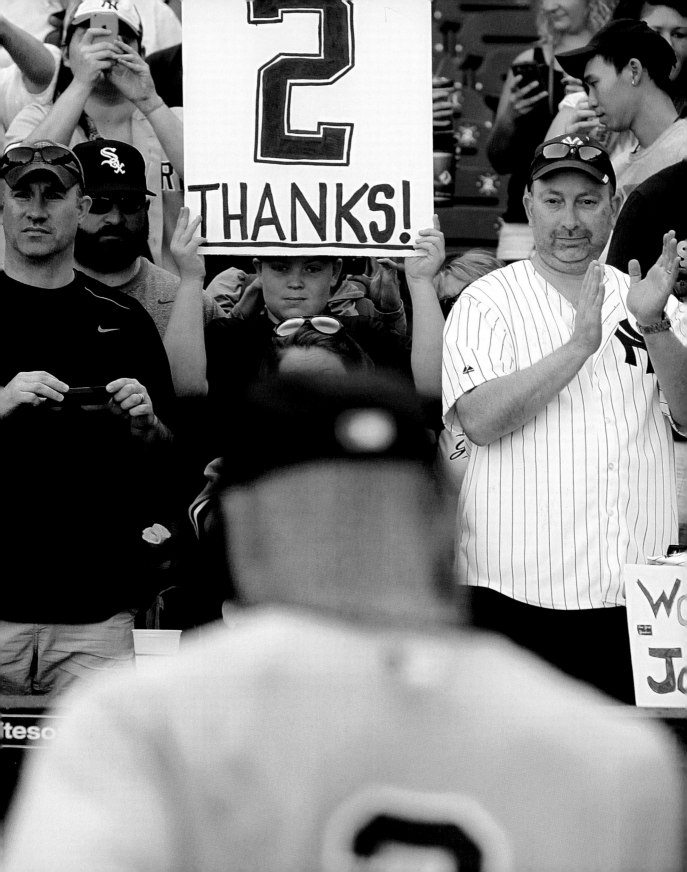

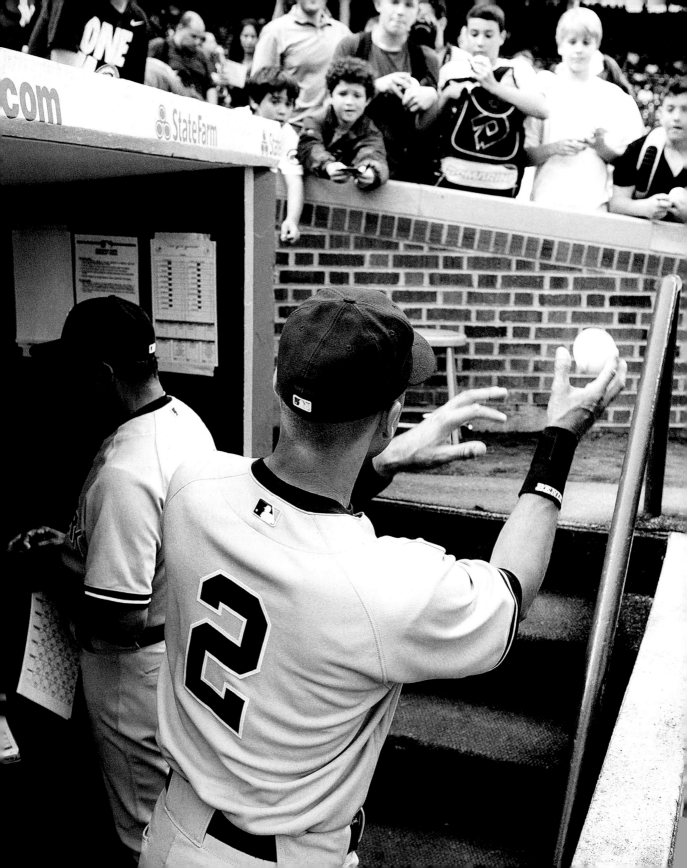

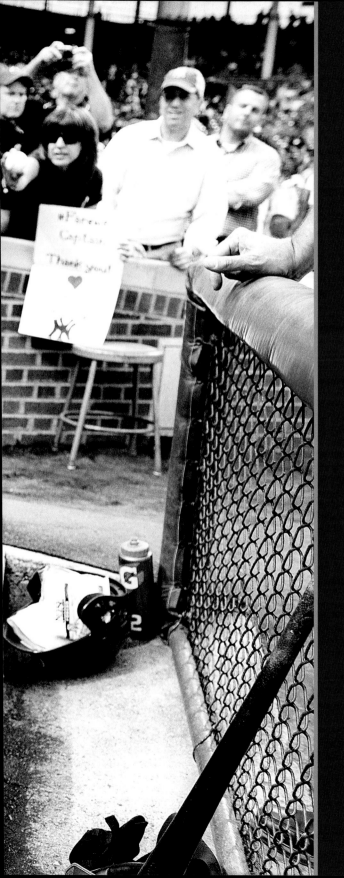

THE FANS

This year has been incredible—more than I could have ever expected, or dreamed of. Words can't even begin to describe how special this feels. The fans everywhere are treating me so well. In my last game in each stadium, I've been treated to standing ovations and cheering. Opposing teams' fans have pretty much always been respectful to me, but they've taken it to another level—a level I didn't think was possible.

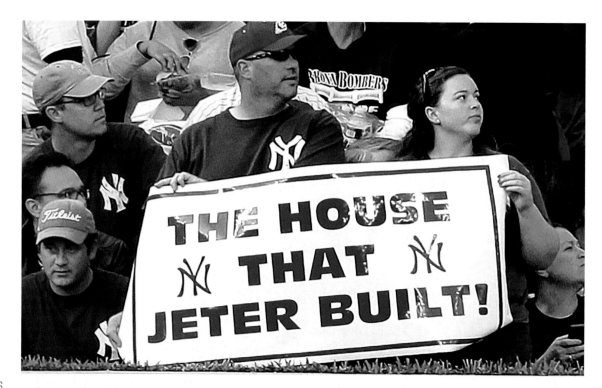

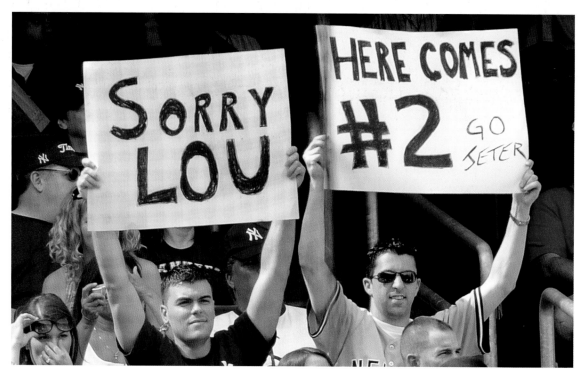

Words to Remember

I certainly didn't expect such a strong reaction from fans across the country.
People have said so many memorable things to me during my final season,
and some of the best have been the simplest. Some people will just say
"Thank you. Thank you for playing the game the right way. Thank you for
the way you handle yourself, playing hard but always with respect." A lot of
parents have thanked me for being a great role model for their kids.
Those are the things that really hit home for me. Those are the things
that I'll remember for the rest of my life.

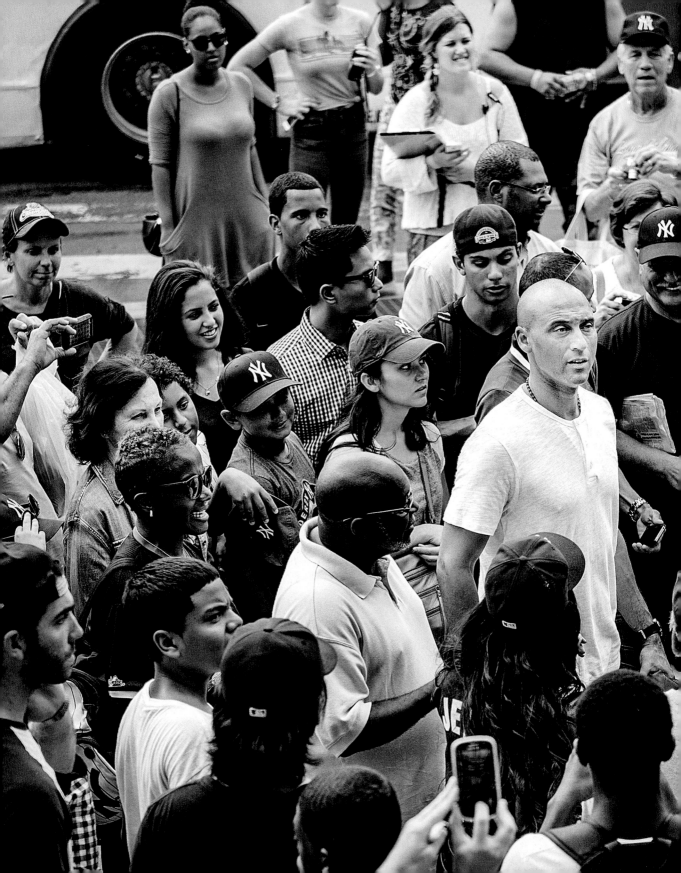

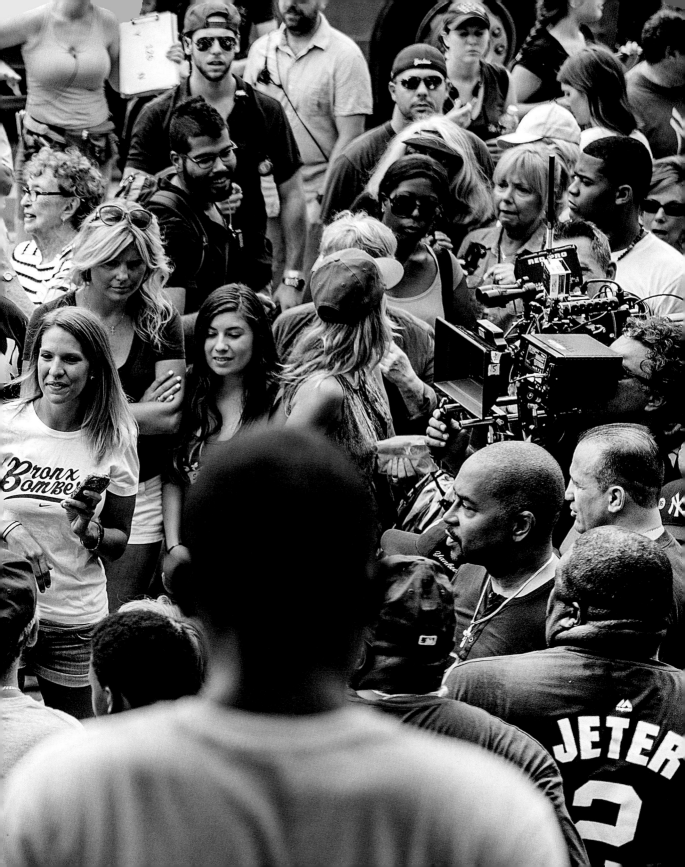

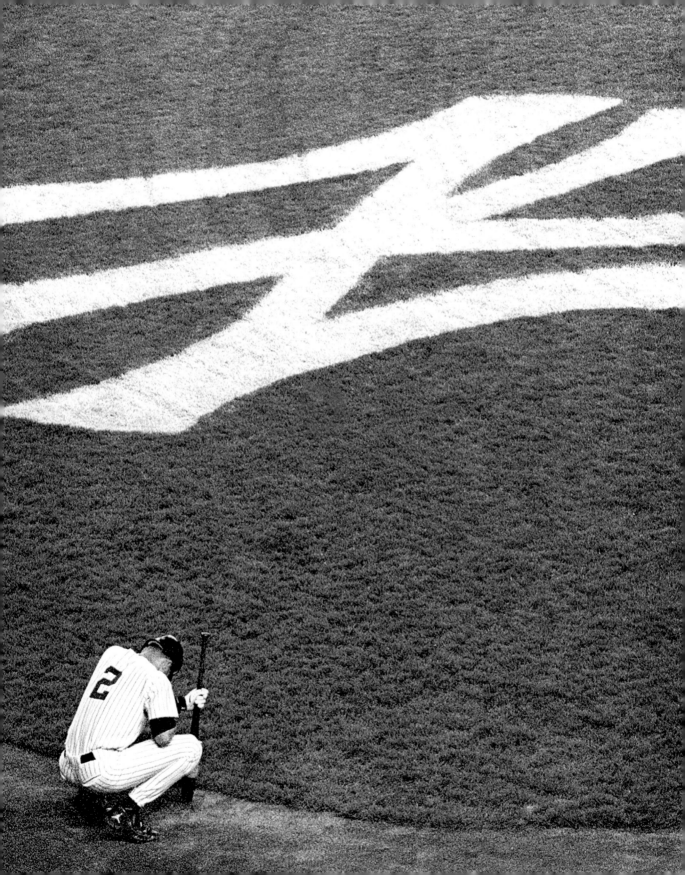

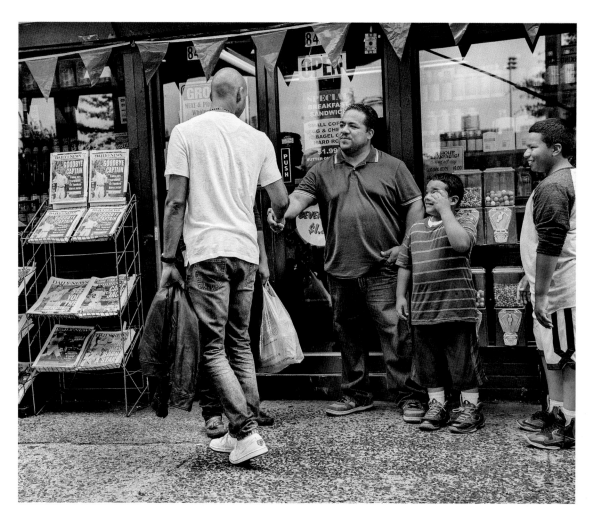

Nothing Quite Like It

Our fans are great. When they start chanting your name, and you hear the sound of thousands of people chanting together, there's nothing better. When I was younger and dreamt of playing in the majors, I imagined a lot about what it would be like, but hearing the fans cheer wasn't part of my dream. And even if it was, nothing can prepare you for that when you experience it for the first time. The cheering feels really good.

I've been on the other side of that as well, having a whole stadium boo me. I got that on the road a lot in my career, which makes how I've been received on the road this season all the better. It's been awesome, but I have to say, when Yankee fans cheer for you and chant your name in Yankee Stadium, there's not a single feeling in the whole wide world that can top that.

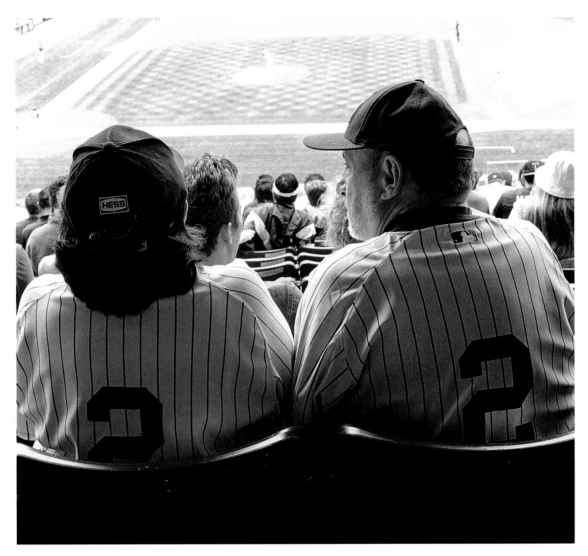

Fan Club

I remember the first time I saw a fan wearing my T-shirt. I was out at a restaurant on the Upper East Side called Cronies that was not too far from my apartment, during my first season, and I saw a girl walking by with my name and number on her T-shirt—I thought that was the coolest thing in the world.

Me Time

I love driving myself to the stadium for home games. I use that time to call family and friends, or just take some quiet time for myself before I get to the ballpark. It's the one hour in the day that's all mine. Once I'm there, I have very little free time, because there's always something going on: batting practice, media interviews, meet and greets, trainer time, you name it. I've gotten rides when I have events I'm going to before or after, but generally I really like driving myself to the stadium and pulling into my spot.

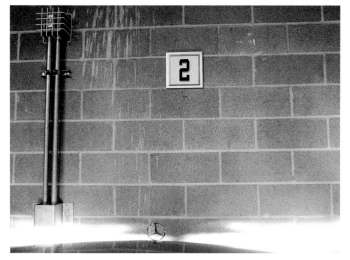

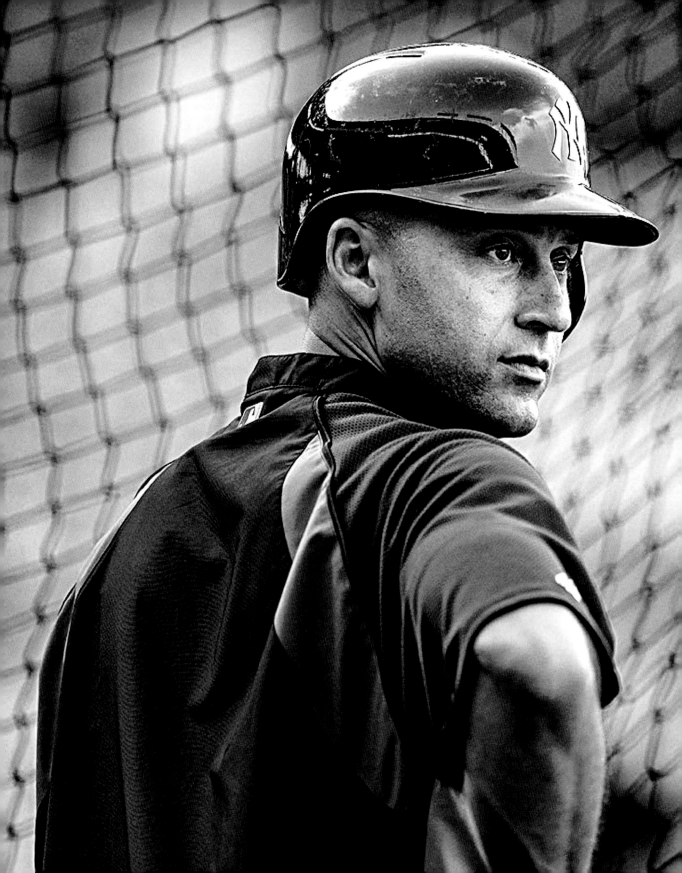

OPENING DAY

The one thing that never changes is the butterflies. I've gotten them every Opening Day since my first, and 2014 was no different.

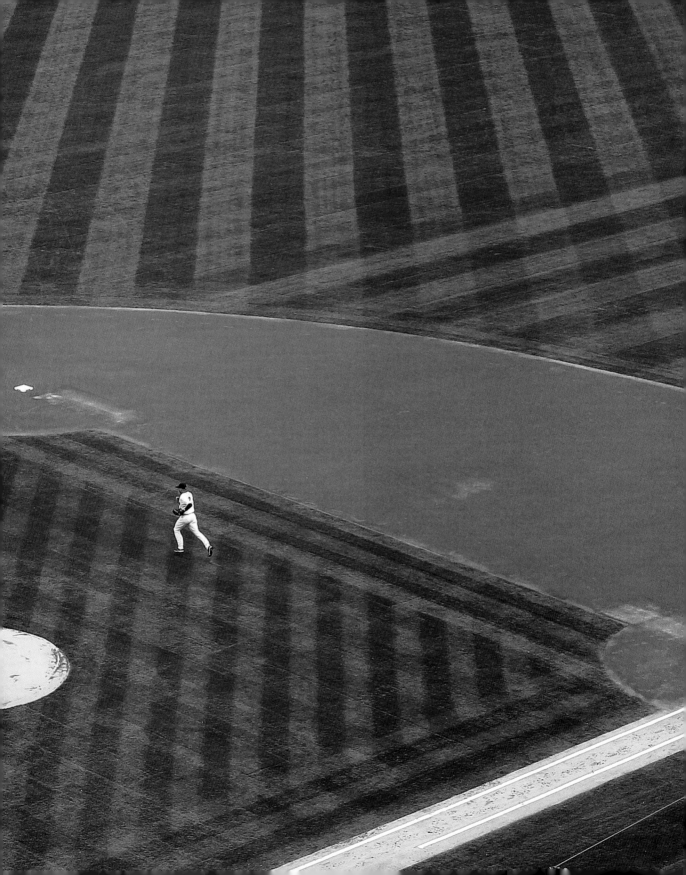

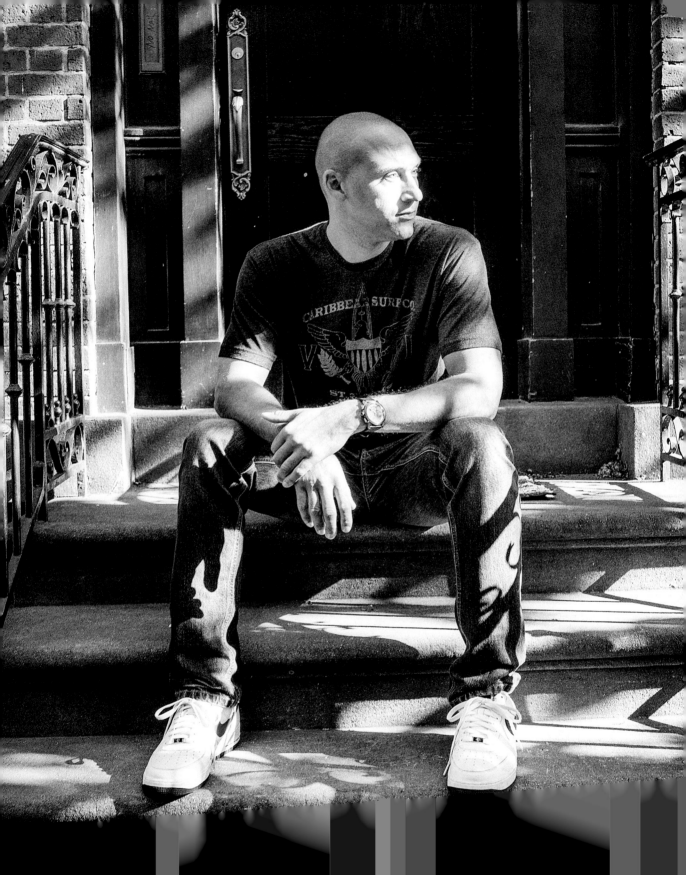

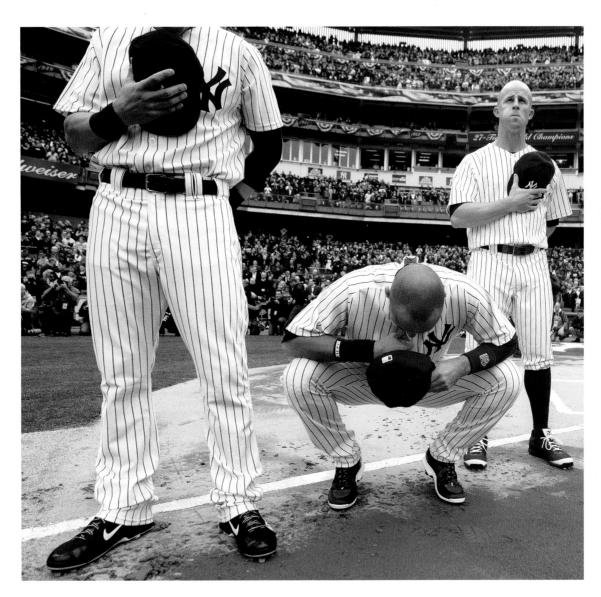

An Invocation

When I kneel down before every game, I say a prayer that I've been saying pretty much
the same way since Little League. It's a quick prayer, before every game and every at
bat. It's short but important. I pray that I have a good game and that I don't get injured.
I pray to play well and stay healthy.

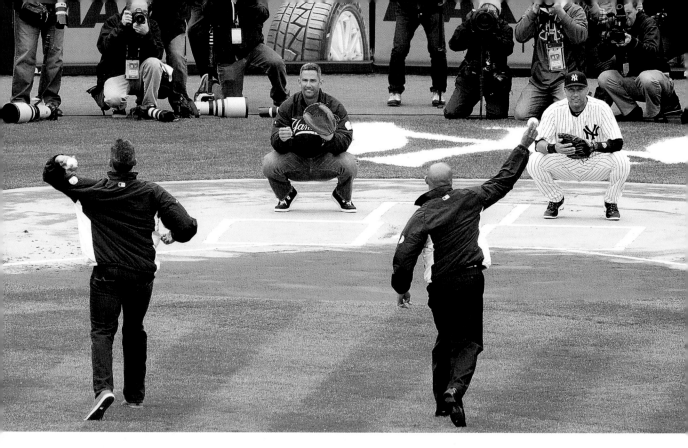

And Then There Was One

It was cool to have Mo, Andy, and Jorge at the stadium with me on Opening Day—those guys are like brothers to me. I wish they were still playing with me; this is the first year where I haven't played with at least one of them. That took some getting used to. For me, Jorge was the toughest one to see go, because we are so close. He was a position player, so he and I were together pretty much every day for eighteen years. We relied on each other and picked each other up when times were tough. Back in 1997, Jorge was sent down to the minors and brought up again four or five times and we dealt with that. He felt like he was being demoted, and I had a hard time losing my best friend on the team every other week. It was frustrating but we talked a lot and I tried my best to help him stay positive and confident. That happened to all of us—I got sent down, Mo did too. It makes you feel like you're not doing your job, and when that happens you need your friends there to pick you up. So Jorge retiring was the most difficult transition for me. Then Andy and Mo retired in 2013, so I got used to it. I didn't like it, but I got used to it.

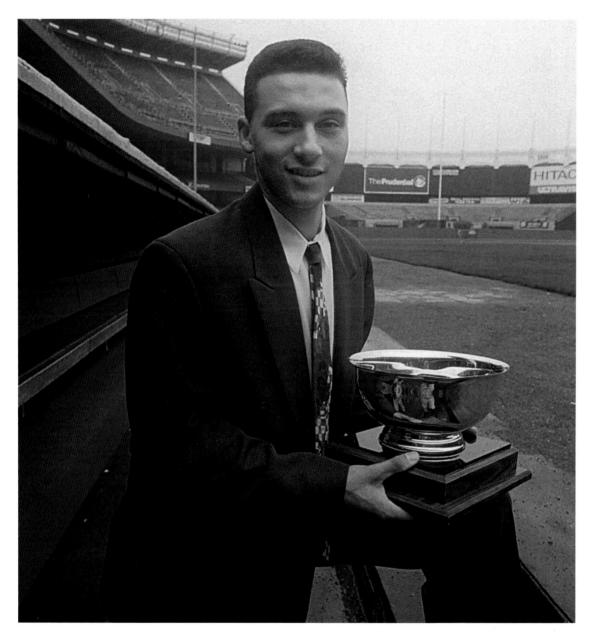

An Empty Introduction

The day I received the 1994 Minor League Player of the Year Award, I went to New York to attend a ceremony at Yankee Stadium. Major League Baseball players were on strike, so there were no MLB games being played, there or anywhere. I was twenty years old and had just two suits and two ties . . . I've gotten a couple more since then. It was strange, no one was there. It was a small event in a ghost stadium.

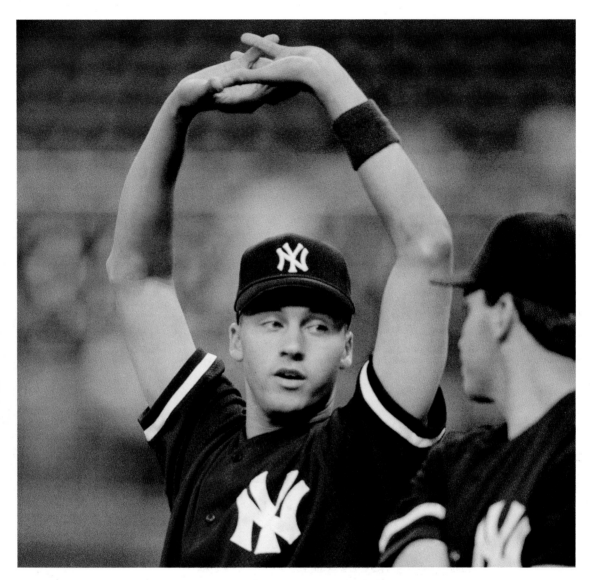

It's Go Time

This is me, warming up on May 29, 1995, about to make my first appearance as a New York Yankee, and I was scared to death. The morning before at like five or six o'clock I got a call from our Triple-A manager. I had no clue what was going on, I thought maybe I'd been traded, but he said, "Congratulations, you're going up to the Big Leagues." I was on a plane to Seattle the next day. The team was traveling up from Anaheim, and I was meeting them in Seattle; I arrived first and grabbed a cab to get to the hotel. The moment the cab got to the top of a hill, I took in a view of the skyline and it took my breath away. I could see the whole city below, and I said to myself, "Oh, man. This is it." Even though my first game wasn't in New York, it was still huge to me.

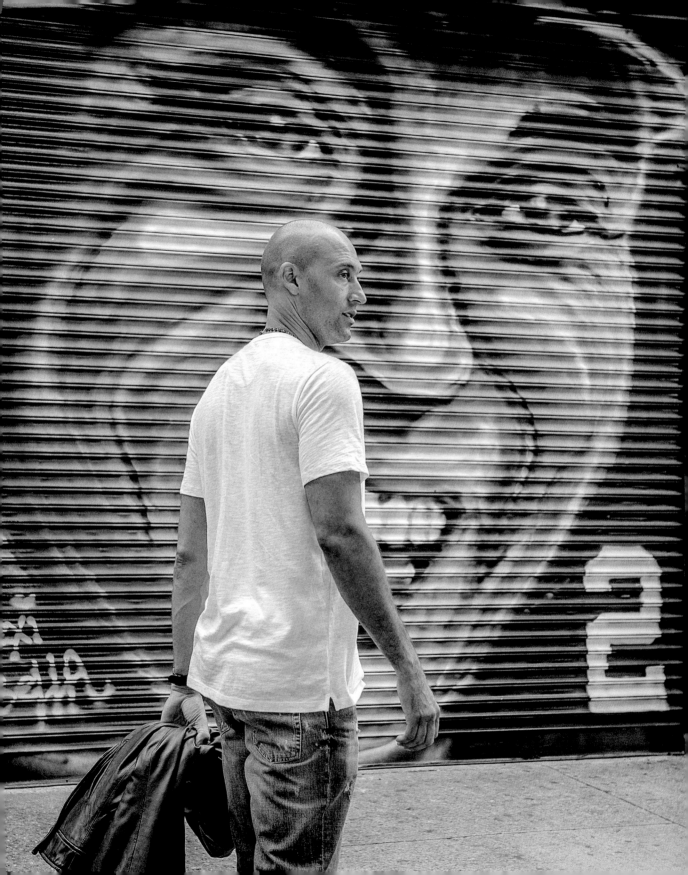

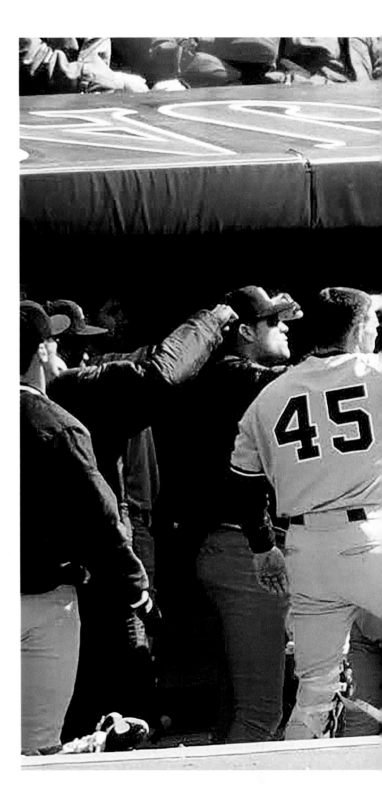

You Never Forget the First Time

My best Opening Day ever was my first one, on April 1 in Cleveland in 1996. I hit my first MLB home run, I played pretty well, and we won. Your memory of the first time you do something always stays with you, so that will always be one of the most special games I've ever played. The guy who caught my home run ball wouldn't turn it in, so I don't have it. Maybe he still has it, maybe he threw it away. I guess we'll never know.

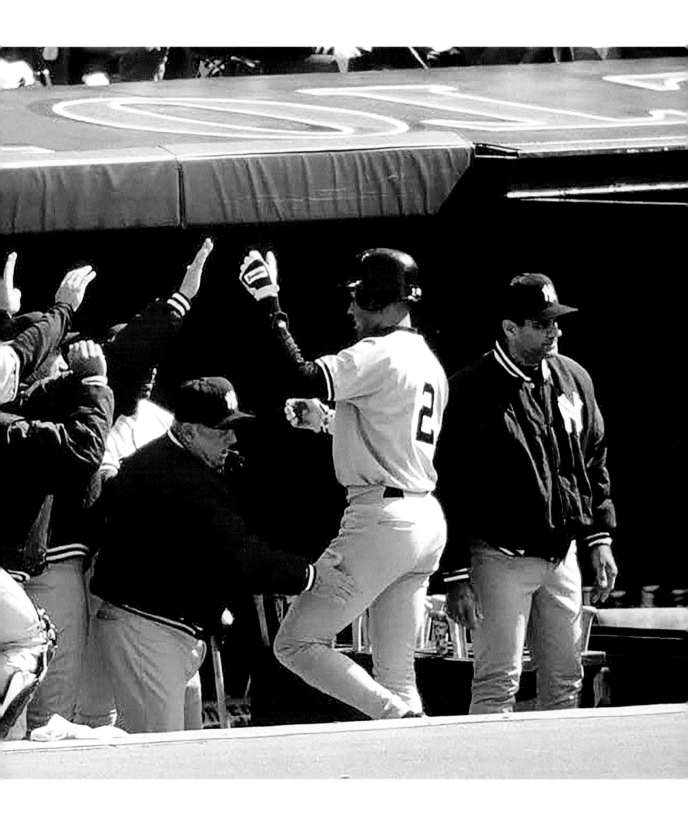

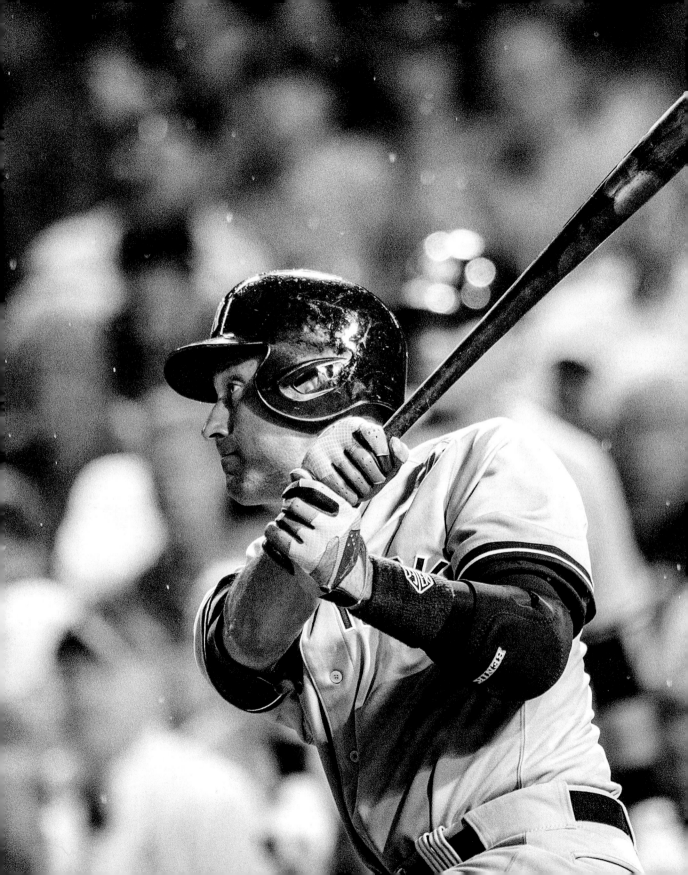

PRACTICE, PRACTICE, PRACTICE

My biggest fear in life, on or off the field, is to be unprepared—for anything. I've always relied on practice, repetition, and discipline, so not being prepared makes me nervous and uncomfortable. In any profession, the more you do things the more they become second nature, and once that happens, you no longer have to think, you just do. That is what practice is for—to think about what you're doing and how it's all working so that when you play, hopefully it all comes together naturally. That is the goal, and the only way to reach it is through dedicated repetition.

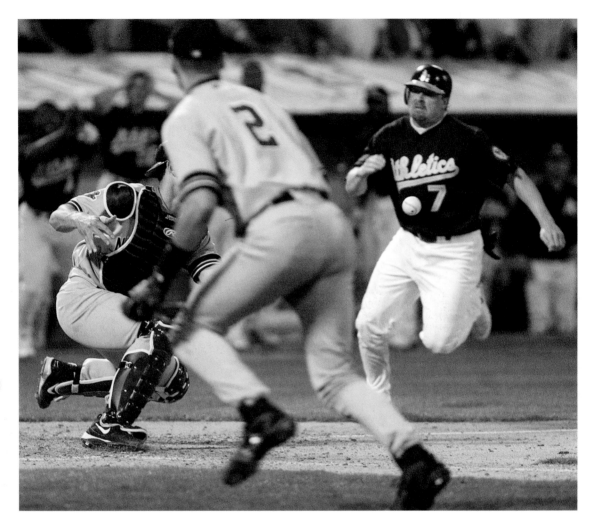

The Flip

Now this is something that no amount of practice can prepare you for. No team or player ever practices flipping the ball home, so I can't say I was prepared for this play. I just was where I was supposed to be on the field, which was the right place at the right time, I guess. I caught the ball running with both hands on a bounce, and flipping it to Jorge was the only way I thought we could get the out. This play is one of those things you'll never see again. I don't think any other teams practice the alignment we had on that play, and we certainly never practiced a situation where the ball was off-line and there was a play at the plate, so everything about that moment was completely improvised. It was the playoffs and we were on the brink of elimination, so it got a lot of attention, and though it's tough for me to rank, I consider it one of the best plays I've ever made.

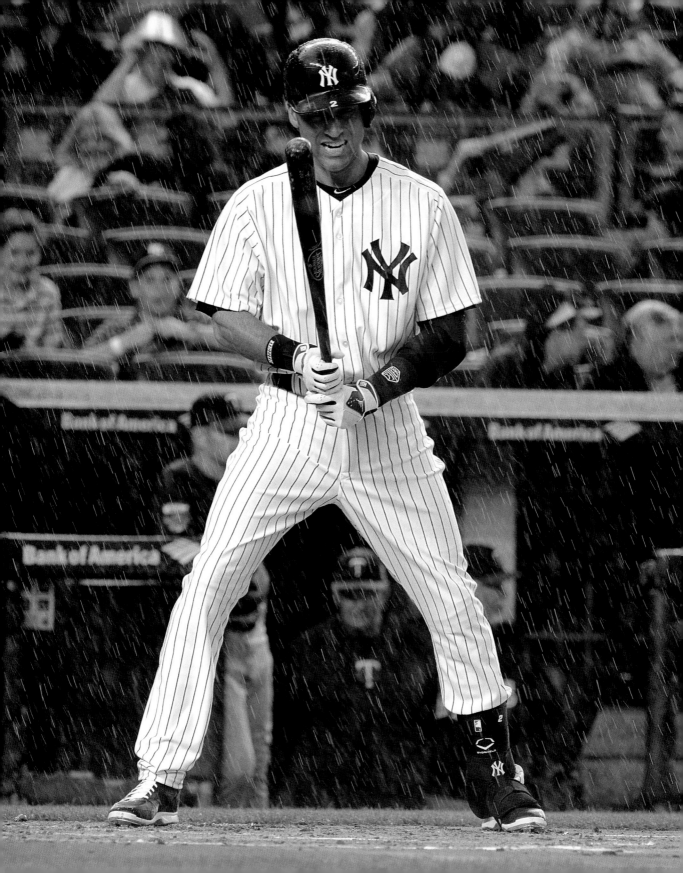

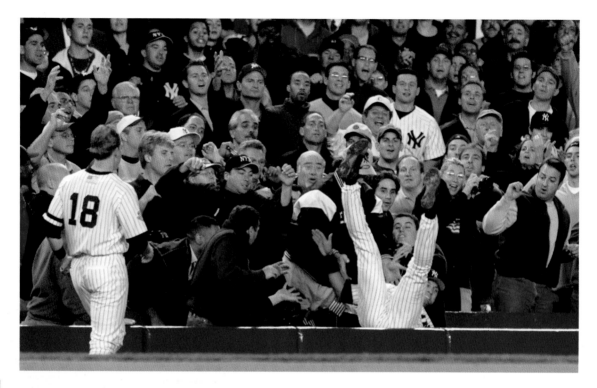

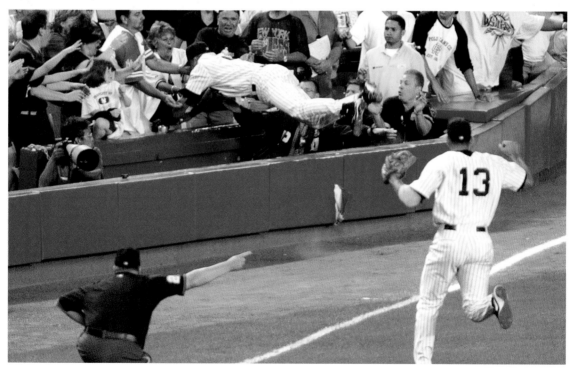

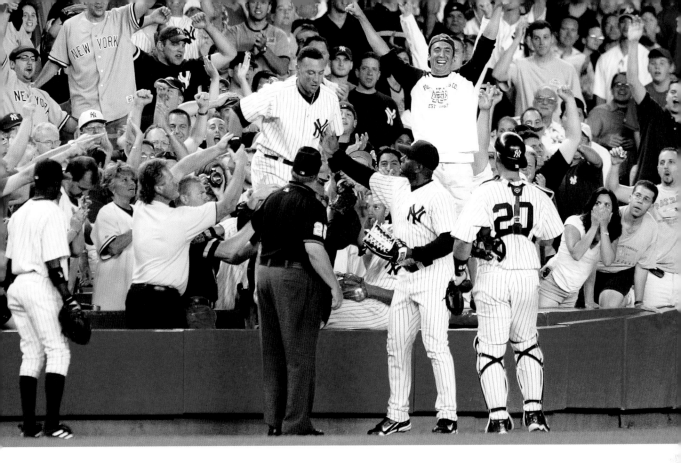

The Dive

It really wasn't difficult to catch the ball. The landing was another story. In in our old stadium there was a photographers' pit on the other side of the wall—I'd gotten well acquainted with it a couple of years before this during the playoffs. It was the game after the "flip play," actually. We were playing Oakland, and I caught a pop-up and fell over the wall directly into the photographers' pit, which is nothing but a cement-lined open space. Not a very nice place to land.

So when I found myself in the same situation, I had the bright idea to jump the pit this time around. I was running full speed and knew I couldn't stop in time, because there wasn't a lot of room in foul territory in the old stadium. In my mind, my best bet was hopping over the pit and running into somebody in the crowd. The only problem with my plan was that I ran right into an empty chair. I missed the cement, but I hit a chair face-first instead. Neither one is a great option, but given the chance again, I'd probably choose the cement. I actually own that chair now—Steiner Sports gave it to me when the old stadium was torn down.

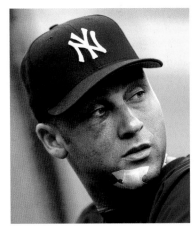

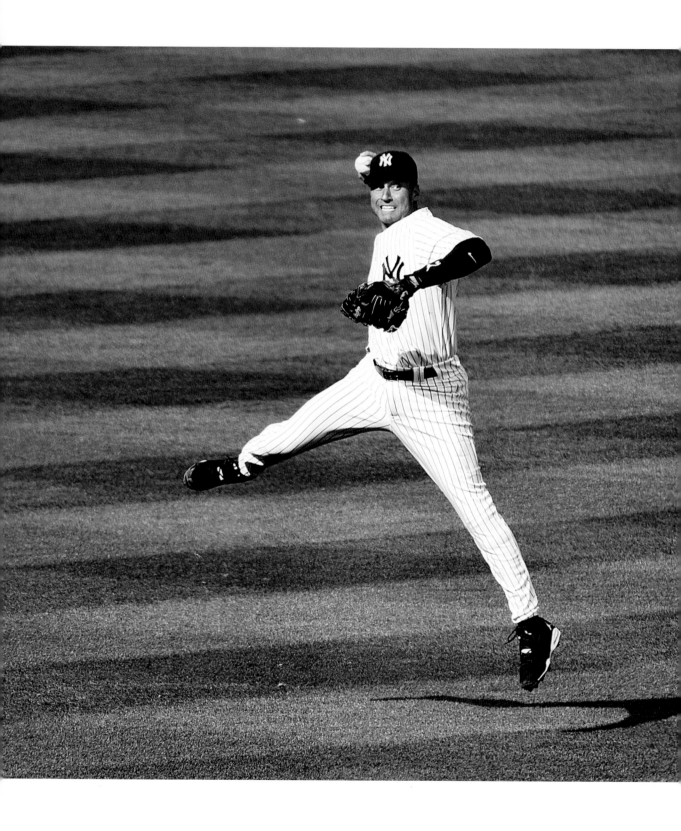

The Jump Throw

People always talk about my jump throw and ask me how I developed it. It was a move I did in the minors, but just in practice, just messing around. I kept working on it and having fun with it until it got to a point where I realized I could pull it off. I didn't try it in a game for quite a while. It's not something you just go out there and do—particularly in a game, because a lot can go wrong with it.

It's like anything else: I got there through repetition and focus. You continue to work on your skills and improve and refine your game, and some things that really work for you come out of it. If you continue to work on your defense and offense, honing your abilities in every aspect of your game, good things will happen. I like to think that I was an okay athlete growing up, and I think playing other sports helped me to learn different moves, to be able to integrate jumping in my defense maybe more than other guys would.

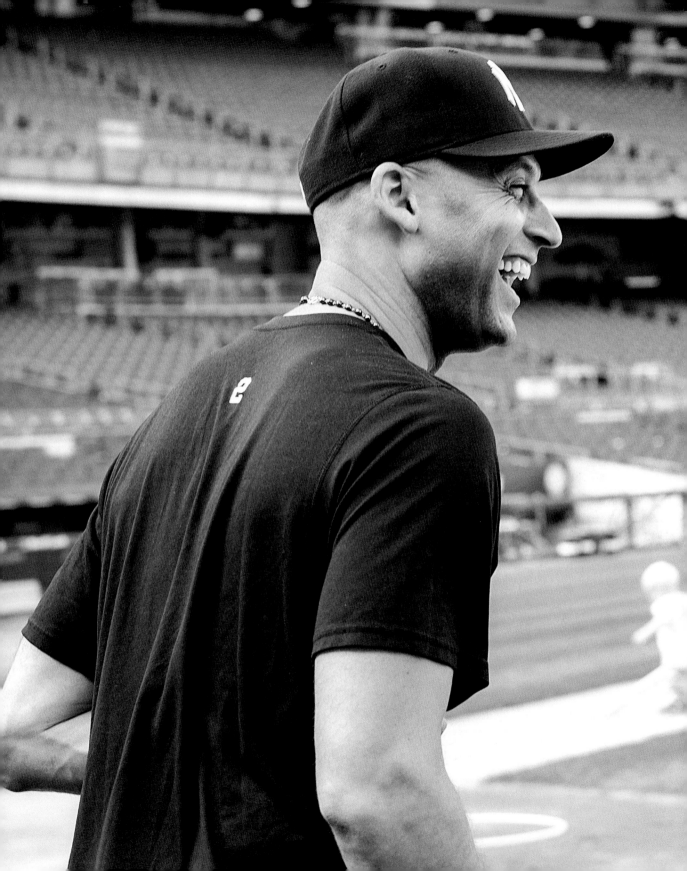

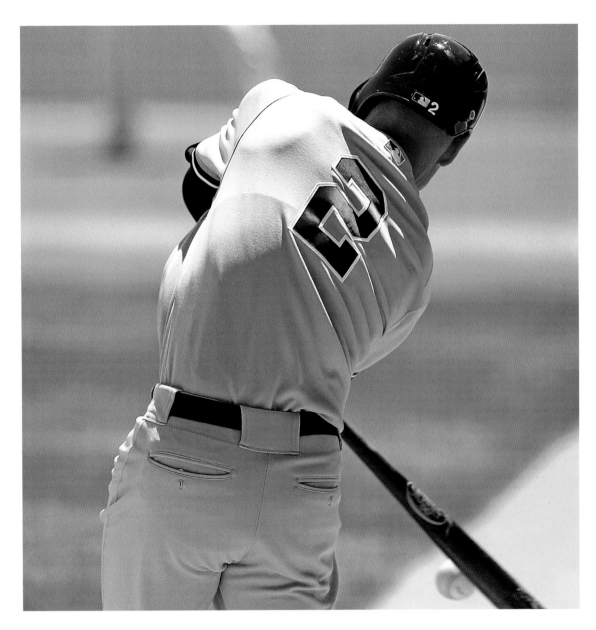

The Swing Doctor

I don't want to keep repeating myself, but the truth is baseball is about practice, discipline, and repetition. I'm habitual in what I do. I had a coach by the name of Gary Denbo, who was my first manager in the minor leagues. I was with him throughout the minors and when he was a hitting coach in New York in 2001. He is based in Tampa, and I have worked with him in the off-season ever since. In fact, Gary is responsible for helping me perfect my inside-out swing; some of it is just how I hit, but over the years my swing has improved tremendously, thanks to all of my work with Gary.

It's Not Just a Numbers Game

In terms of the mechanics of defense, one of the hardest things to learn, or teach, is acquiring a feel for the game. Nowadays there's too much emphasis placed on the computer science of baseball. Computers say that 72.3 percent of hit balls go to a certain place, so players are taught to stand in those places—and that can limit their thinking. Too scientific of an approach to the game takes the fun out of it, because if you approach all of the action on the field in that way, it's not a game anymore. I think the best way to learn how to play baseball well is to get a feel for the game before you even try to play it. Anticipation and preparation in particular are the keys to being a good fielder.

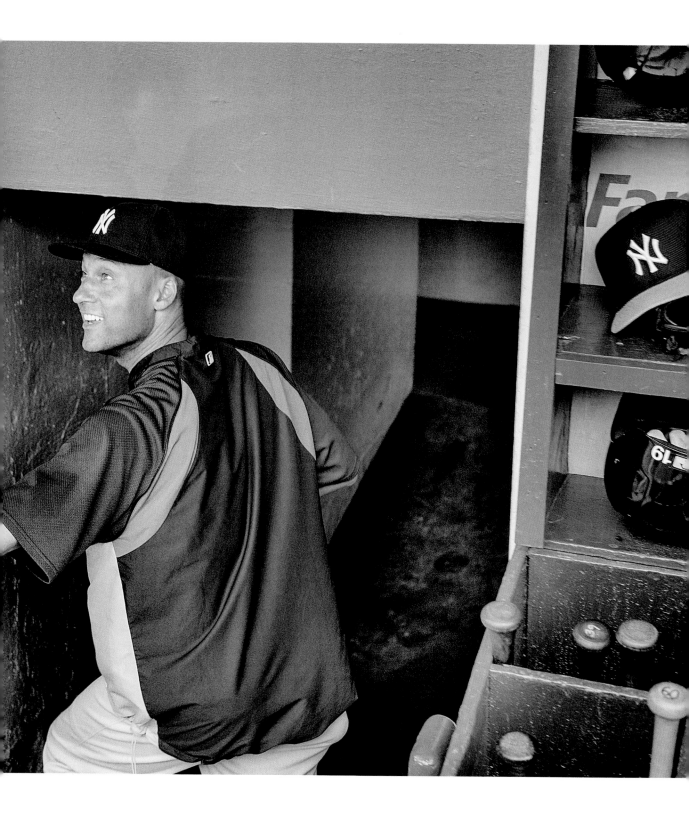

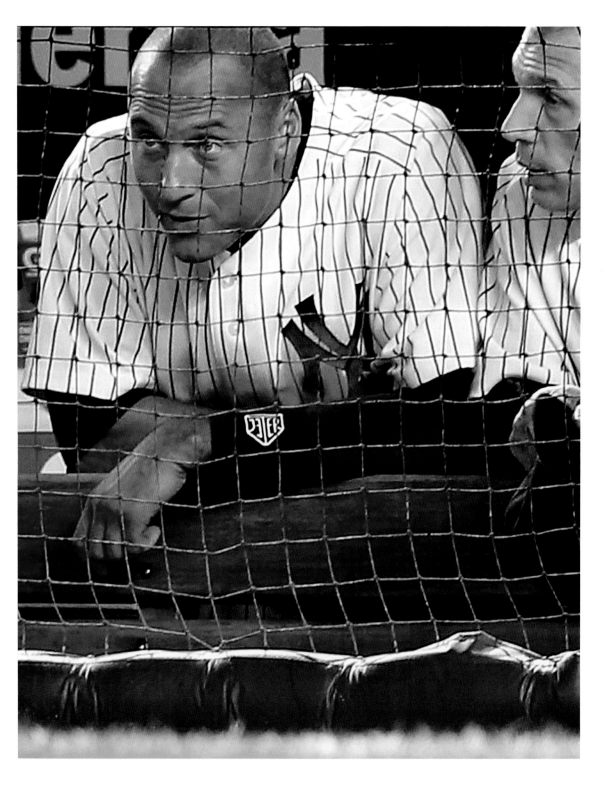

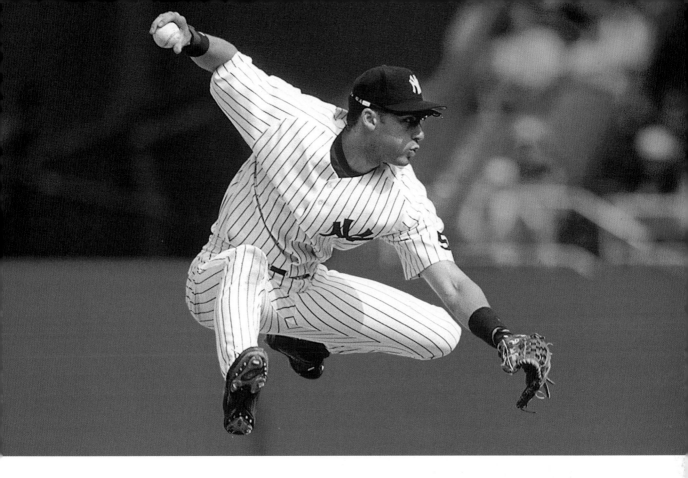

Defense Wins Championships

I take a lot of pride in my defensive game, so winning the Rawlings Gold Glove for the first time in 2004 meant a lot to me, and it has every time since then, too. The Gold Gloves are voted on by a committee of peers, as opposed to by sportswriters, so winning it comes with a huge degree of respect, because the coaches and managers of the teams you're doing your best to beat all season are the ones who vote for you.

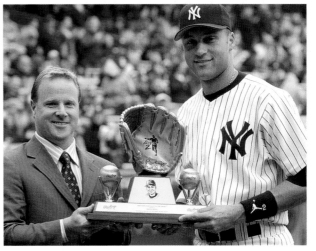

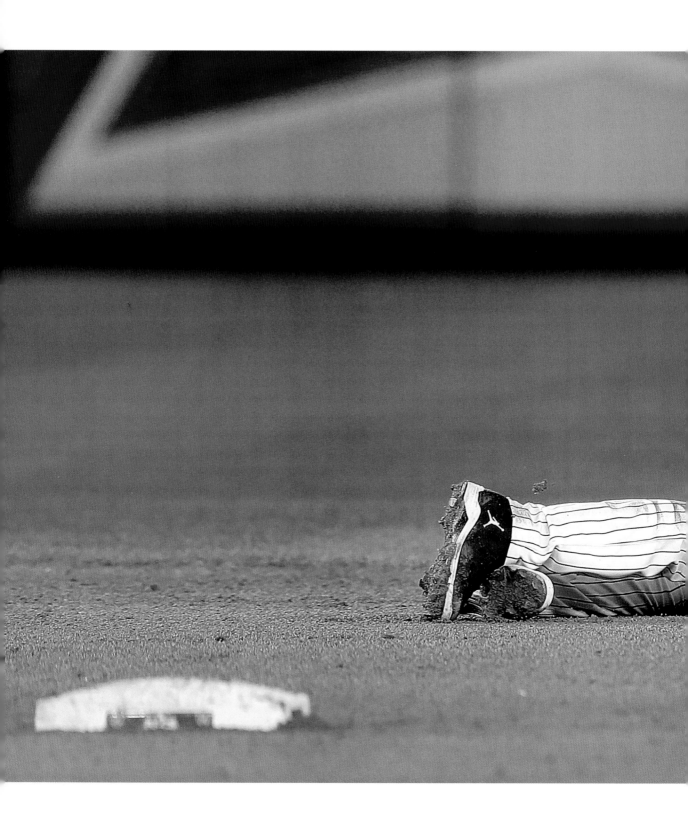

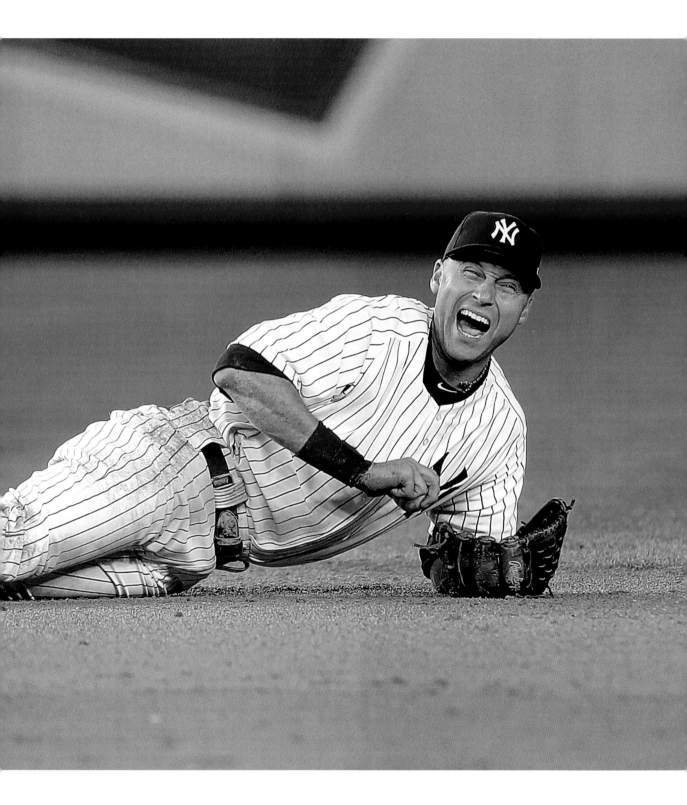

Down But Not Out

I felt it pop. And I knew it was broken. The next thought I had was that I had to get off the field. I did not want to be lying there helpless. Before we even entered the tunnel to the locker room, my initial instinct was: How long until I can play again?

That's where my mind was. I was more focused on that than the pain. Up until that point I had missed a total of about eighty games due to injury in my entire career. My foot would hit the bag wrong in Tampa or in Boston, and I'd end up with a bone bruise. But with just a month left in the season, we were in a neck-and-neck, back-and-forth battle with Baltimore.

So I kept playing. Eventually that bone bruise turned into a stress reaction; then, that day, the malleolus, which is the bone that sticks out of your ankle, just snapped in half. I only took two or three steps.

I've been fortunate enough that aside from dislocating my shoulder in 2003, which took me out for six weeks, I'd had no major injuries during my career. This was something different. It was the first serious, major injury I'd ever had. So there was uncertainty about what the doctor was going to say, but I just tried to stay positive. I kept asking when I could come back, not if I could come back.

I broke my ankle in October and was in a boot until January. When I started playing games at the end of February, I ended up breaking it again and landing back in the boot for another six weeks. All of the off-season immobility made the whole process of coming back that much harder. I had to regain my leg strength. I had to do agility and speed work; I wasn't able to run at all, so I had to get my cardio together. It set me back and took a lot of work to get healthy.

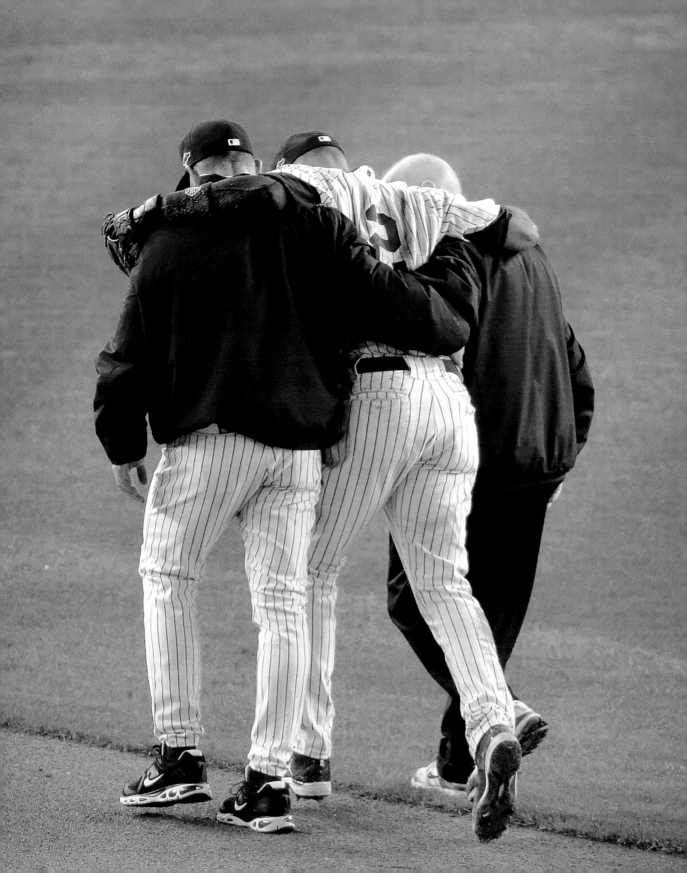

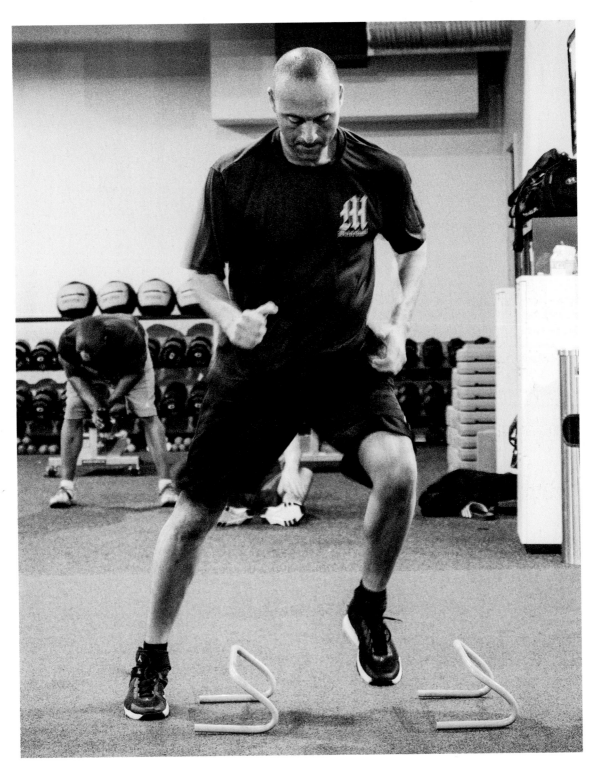

Coming Back

I pride myself on working extremely hard during the off-season, but I probably worked the hardest that I ever have this past year, 2013–14. When I began again it was like starting from square one. I was trying to slim down and rehab my ankle and get the rest of my body in shape all at the same time. All in all, it was a long, hard off-season, the most difficult of my entire career. There are no short cuts when it comes to training; you have to do the work if you want see results. Chef Debbie keeps me disciplined and really helped me this past off-season when I needed to slim down for the sake of my ankle.

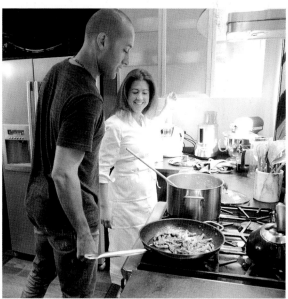

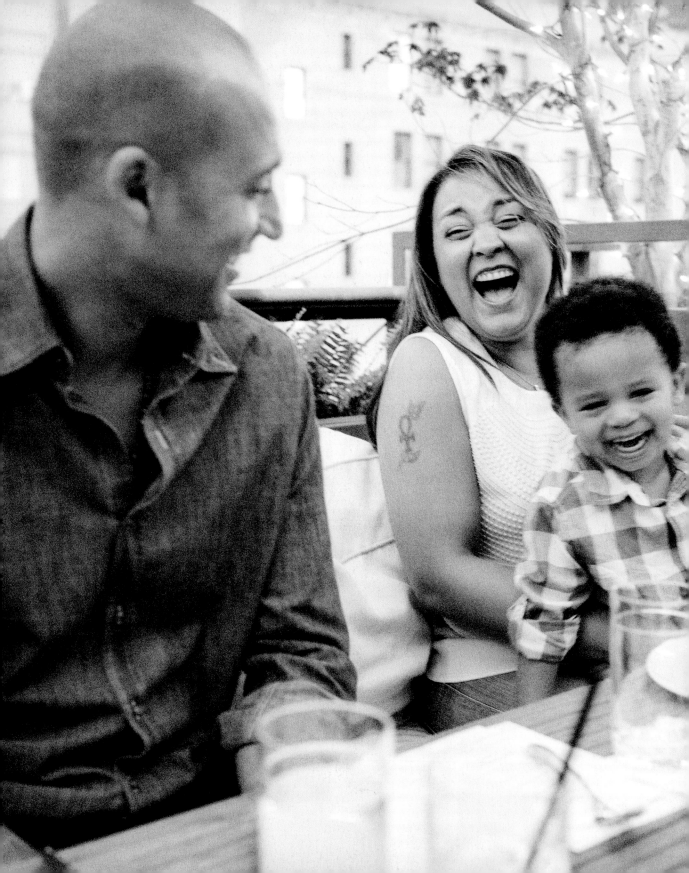

FAMILY FIRST

Without question my family has been a huge factor in keeping me consistent as a competitor. They have been at quite a few home games, every year. Baseball is a game where failure is inherent. Even batting .333 means you fail two-thirds of the time. The thing you need is people around you who are going to stay positive. The media has a tendency to be negative on most days, so if I didn't have people around me to support me, I wouldn't be able to do what I do.

I think it's even more important that I have people around me who are always going to be honest with me and tell me what they think I'm doing wrong or right. My family and friends are those people for me. It's simple: I wouldn't be who I am today if it wasn't for my family. You have to have a good support group, regardless of your profession. If you have any level of success or any level of failure, you have to have a network of people to lean on and count on.

The Family Tree

This past year I participated in the PBS show Finding Your Roots *with Professor Henry Louis Gates Jr. because my parents and I wanted to learn about the history of our family. They take a sample of your DNA and trace your ancestors back as far as historical records will allow. It was incredible—they were able to trace both my dad's and mom's sides back to the 1600s. Because of slavery, it isn't common for the roots of an African-American family to be traced back that far. The most interesting thing they found was that our last name came from the slave owner, and they were also able to trace the slave owner's ancestry further back than anyone else they'd ever had on the show.*

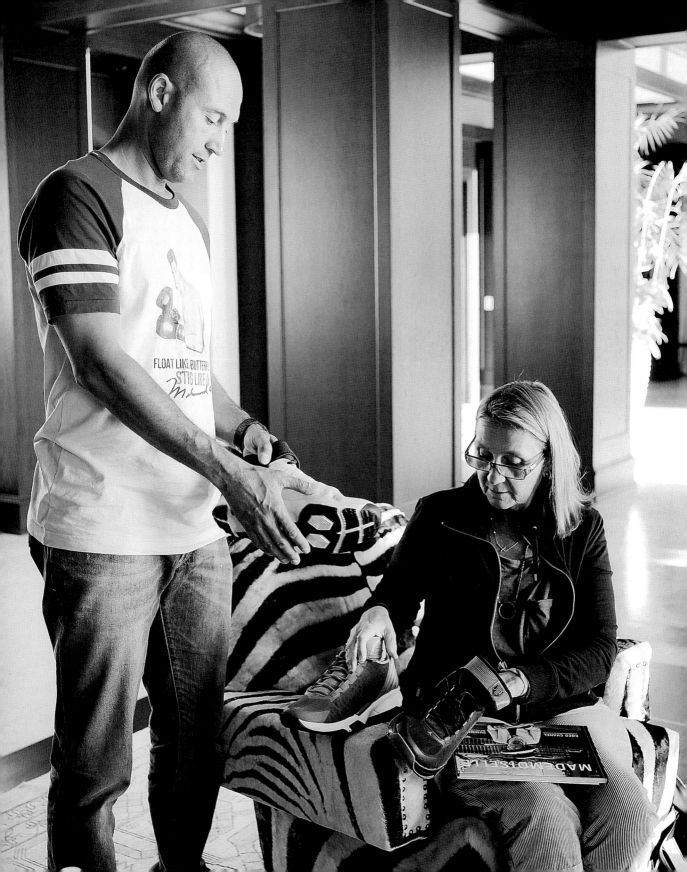

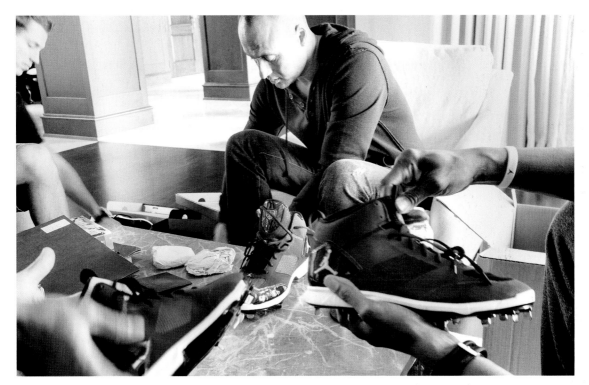

Re2pect

This season I went to the Nike campus in Oregon to have my ankle scanned and to have them do other tests and measurements so that they could make a shoe that fit me perfectly and provide extra support to my ankle. The doctor who operated on me, Dr. Robert Andersen, traveled with me to oversee the design and make sure it was the best it could be. How's that for team effort?

Here, my mom and I are looking at the first pair they sent down. I've been with Jordan Brand since 1999, and it's been such a great thing. I initially met Michael when he was playing baseball in 1994 in the Arizona Fall League. When he asked me to be a part of the brand, I was honored that he would ask me. He's like a brother to me now, because our relationship has grown throughout the years. To be the first baseball player on his brand was flattering, to say the least. And the ad they did in honor of my last season that aired during the All-Star Game was awesome. Now, at every stadium I visit, people tip their caps to me the way everyone did in the commercial. It's really nice, and it's also kind of funny. There was a kid next to the dugout in Boston who did it every single time he caught my eye. I'm happy to do it back—if I have my hat on.

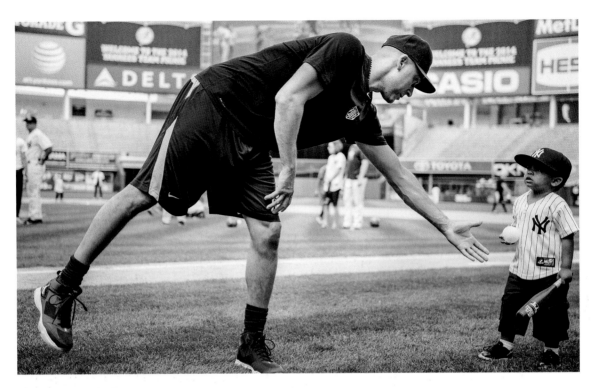

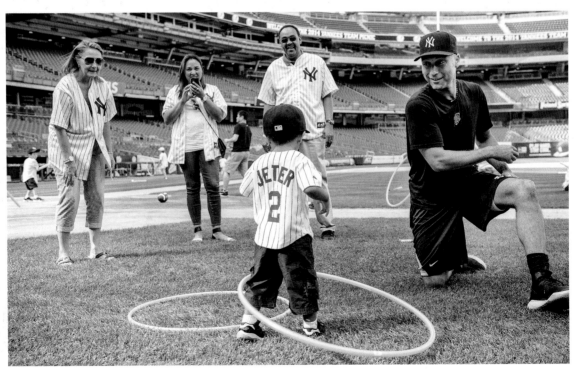

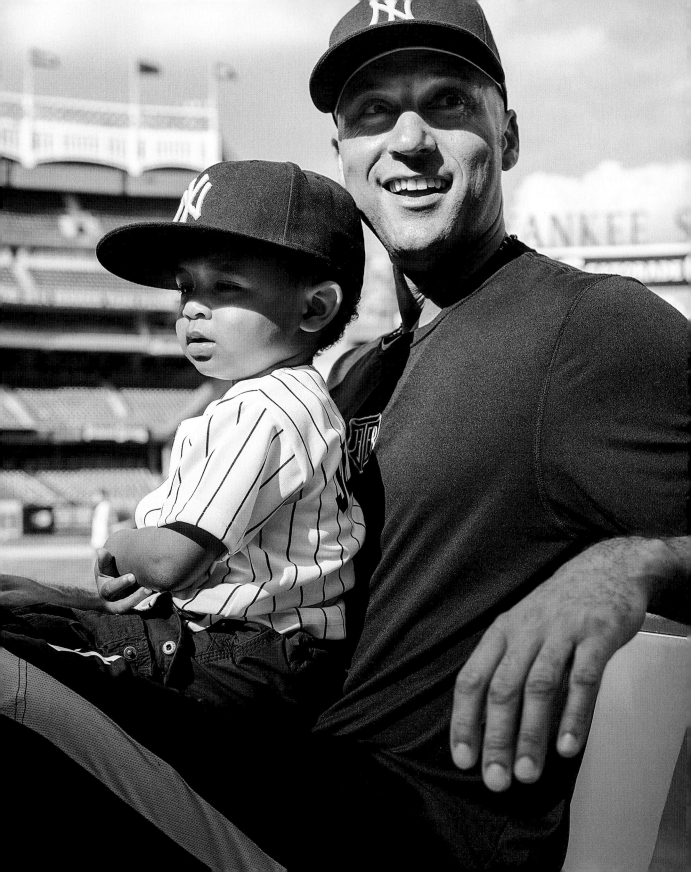

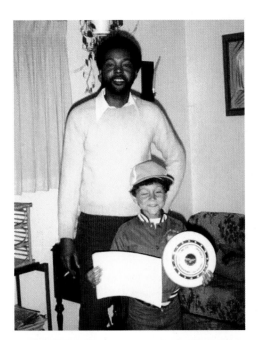

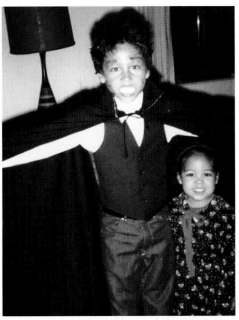

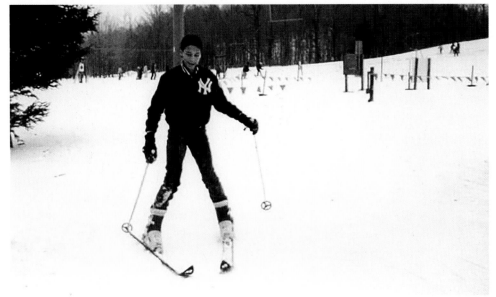

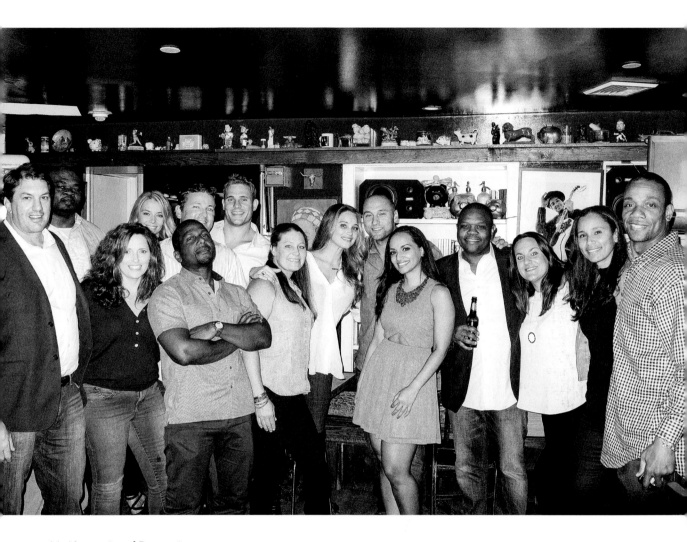

My Nearest and Dearest

*I like to share all of my experiences with family and friends as much as possible.
I've been like that ever since I was a kid. I was the one who always wanted
everyone around. If I'm going to a movie, I want everybody to go. If I go to eat,
I want everybody to come. So it's been fun to share the experiences of this final
year with the people who mean the most to me.*

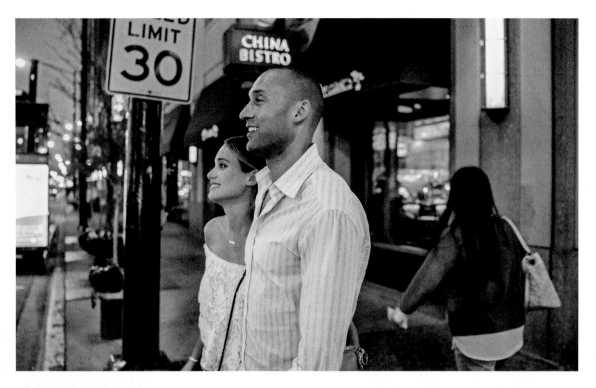

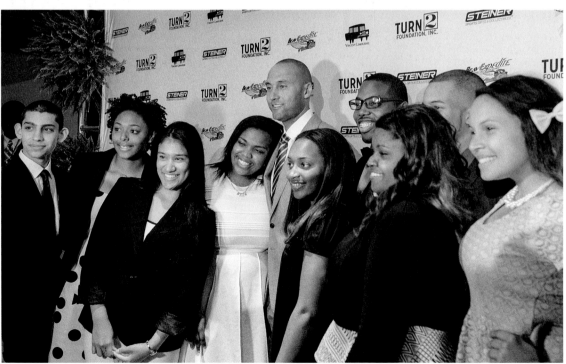

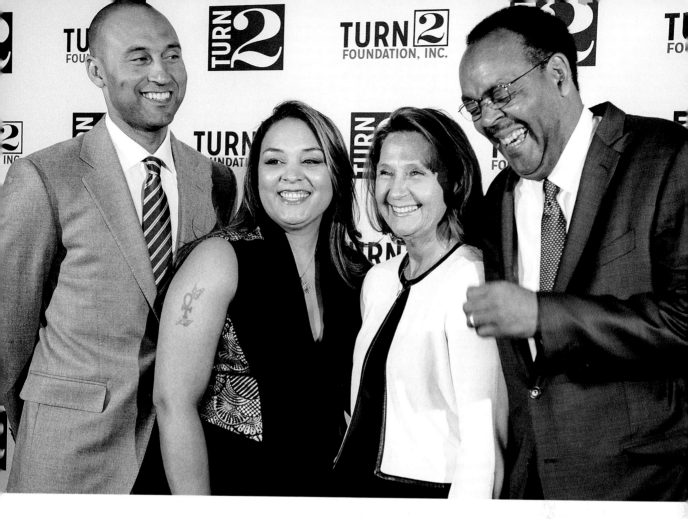

My True Legacy

It's been pretty amazing to watch the Turn 2 Foundation grow since 1996. We've gotten so much support throughout the community, thanks to our fundraisers and through my partnerships with different brands and companies. To see the growth throughout the years has been awesome, and to work on it as a family has been a special experience. We've always been close, but on new levels it's brought us closer. And the torch is being passed: my dad used to run it, and now my sister is taking it over. I left home when my sister was in seventh grade, so aside from talking on the phone a lot, I missed her growing up. But we've grown a lot closer in our adult lives and I'm happy that we work on the foundation together.

Turn 2 has far surpassed anything I could have imagined when my family and I first discussed creating this foundation during my rookie season, and spending more hands-on time with our programs and participants is a major priority for me in retirement. The high school students in our Jeter's Leaders program are so impressive; they dedicate themselves to mentoring others, modeling healthy lifestyle choices, enacting social change projects, and becoming true leaders. Ultimately I hope they are my most enduring legacy.

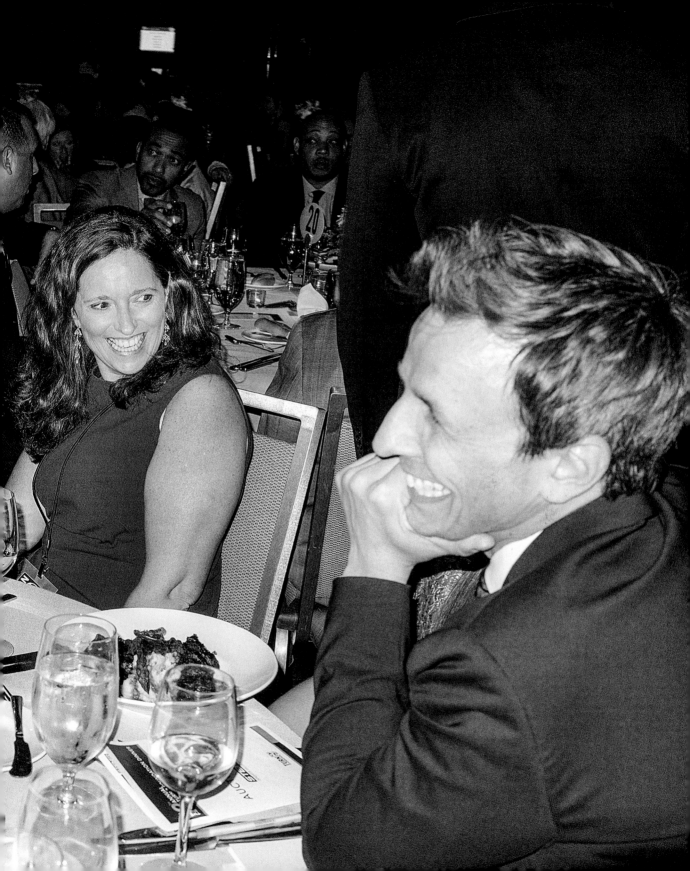

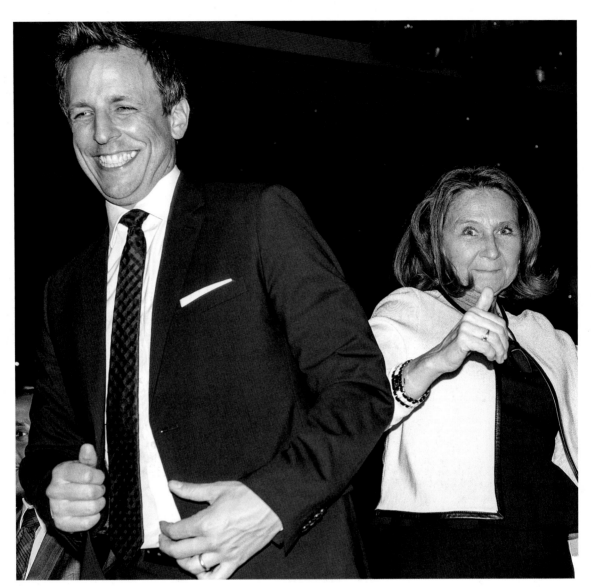

The Host with the Most

I got a chance to know Seth Meyers when I hosted Saturday Night Live *back in 2001, so I was thrilled that he came out and moderated this year's Turn 2 Foundation dinner. He did a Q&A with me and I like to think that I gave as well as I got in that exchange. He was a great host and even danced with my mom.*

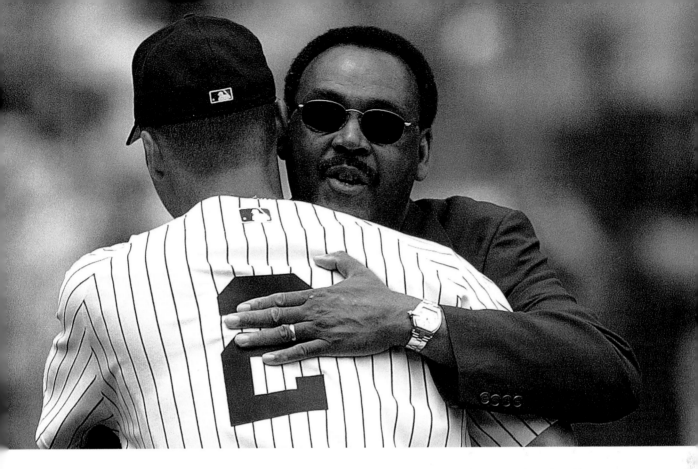

Heeding Dad's Advice

I played everything when I was young, but baseball and basketball were my two favorites by the time I got to high school. Soccer lasted only a couple of years, and I can tell you why: too much running. In baseball, most of the time you run ninety feet, then take a break. Maybe you'll leg out a triple and that's two hundred seventy feet. But soccer? That's nonstop.

I played third, I pitched, but I always wanted to be a shortstop, because my dad had played shortstop. As a pitcher, I wasn't bad, but I wasn't made to be a pitcher. I got out on the mound and threw as hard as I could, but I didn't really have it in me. I mostly played short, aside from the time my dad, who was my coach, wanted to teach me a lesson. He kept telling me to only worry about the things I could control. Apparently I wasn't getting the message. He made his point by putting me at second. If you have no control of it, don't worry about it.

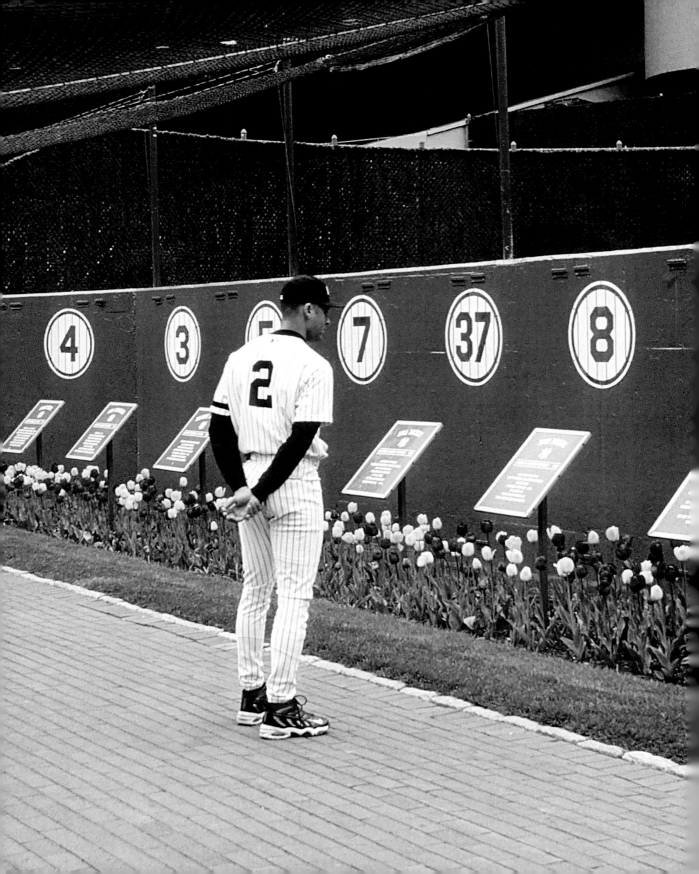

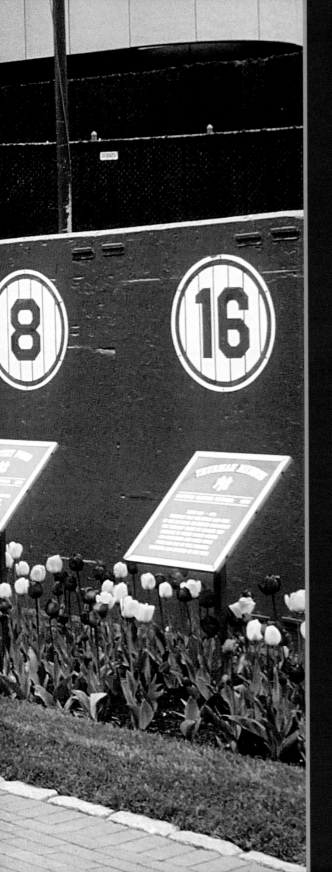

THE TEAM

I had always dreamed of playing for the Yankees and playing in a World Series, but I never dreamed that one day I might end up in Monument Park. That was never part of it and I don't allow myself to think about it now, even in my last season. That would be getting way ahead of myself and I could never do that. But once the season is over and I've had some time to reflect, maybe I'll let myself think about it. And who knows, one day, maybe they will make a space for me there.

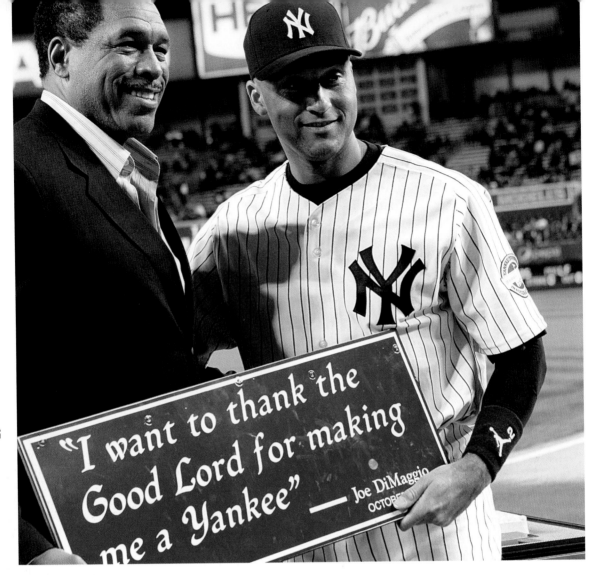

My Hero

I remember the first time I saw Dave Winfield on TV: he was larger than life. He was six foot six, just huge, much bigger than everyone else. He hit the ball harder, he threw the ball harder, and it seemed like he ran faster. He was a hero of mine. To this day I think he's still the only athlete to be drafted in all three sports—football, baseball, basketball—and he'd never even played football.

Dave was the epitome of the all-around athlete, and in my mind, as I was growing up, he could do no wrong. He also inspired me to start Turn 2, because he was one of the first athletes to have a personal foundation. I met Dave for the first time during my rookie season in 1996, and that was a thrill for me. He never gave me any baseball advice; he just congratulated me and told me to always enjoy the game. I now pass that same tidbit along

Dave is as well known for his colorful relationship with the Boss, but he never gave me advice on handling him—that's because with the Boss, you just had to live and learn. You can say the same thing about playing in New York. People can give you all the advice in the world, but you just have to experience it.

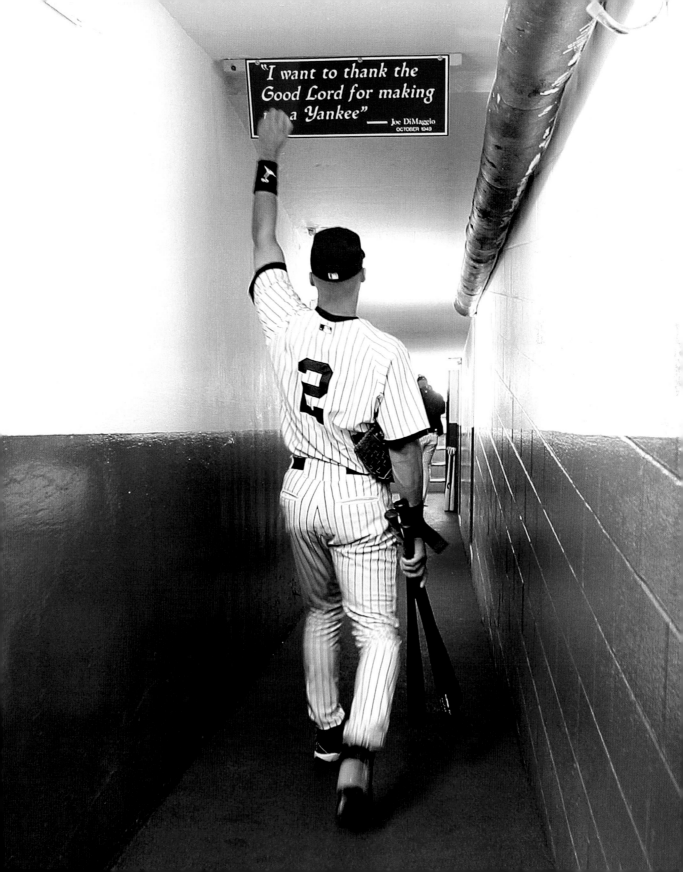

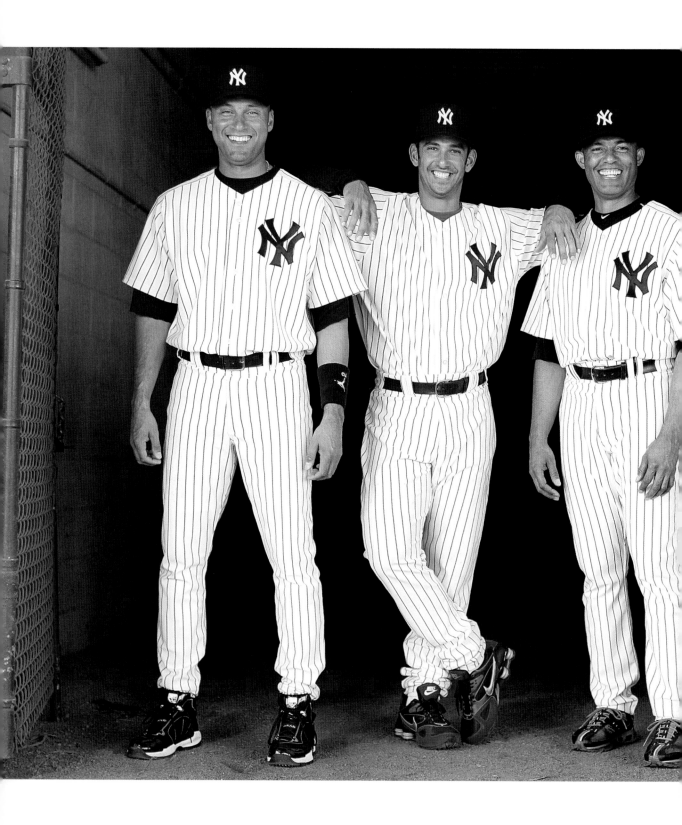

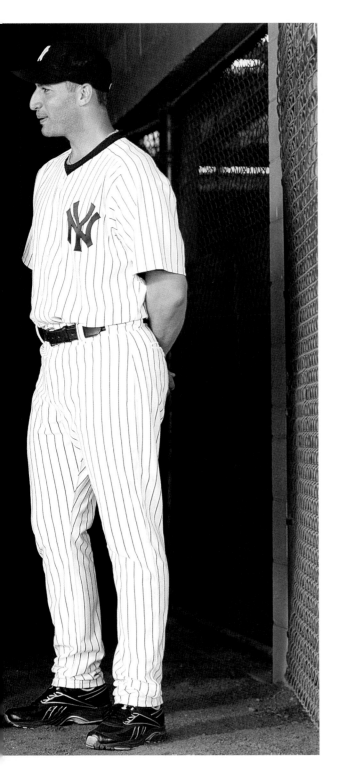

The Core Four

Jorge and Andy were the first two guys I played with back in 1992. I got called up to Greensboro, but I only played with them for a couple of weeks. I didn't know them well, and they were older than me. I was just eighteen and the new guy showing up for the last couple of weeks of the season. And then Mo and I played together the next year.

But of the three of them, Jorge became my best friend. I was the best man at his wedding. He is truly like a brother. We've spoken a few times this season, and I saw him at spring training. Other than that, Jorge is enjoying the retired life now and pretty much stays away.

We were all disappointed when Andy went to Houston, because we all wanted to keep playing together. We wanted Andy to come back, and we were very glad when he did. One thing you learn very quickly is that MLB is a business, and it can be a cruel one—you have to get used to that. People always talk about players not being loyal to teams, though I don't think that applies in Andy's situation, but people do come and go. In any case, we played together a long, long time.

I was amazed to find out at one point that Mo, Jorge, and I had played together for seventeen years. We were the first trio in any professional sport to play together that long. In this era of free agency, I have a feeling that our record is going to be around for a while.

109

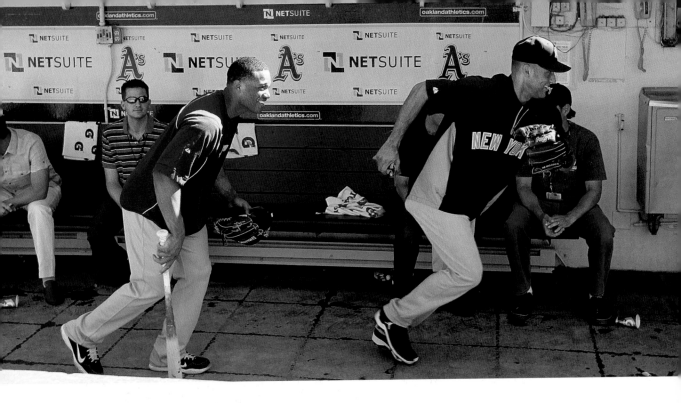

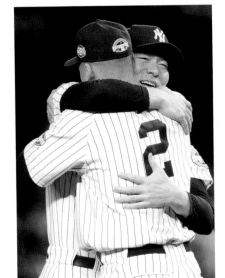

There Is No "I" in Team

The thing I'll miss the most when I hang it up is my teammates. I've played with some of the best players and some of the best guys I've ever met. Robinson Cano is a fun guy. He always has a smile on his face and loves playing the game. He makes it look easy when he's on the field. Robby was the longest-tenured second baseman that I played with in my career, and I was sad to see him go. I do miss Robby a lot this year. For selfish reasons I wish he were still on the team. He's going to have a long, successful career, and I look forward to watching him.

CC Sabathia is a gamer. He wants the ball, and he wants to be out there pitching in all the big games, regardless of how he's feeling. He works hard and I've always gravitated toward players like that. He's not afraid to fail; he just wants to be out there, playing his part, being in the big games.

Hideki Matsui was a great teammate and a true competitor. One spring training, Matsui, another teammate, and I were at the batting cage talking about who would get married first. So we decided to bet on it. Two days later, Matsui wasn't at spring training, because he'd flown to New York to get married. Then he flew back and collected his money from us. The whole time he was making the bet, he knew he was getting married in two days. That's a competitor.

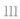

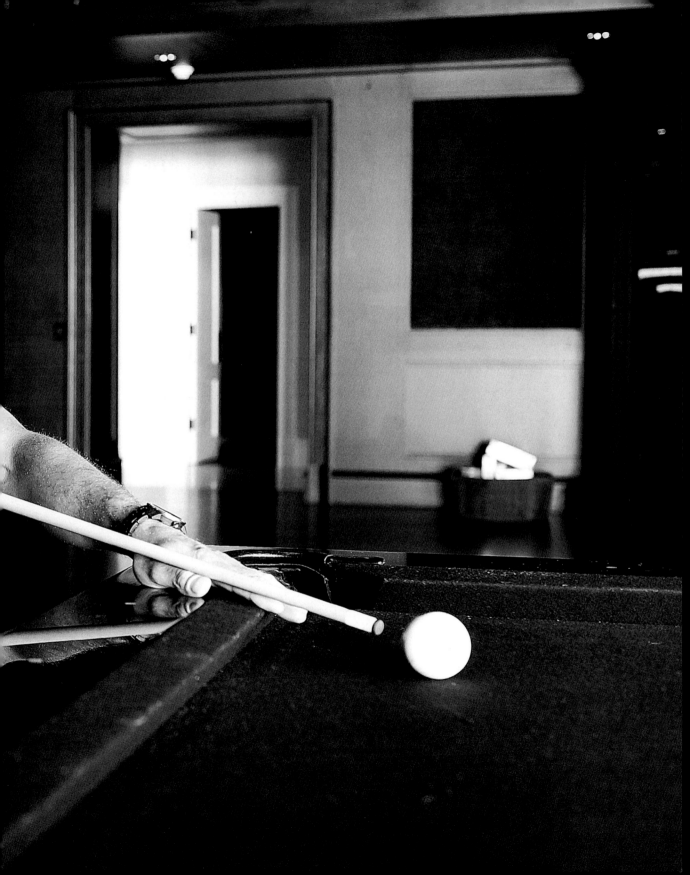

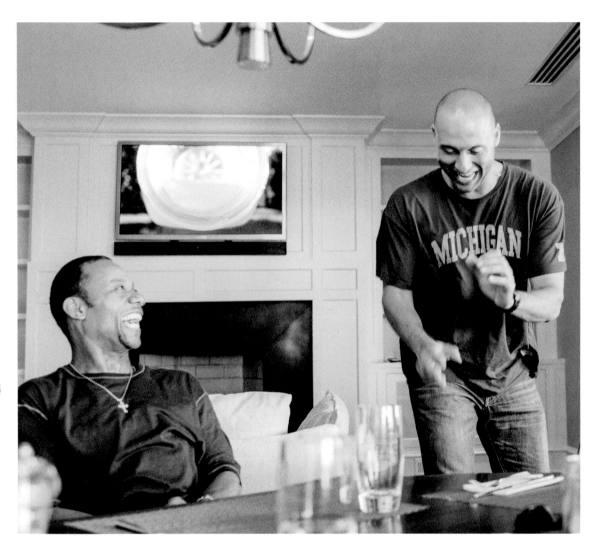

My Boy Gerald

Gerald Williams took care of me when I first signed with the Yankees in the minors, and we were teammates when I was called up to the majors. He's still one of my best friends. He lives down in Tampa as well, so we spend a lot of time together, and as you can see in this picture, I've got him laughing. People tend to think I don't have a funny side, but trust me, I do.

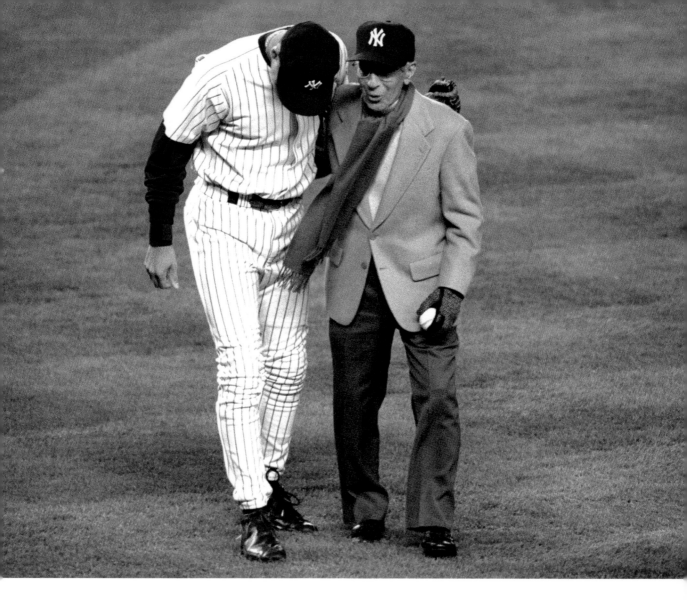

Scooter

I loved listening to Phil Rizzuto broadcast when I was growing up, just all the funny things he would say and his amazing voice. That's how I got to know him, but once I joined the organization I quickly learned how great a player he was. Whenever Phil came to visit, he would seek me out and take the time to talk. He was always very complimentary and asked me me how I was doing. We never sat down and talked about the intricacies of playing short shop because Phil was about five foot seven and I'm a completely different size, so we played the game differently. But he always treated me great when I was a young player, and those are things you remember—how people treated you when you were coming up. It's the example players like Phil set that inspire me to help the younger guys now.

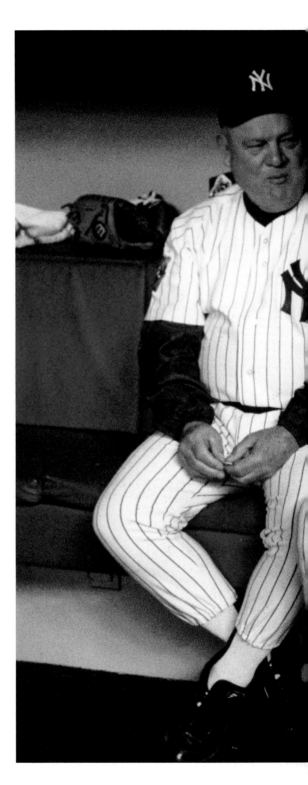

116

Popeye

The best thing about Don Zimmer was the depth of his knowledge. This man spent sixty years in and around the game, and since I've always been a sponge for knowledge, I enjoyed hearing about it all. Whether it had to do with playing shortstop or hitting, my ears were open to whatever bits of wisdom Zim had to share. He was a hard-nosed player and he was like that as a coach as well.

Zim was the kind of guy, who, at seventy-two, would go out on the field and get into an altercation, which is exactly what happened in the 2003 ALCS when Pedro Martinez threw him to the ground after Zim got in his face. Zim had a fiery attitude and demeanor, so to think that he would do that didn't surprise me. Still . . . seeing it actually happen? Now that surprised me.

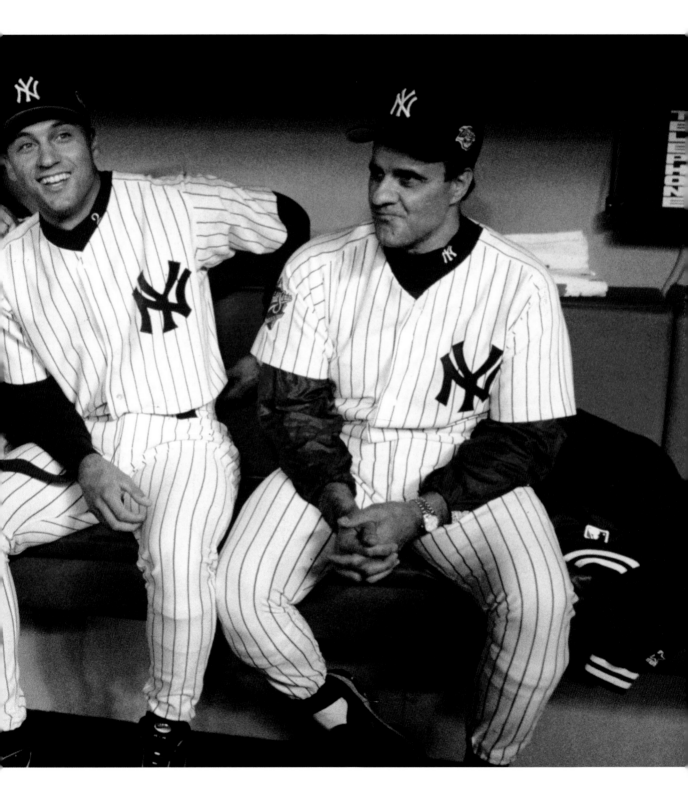

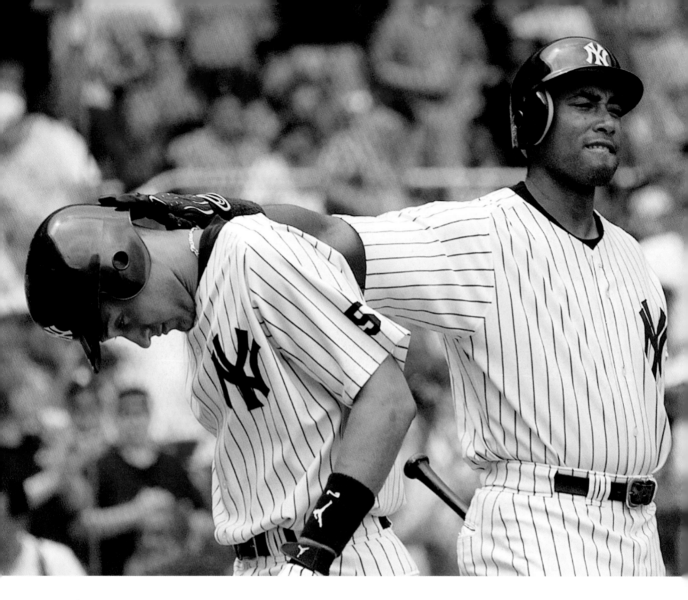

The Core Five

Bernie was the first player to come up through the Yankees organization in my era to have great success. The Yankees were known for trading the younger players, but Bernie changed that and paved the way for the rest of us to have that opportunity. Without him, the Core Four might not have been allowed to happen.

He doesn't get grouped in with the rest of us, and there are a few reasons for that. First of all, our first year was when the team started winning, and Bernie had already been there. Also, he retired before we won our fifth championship. But even though he doesn't get mentioned when people talk about the Core Four, Bernie is without a doubt the reason why we had the opportunity to take Yankees baseball to the highest level of play.

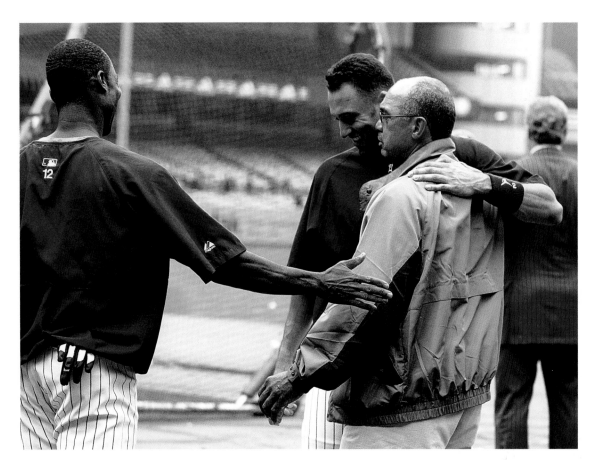

Mr. October

When I was growing up, everybody knew Reggie Jackson: Mr. October. I've been lucky enough
to know him personally since I was eighteen. Reggie is one of the best storytellers I've ever met.
He is fun to be around. He's very honest. He's very open, and he knows how to relate stories
from his own life when he's talking to people about their lives. I always enjoy being around him,
because Reggie is one of those players with a lot of knowledge, and I like to take his wisdom
and apply it to my own life. He really has been a mentor to me.

Reggie played the game for a long time and with a lot of success, and obviously he's in the
Hall of Fame. But Reggie is great to learn from, because along with his success he also had
failures. Some people assume that if you were a great player and are in the Hall of Fame,
you never failed. Reggie will be the first to point out that he had plenty of failures but he never
let them hold him back. When he failed, he just kept pushing through. Reggie hit home runs,
but Reggie also struck out.

Brother Tino

*Tino was playing first base when I got my first major-league hit in Seattle.
I didn't know him at all, and he came up to me and said, "Congratulations,
it's just the first of many." He and I have grown extremely close. He lives in
Tampa as well, so we hang out a lot. Tino is like family to me. I've watched
his children grow up. He lives a few houses down from me, so we will take
the boat out, go out to dinner, or he and his wife and kids will come over.*

 *Tino is the kind of guy I admire. He played hard, he's intense, he was
part of those championship teams. He's like a brother to me—we won four
championships together and that lends itself to a relationship you can't
have with just anybody.*

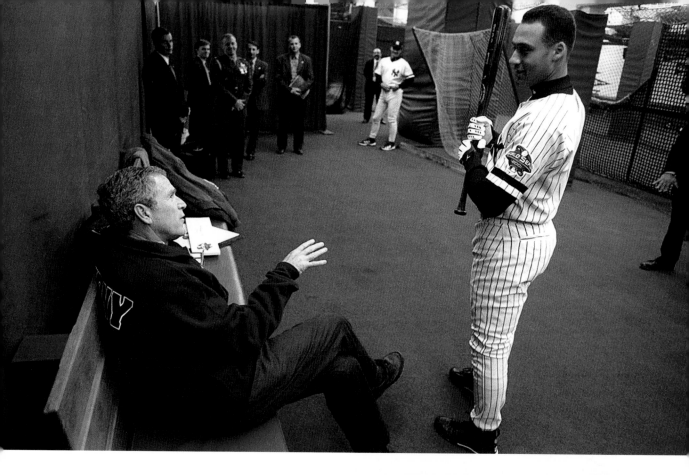

Mr. November

I told President Bush to make sure he threw the first pitch from the mound and didn't bounce it before it crossed home plate, because if it did, people would boo him. They don't care who you are or what the situation is. If you don't throw a strike, you're going to hear about it.

It was cool to be named Mr. November, but it was a unique set of circumstances that came from unfortunate circumstances. We were only playing in November because of the September 11, 2001, terrorist attacks. The World Series had never been played in November, and I don't think it ever will be again.

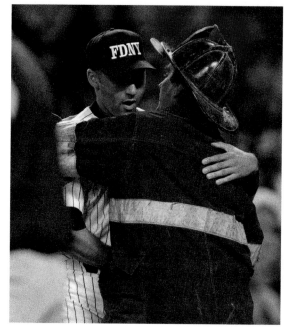

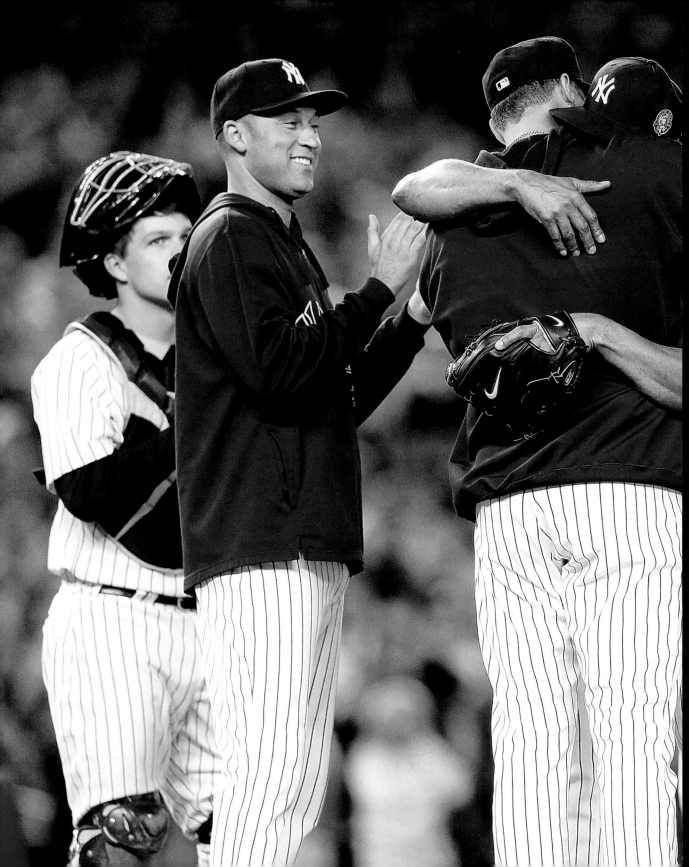

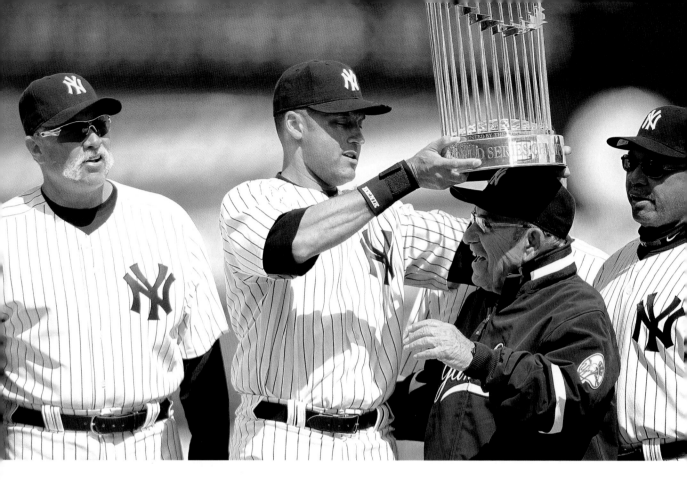

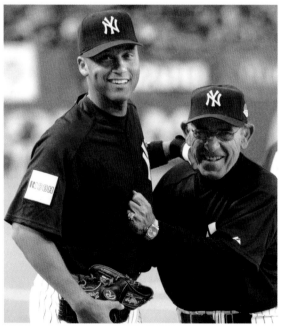

The One and Only

Yogi is like a cartoon character. I've never met anyone like him, and I doubt I ever will. He always finds his way to my locker when he comes in. Ever positive, he always has good things to say. I love asking him questions about ex-players and situations. Yogi would always brag about having ten rings and me only having five. To which I liked to point out that there were no playoffs when he played— the best teams went straight to the World Series. So the way I figured it, he really had only five rings himself. To that he always said, "Well, you can come count them if you want."

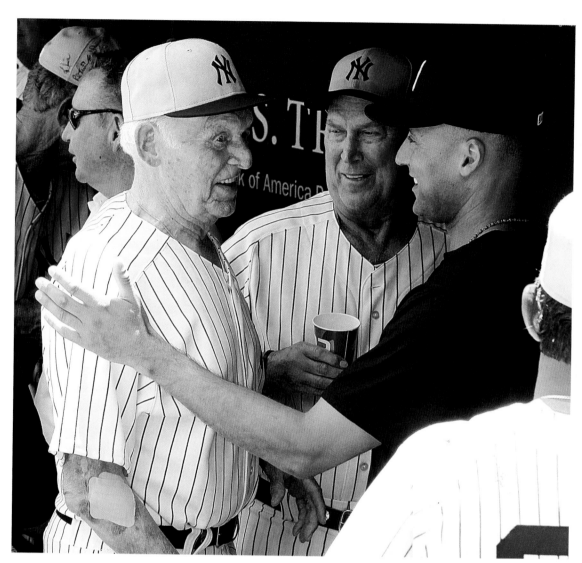

A History of Tradition

We get spoiled in our organization, because so many of the greats come back. That's what makes Old Timers' Day so special. Other teams may invite back former players, but Old Timers' Day really is a Yankees tradition. The fans learn the history and the tradition not only of the team but of the sport itself. It's great for players like me, too, because we get the chance to meet these guys—one of the many privileges that come with being a New York Yankee. I haven't even thought whether or not I'll ever play in an Old Timers' Game. I can't even imagine that at the moment.

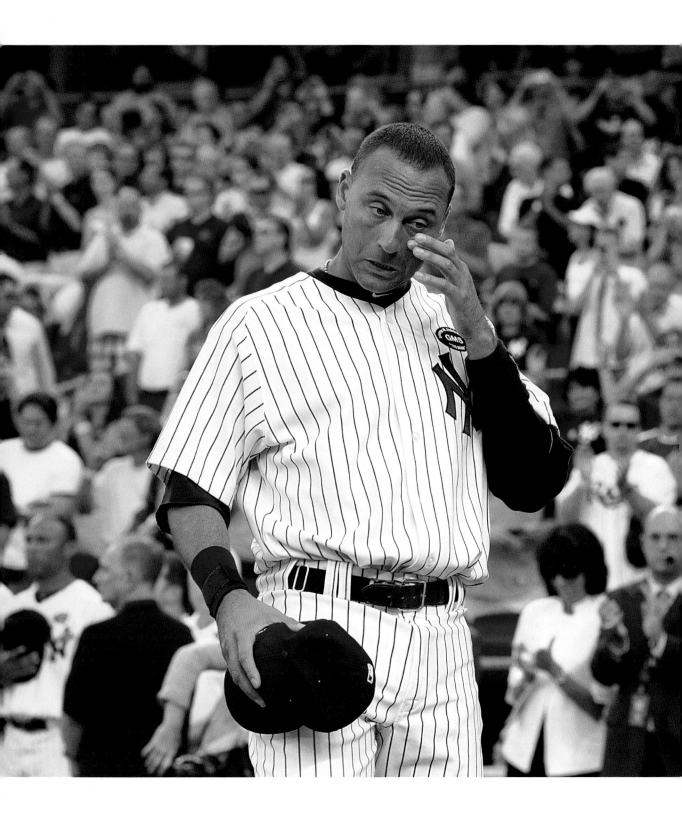

There Will Never Be Another

The day George Steinbrenner died was a rough one for Yankee fans, particularly because the Boss and public address announcer Bob Sheppard passed away one right after the other. Bob played as big a part in the experience at Yankee Stadium as any player ever did. I was so happy that I'd thought to have Bob's voice recorded so that he would always introduce me at the plate. His was the only voice I'd ever heard at Yankee Stadium, and I wanted to preserve that as best I could.

The first time I met the Boss, I was eighteen and I had just signed with the team. He was intimidating—he'd walk around with his turtleneck and his sport coat, hands in his pockets, in hundred-degree Florida heat. He knew everything about the organization from the ground up, and when we met he kept saying, "We expect big things from you." All I could do was nod and say, "Okay, okay." Our relationship grew into a friendship, because we had the same goals. The Boss expected perfection, he wanted to win, and he was a fierce competitor—in that sense our attitudes aligned. I wanted the same things and cared about them as much as he did, so I never had a problem with his expectations.

We would get together during the off-season, and all I can say about him is that he was unique. He was tough, and if you couldn't take it he would beat you down. Like Yogi, he was one of a kind—there was no one like him, and I don't think there ever will be.

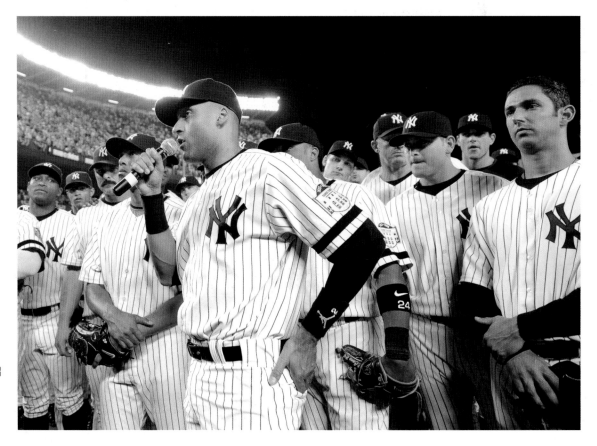

The Greatest Stage in Professional Sports, or What I Like to Call "The Office"

The night before the last game at the old stadium, the Yankees organization asked me if I would speak afterward. I'm not one for prepared speeches, because if I prepare a speech and practice it and then forget something when I recite it, that one mistake will throw the whole thing off. So I always speak off the top of my head. I came out of the game with one or two outs in the top of the ninth, and that's when I realized I had to figure out what I was going to say, and do it pretty quickly.

It wasn't hard. I just thought about both stadiums and what they meant to me, but most of all to the fans, with all their memories and baseball history. When I was younger I dreaded speaking in front of people. I really hated it, to the point that I nearly couldn't do it. For weeks I'd be nervous when I knew I had an oral report to do in class. For me, to end up standing there on the pitcher's mound in Yankee Stadium speaking to fifty-six-thousand-plus people, I'd say I've come a long way.

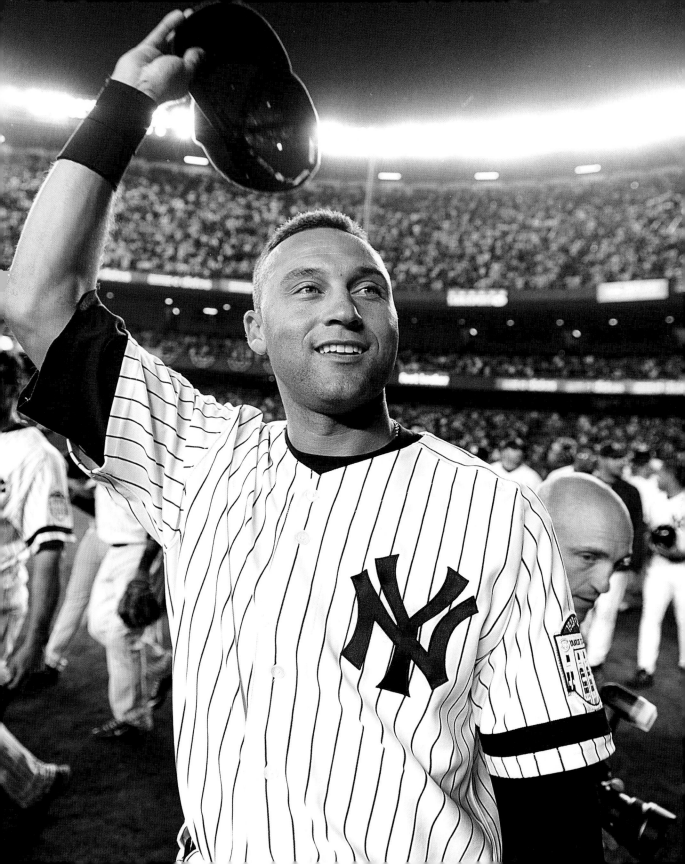

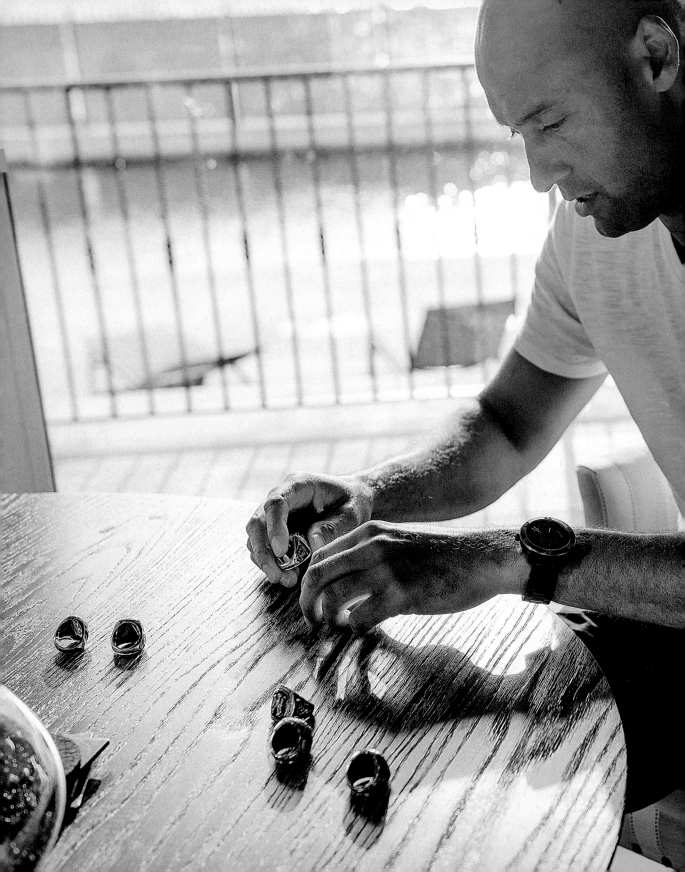

THE POSTSEASON

I had butterfiles going into my first postseason but I was more excited than nervous. I really like those times when I know there are more eyes on us. And that's what the postseason is. I tell the younger guys heading into their first one to treat every game the same way they would in the regular season. It's the same game, there are just more people watching.

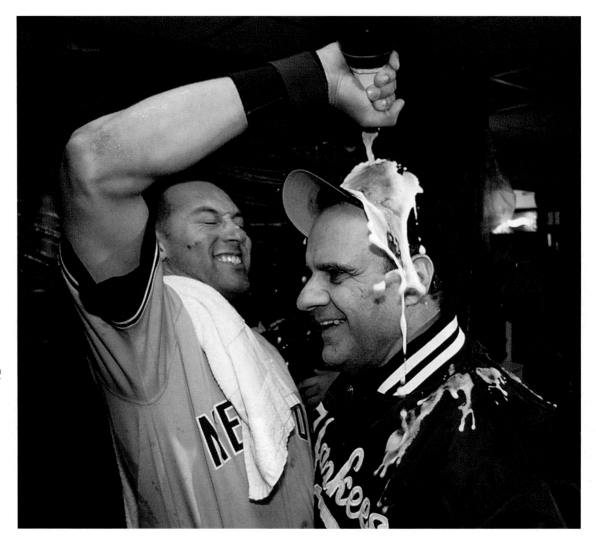

Mr. T

Joe Torre, or Mr. T, was a father figure to me. I learned a lot from him but, most important, I learned how to deal with people and how to treat people. You have to take the time to get to know everybody's personalities—I learned that from Joe Torre. He was a wonderful people person.

There's an old adage that says you should always treat everyone the same: I don't necessarily agree with that. I think you should treat everyone fairly but not the same. He was tremendous at dealing with people's personalities, and that is one of the reasons why he was a great leader. If you're going to lead a group, you have to get to know everyone you're leading.

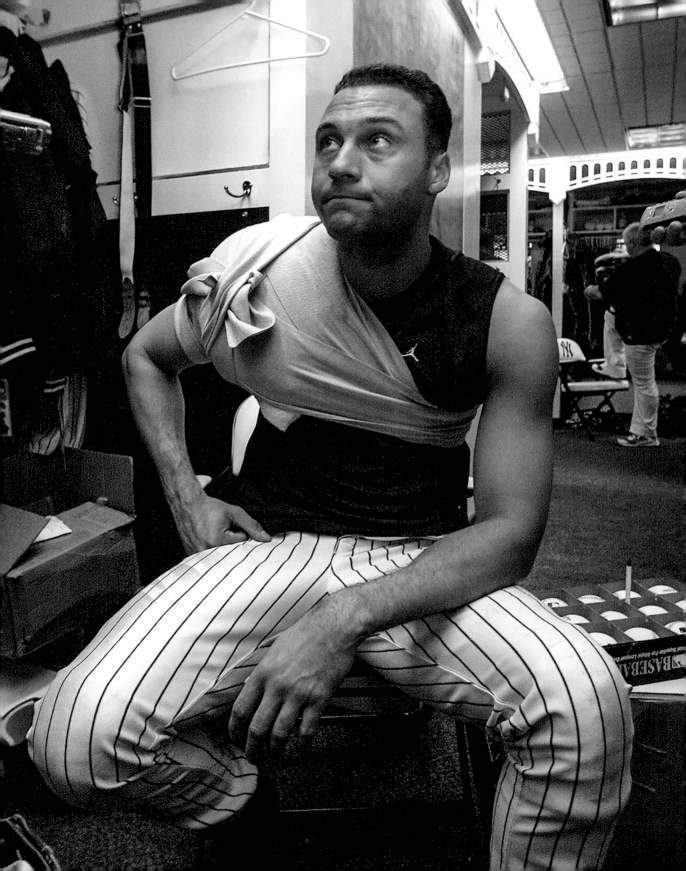

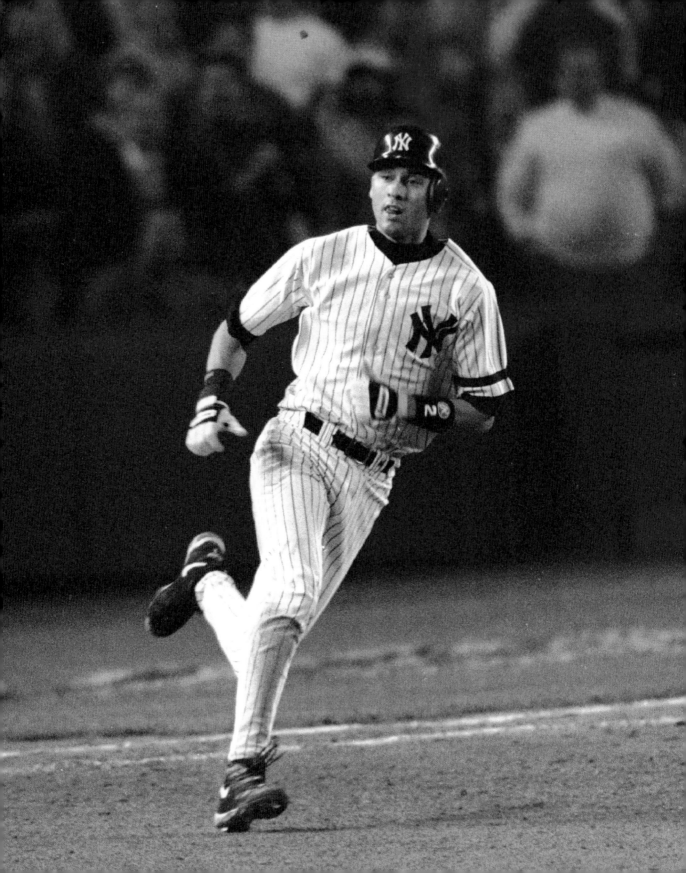

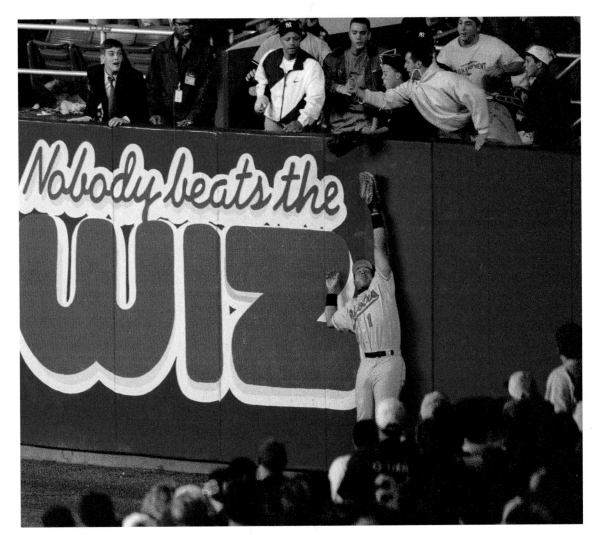

I Earned It

I hit my first postseason home run in the eighth inning of Game 1 of the American League Championship Series versus Baltimore in 1996. There was some controversy about it because of the kid pictured here, who leaned over the wall and caught it. The kid may have reached, but I played with Tony Tarasco and told him that he should have jumped—and that he would have missed it anyway.

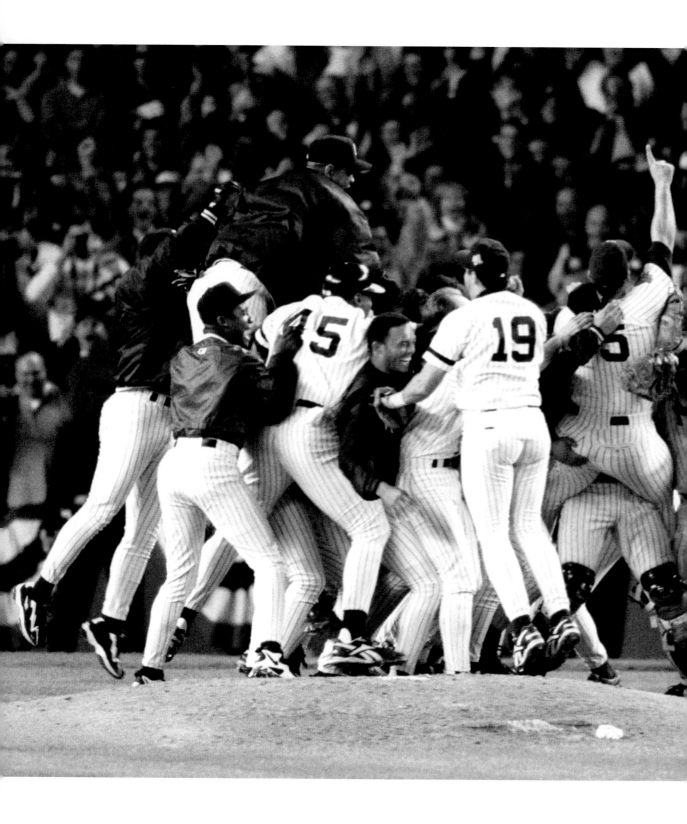

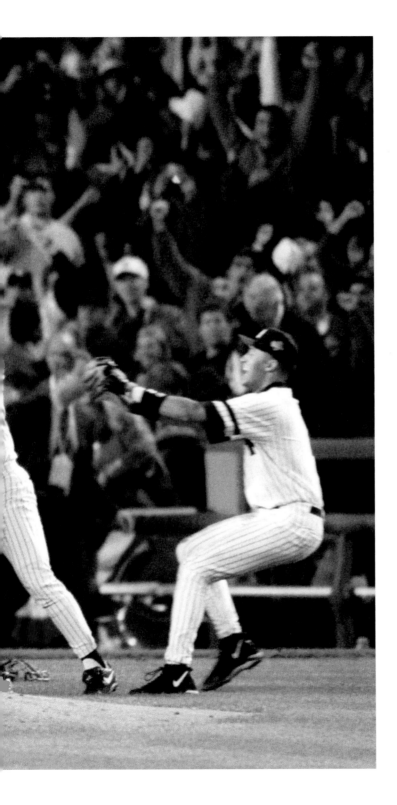

We Are the Champions

The team hadn't won a World Series

since 1978, so it was wild in Yankee
Stadium when we won in 1996—
you can feel it just by looking at this
image. The old stadium was much
louder because of the way it was
designed—more stacked and less
spread out, with several thousand
more seats than the new one. It felt
as though the fans were always right
on top of you, closer to the field.
The new stadium has underground
restaurants and bars and tunnels to
occupy fans while they're watching
the game, whereas in the old
stadium, you had to be in your seat
to see the game. It was intimidating
to play there, believe me—even as
a member of the home team.

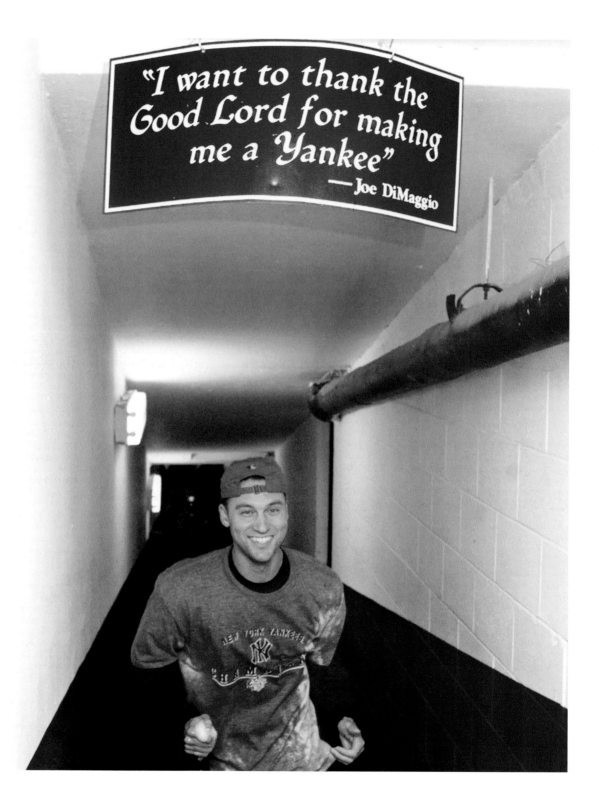

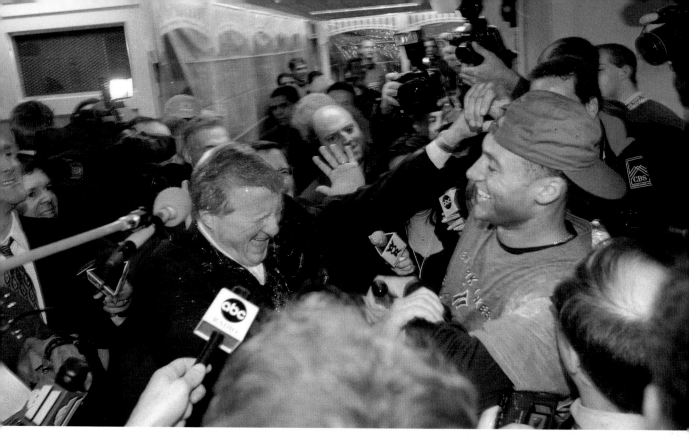

Party Time

These photos were taken after we beat the Braves in 1999, our third Series win in four years. I was always the one who poured champagne on the Boss. He was a very stern, intimidating leader, but he and I had a great relationship, so I'd always look for him and be the guy who poured champagne on him. I'm lucky to say that we were pretty close. I think it all started with that age-old Ohio State/Michigan rivalry—the Boss was a big Ohio State guy.

He was a perfectionist in every single way. When he and I filmed a Visa commercial in 2003, he wanted it to be perfect. He didn't want them to edit at all, he wanted to do it until he delivered his lines perfectly. So we did it until he was satisfied. If you've seen the commercial, you'll know that I'm one of the few people on this earth who can say that they danced in a conga line with George Steinbrenner. That was the only part of the commercial he wasn't concerned about getting right. After two takes, he said, "Okay, that's it, I'm only doing this one more time!"

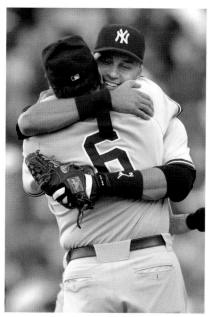

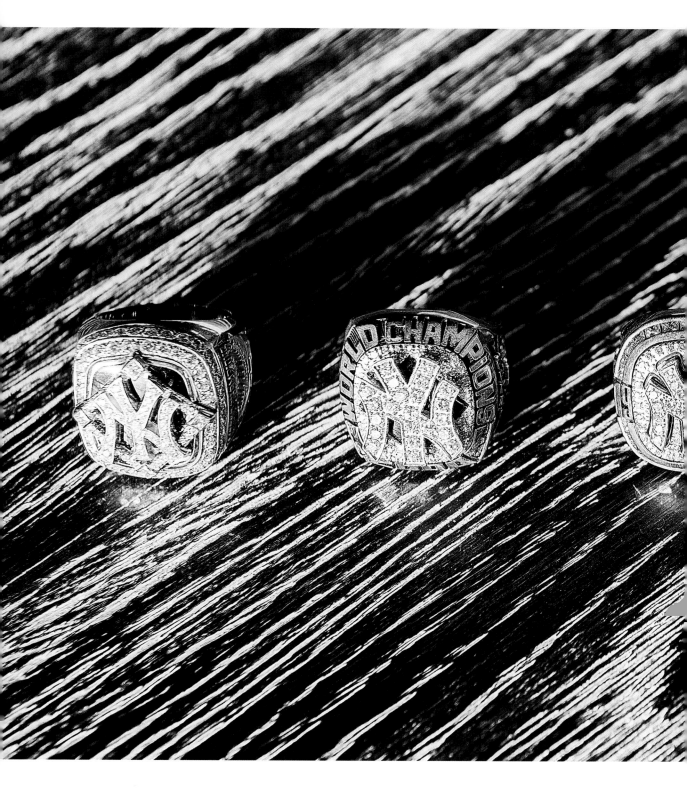

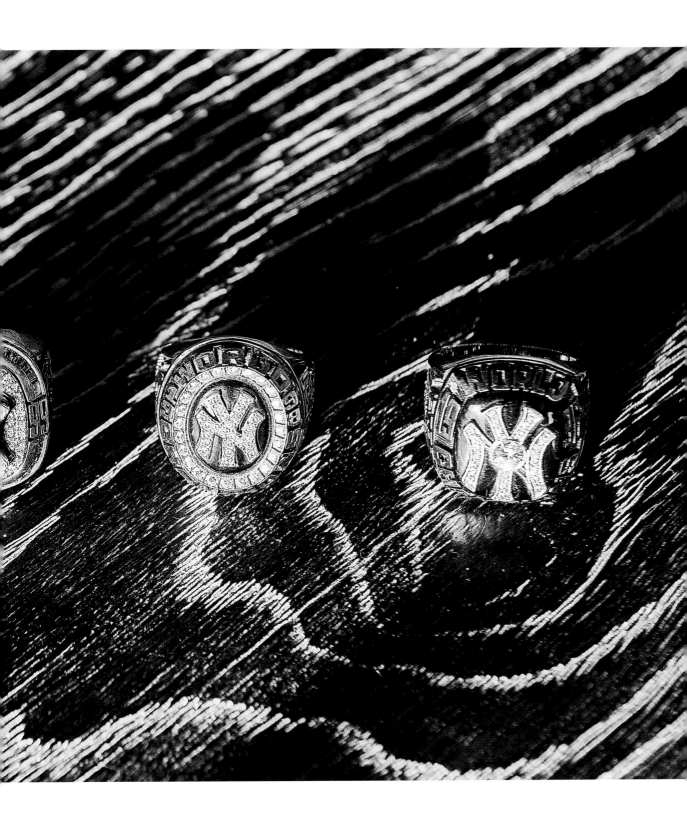

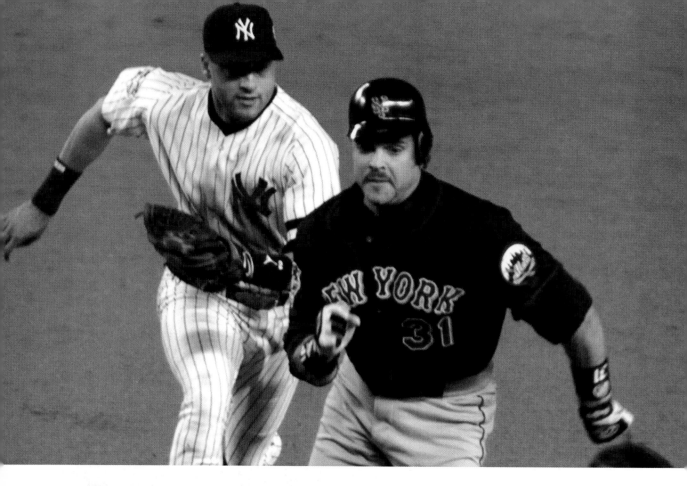

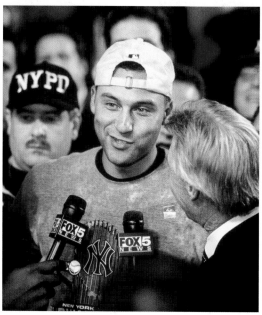

Subway Series

When I think of the five World Series we won, the Subway Series in 2000 was the one we had to win. If we hadn't, I don't think I would have stayed in New York City. I was living in Manhattan, and everywhere you went for two or three weeks before we even got into the Series, the Yankees-Mets rivalry was all that anyone talked about—I think most Yankee fans felt that if we didn't win, we could have thrown those three rings that came before out the window. So that was a big showdown for us, and a very important victory.

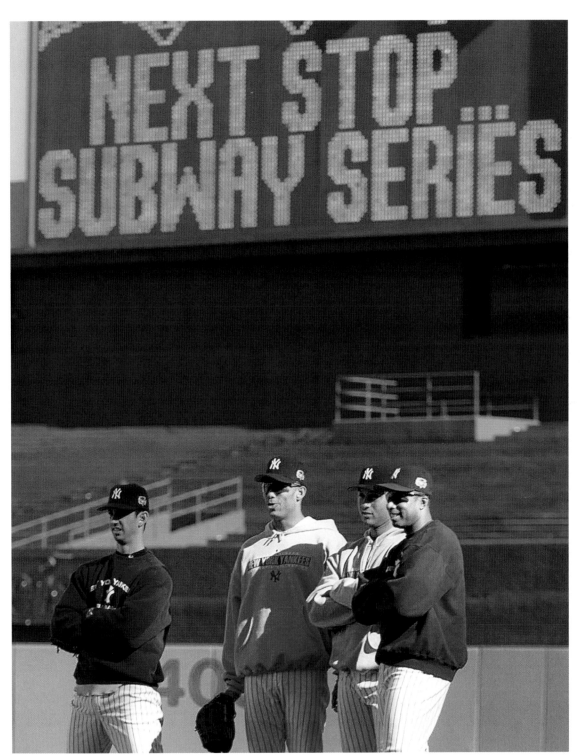

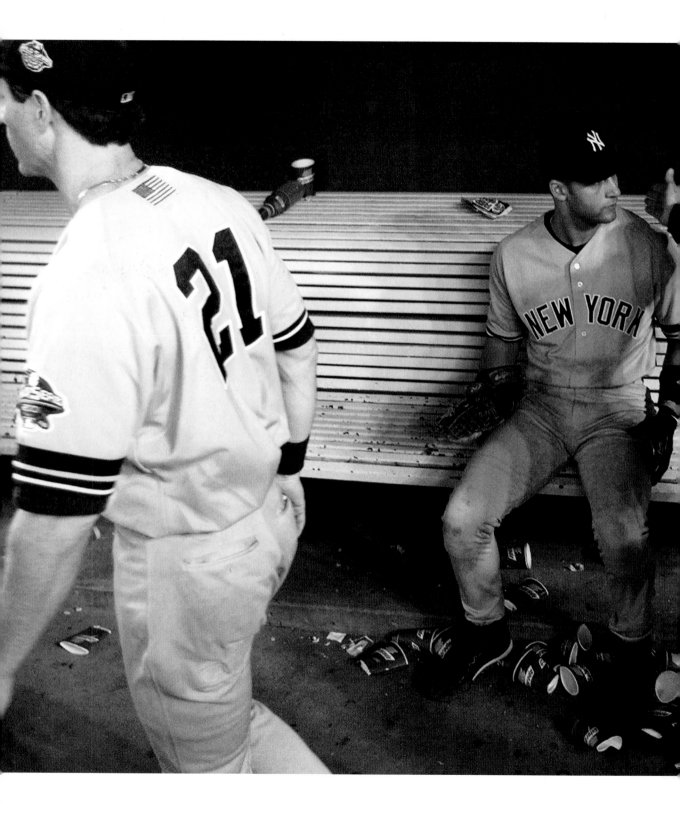

Don't Let Defeat Beat You

Losing to the Diamondbacks in the 2001 World Series was one of the toughest losses of my career. We were three outs away from our fourth championship in a row. We'd won in situations like that ninety-nine times out of a hundred, but this was the one time that it wasn't meant to be. To get that far in the season and have it be so close made it so tough to take. All you can do after something like that is pick yourself up and use it as motivation to work harder next year.

I believe that it's important to remember the tough times, as it makes experiencing the good times better; it also makes you work harder for them. Every year you have to assess how you played—especially when you win. That's when you should take the time to look in the mirror and figure out how to do better and what you can improve.

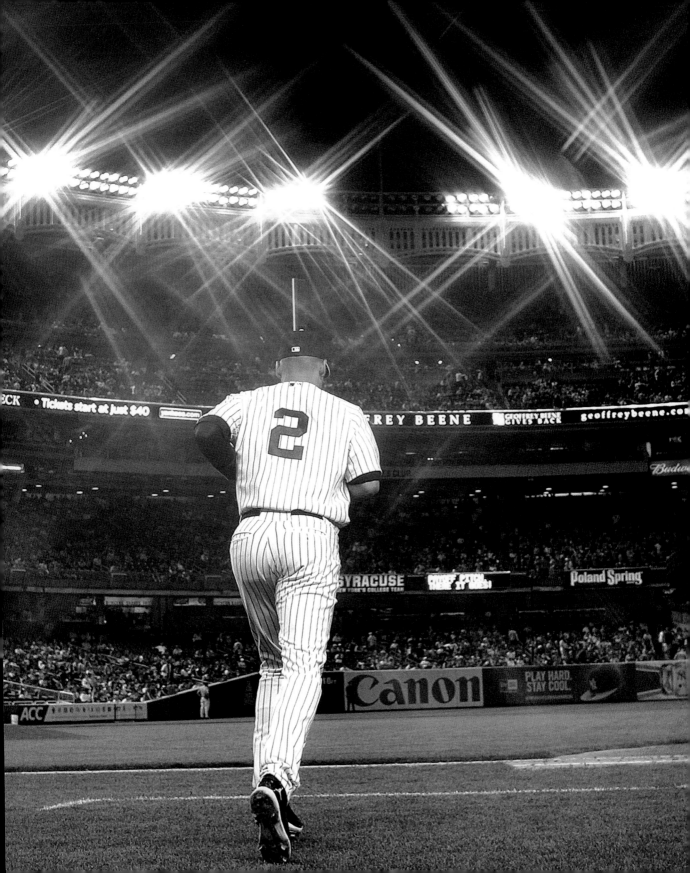

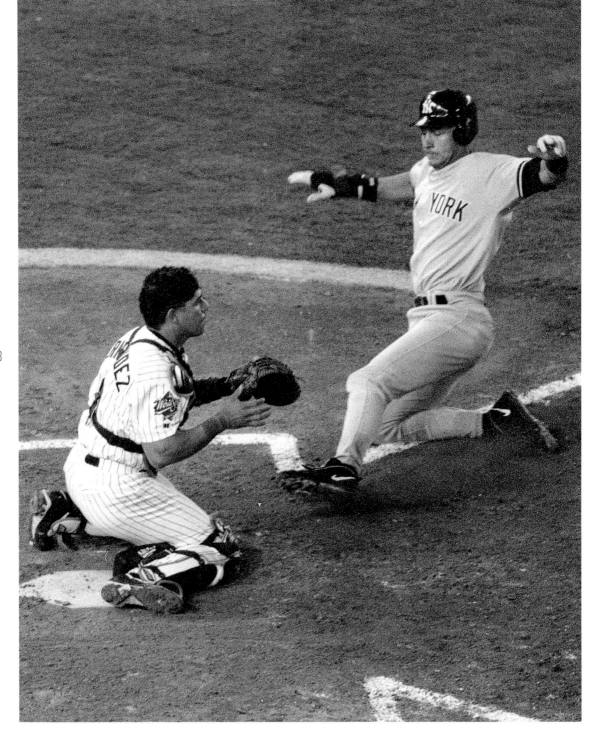

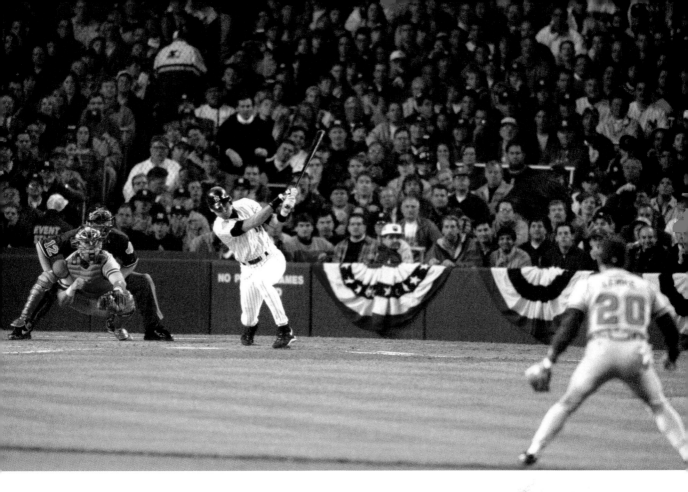

Mind Over Matter

I have fun in clutch situations—I really enjoy them. The key to achieving in a clutch situation is to not be afraid to fail. I've always thought to myself, "What's the worst I can do? Strikeout?" Then I try to think about the times that I've had success in similar situations. It's a case of mind over matter. Baseball is a game of failure—and I've failed a lot—but I think the biggest key is remembering success. A lot of guys get so excited and amped up in clutch situations that the game speeds up for them, but I try to slow it down as much as I can and enjoy it. I'll say to myself, "You've done it before. Do it again."

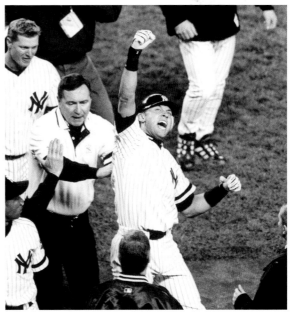

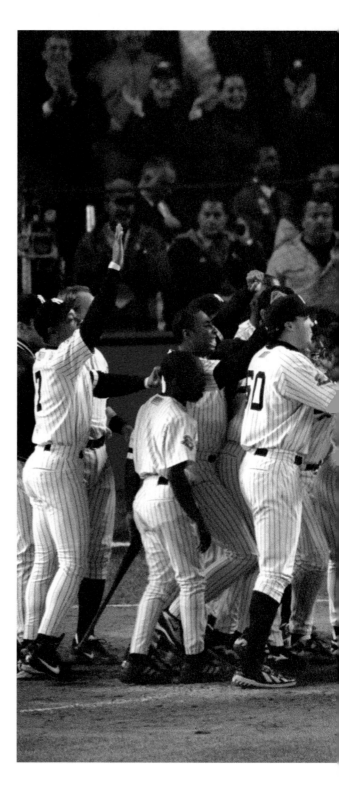

Boyhood Dreams

This was the moment I dreamed of when I was playing ball in the backyard as a boy. Every kid who plays baseball dreams of hitting a home run in the World Series. But for that home run to be a walk-off to win the game? This photo is of a childhood dream exceeded.

I was so happy, I jumped as high as I could when I came into home—so high that I almost broke my ankle landing on the plate. I'm not kidding. If you watch highlights from the last two games of that World Series you'll notice that I can't run at all. I was lucky—a guy playing for the Los Angeles Angels did the same thing in 2010 and broke his leg. If I got the chance to do it over I wouldn't have jumped, but I was living out that backyard dream. What can I say?

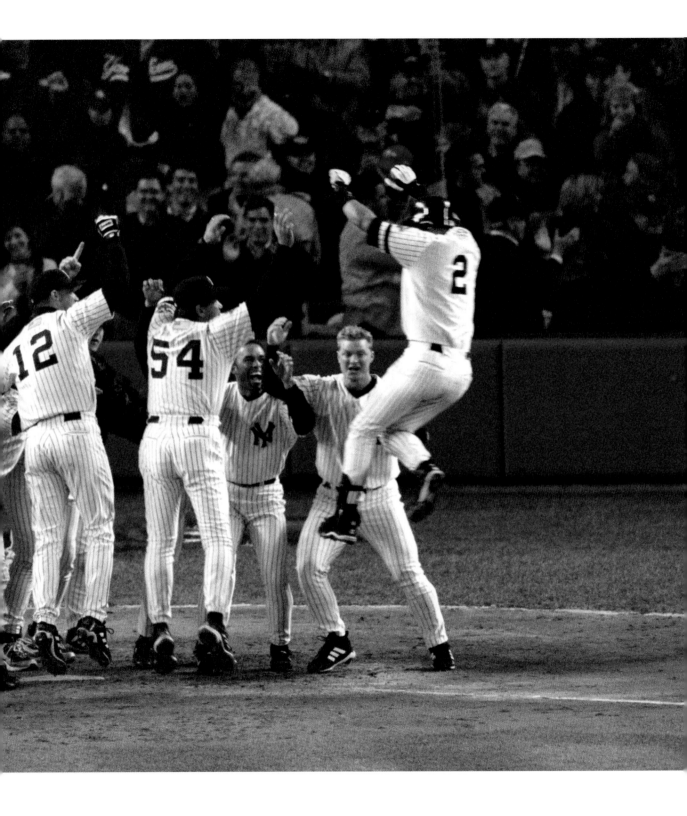

If You Can Make It Here . . .

Being the toast of the town when that town is New York City—it doesn't get any better than that. I wouldn't know, but I can't imagine that there's a better place to win than New York.

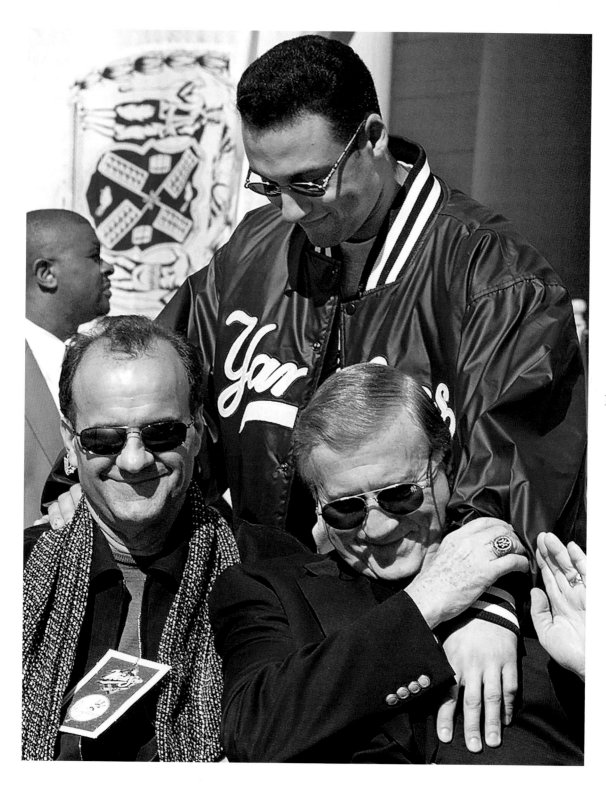

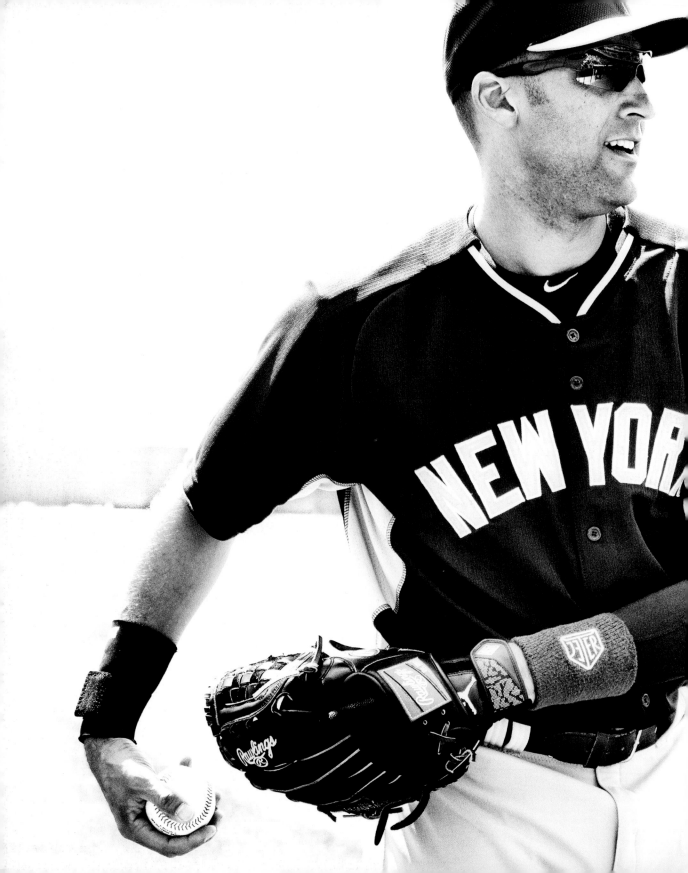

A BANNER YEAR, 2009

We were in four Series during my first five years in Major League Baseball, and six in my first eight years. Then we didn't go back for eight years. So the Series in 2009 felt really good. And it was our first year in the new stadium, so it was really gratifying. I felt we were going to win that year, I really did!

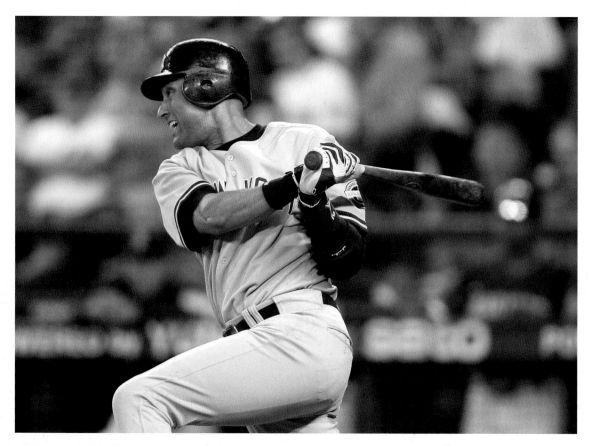

Passing the Iron Horse

Hit number 2,722: Passing Lou Gehrig's record was incredible for me, because any time you're mentioned in the same breath as Gehrig it's very special. A few years before, I'd noticed that no player had reached 3,000 hits with the Yankees. I almost didn't believe it, given the history of the team and all the great players who have worn the pinstripes.

I was well aware that Gehrig had the most hits, but I tried to keep all of that "history-making" stuff out of my mind. If you play long enough, if you're consistent, and if you stay healthy, good things may happen. I never set out to pass Gehrig in hits; it was never a goal of mine. I must say, though, that as soon as I got close I was reminded of it constantly, because that was all that anyone wanted to talk to me about.

I'm very grateful that it happened at home, because you want moments like those in your career to happen before your hometown crowd. I'm not saying other cities wouldn't have appreciated that achievement with me, but the Yankees are big on tradition and history, so it was all the more special for me to do it in New York.

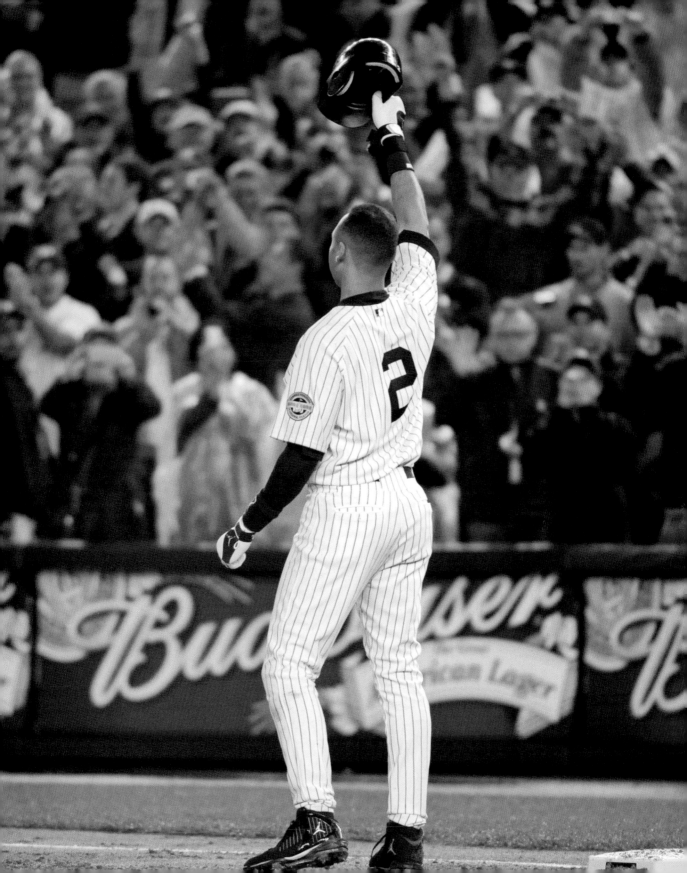

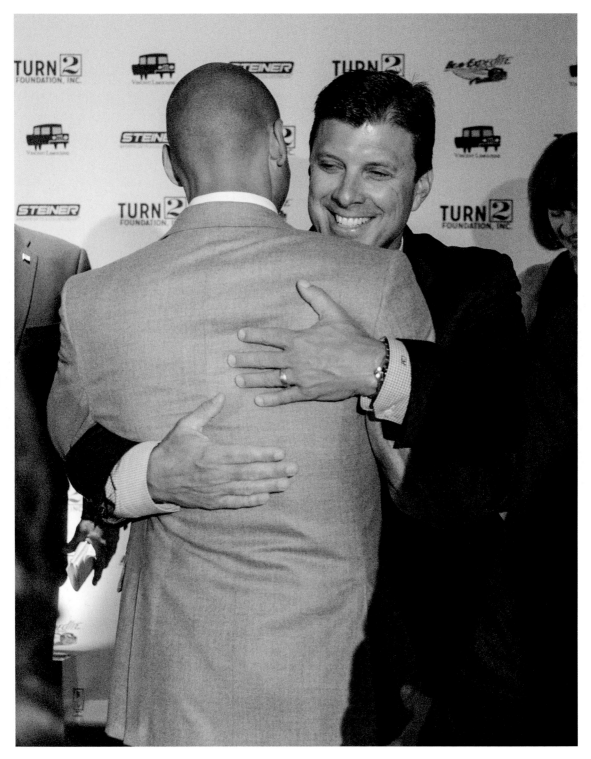

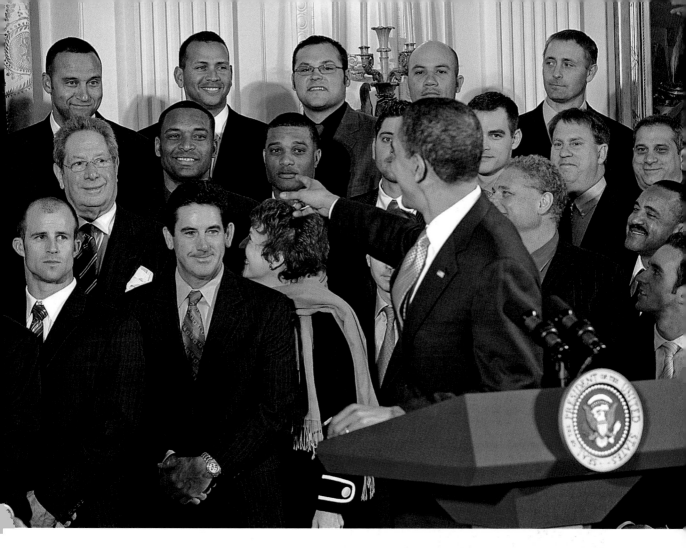

Hello, Mr. President

It's always shocking when you meet someone and they know who you are, let alone call you by name—even more so when it's the President of the United States. When I first met President Obama and he spoke to me and knew all about me, it was hard for me to grasp what was happening.

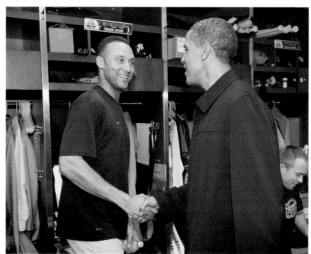

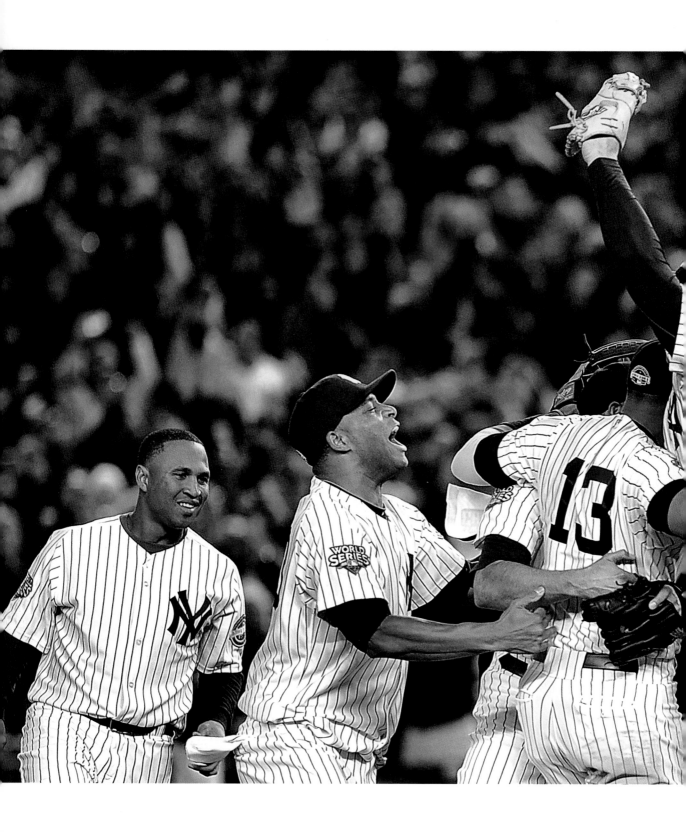

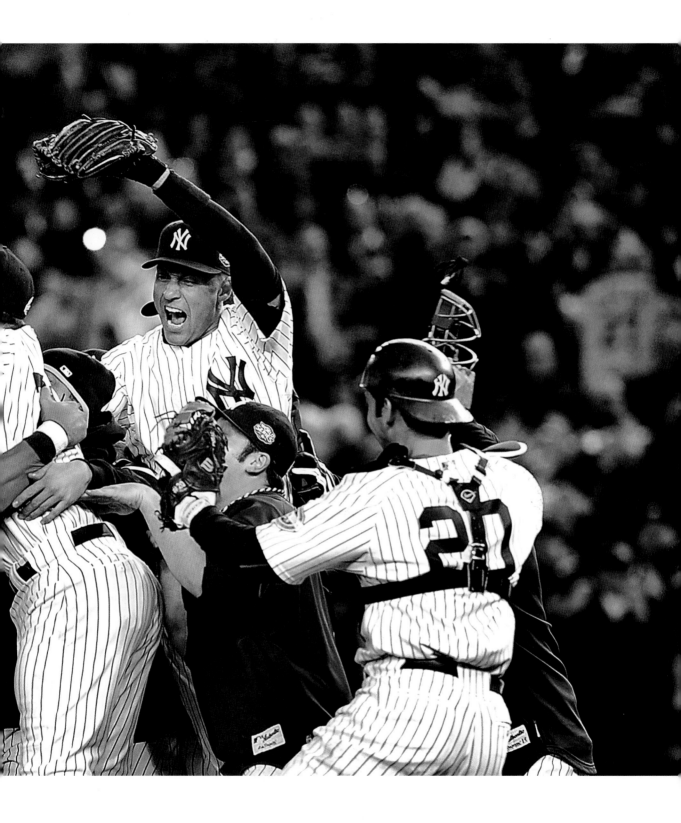

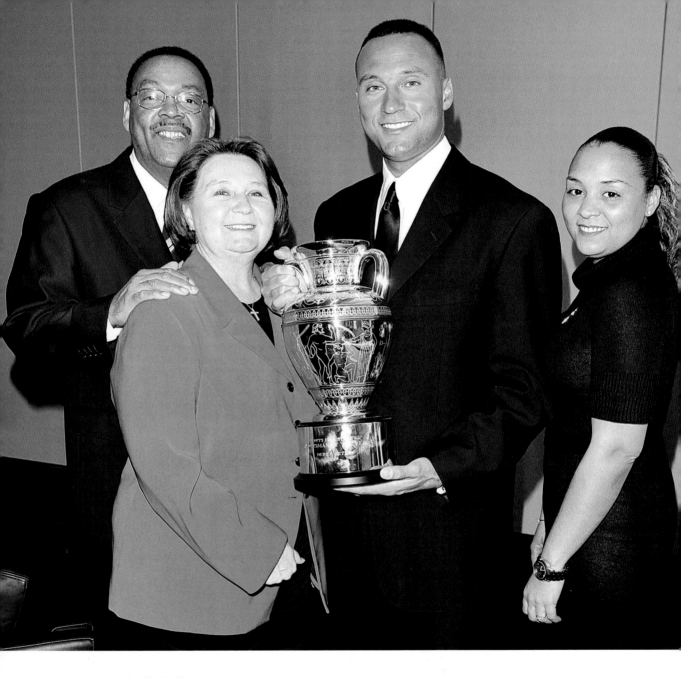

Sportsman of the Year

*When I was recognized as Sports Illustrated's Sportsman of the Year in 2009,
I learned that I was the first Yankee to be granted the honor, which was hard to
believe because there have been so many Yankees legends who have made major
impacts on and off the field. My parents have always stressed the importance of
teamwork, character, and leadership, so this felt like an honor we all shared.
It was a huge one, and I'm glad my family was able to go to the ceremony.*

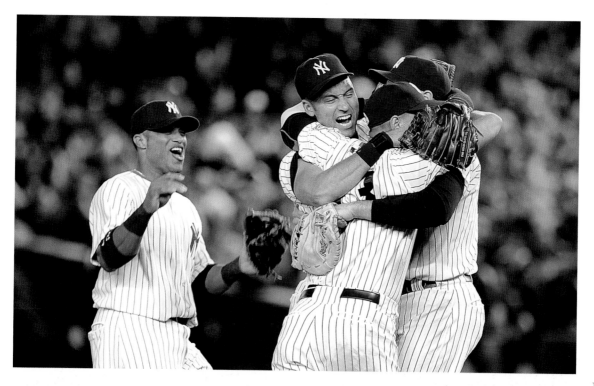

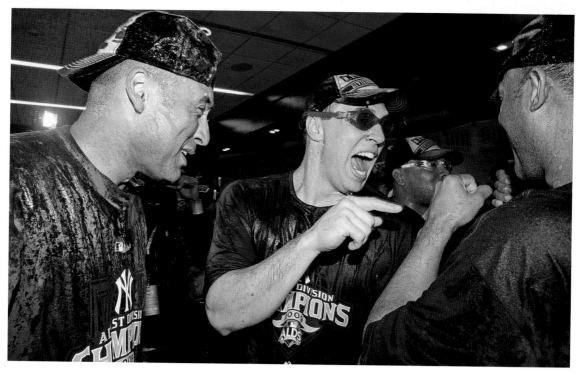

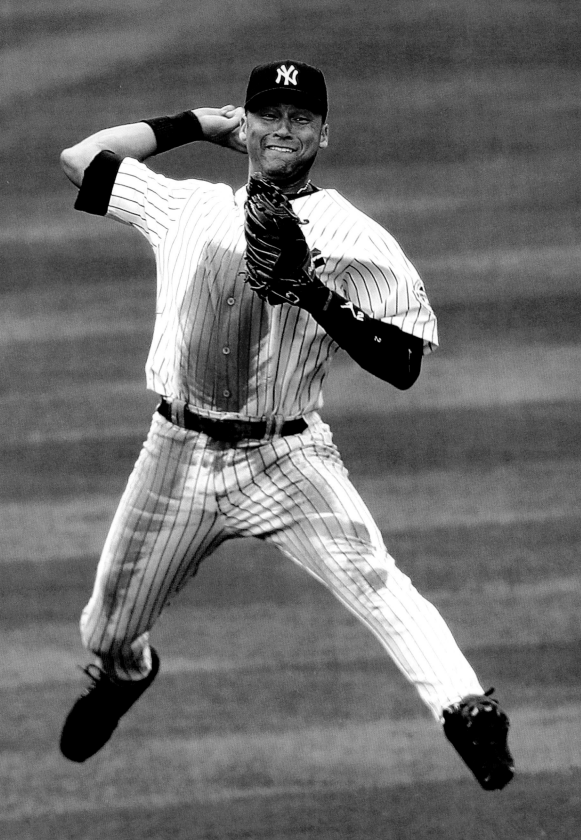

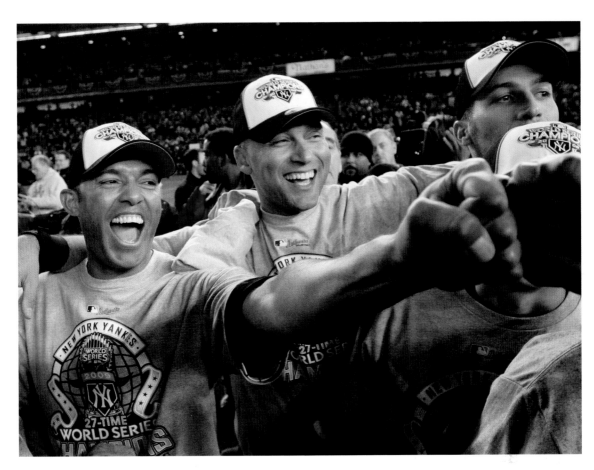

You've Got to Be Hot

The best teams make the playoffs, but the hottest team wins. That's just how it is. All the teams that go to the playoffs can win the World Series, but you have to be hot to win it. And that's not something you can plan or teach.

There were a lot of years I felt we should have won. I felt we should have beaten Arizona, and the Marlins, too. I felt we should have won the pennant against Boston the year we blew a 3-0 lead. Then again, every team says that when they lose: "We had a better team than they did, we just didn't play well enough." I'm not so sure it's that simple, because I don't believe in chemistry as much as other people do. When you win, they say your team has good chemistry, and when you lose, they say something is wrong with your chemistry. I don't think chemistry has anything to do with it. I think good fortune plays a bigger role in winning it all than people are willing to admit.

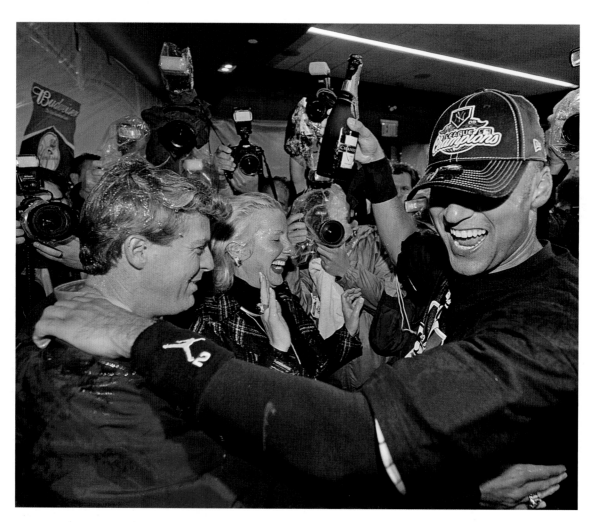

A Jeter Tradition

*After we won the World Series in 2009, I sought out the Boss's son—who now
runs the team—and daughter and poured champagne on them. "This is what
I used to do to your father," I said. "So now I'm going to do it to you!"*

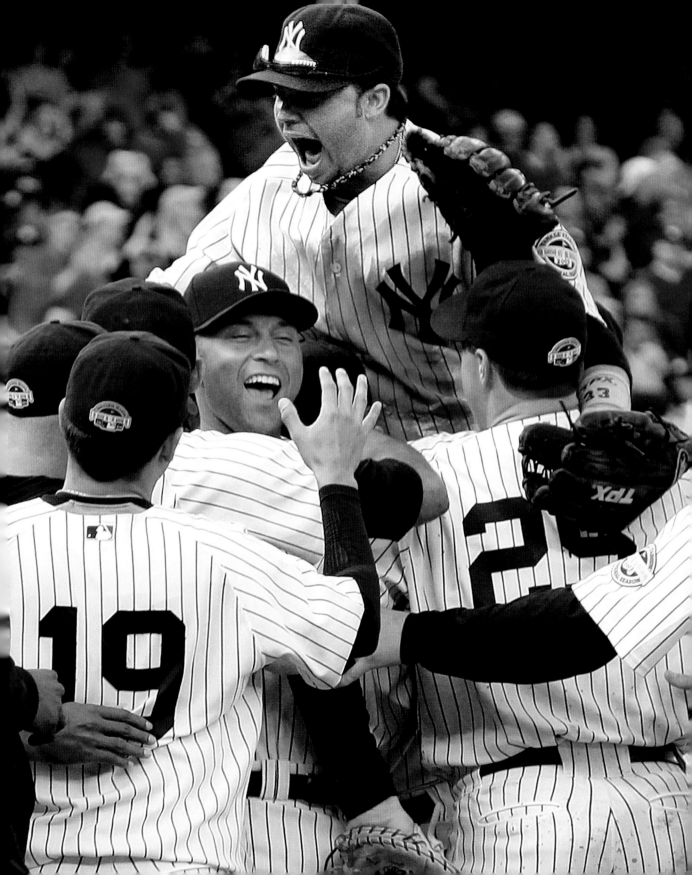

3,000

If you go back through the history of the game, you'll notice that the number of players getting 200 or more hits remains about the same each year— it's always just a handful of guys putting up those numbers. To make 3,000 hits in your career, you have to get 200 hits for fifteen straight years. The key to that is simple: consistency and longevity. You can't do it if you don't stay healthy.

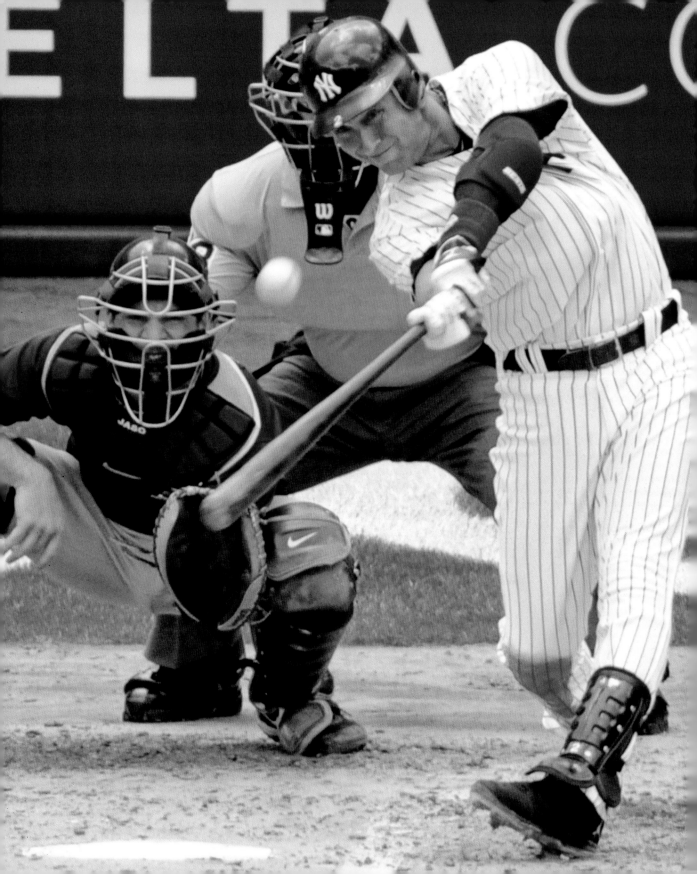

#3000

My 3000th hit, I just wanted to hit the ball hard. I was joking around with one of my teammates before the game, saying I was going to hit a home run. I was just joking because at that point in the year, I only had two home runs. I wasn't really trying for one, but I did hit it hard. I knew it was going to be a milestone, replayed for years to come, especially with the way the Yankees keep tradition and history alive, so I didn't want it to be an average or boring hit. That was a special day; everything seemed to go right. I didn't give it much thought at the time, even after I hit it; I wasn't thinking that I had to get that ball. It was only afterward that I heard that Christian Lopez wanted to give it back, and I really appreciated it.

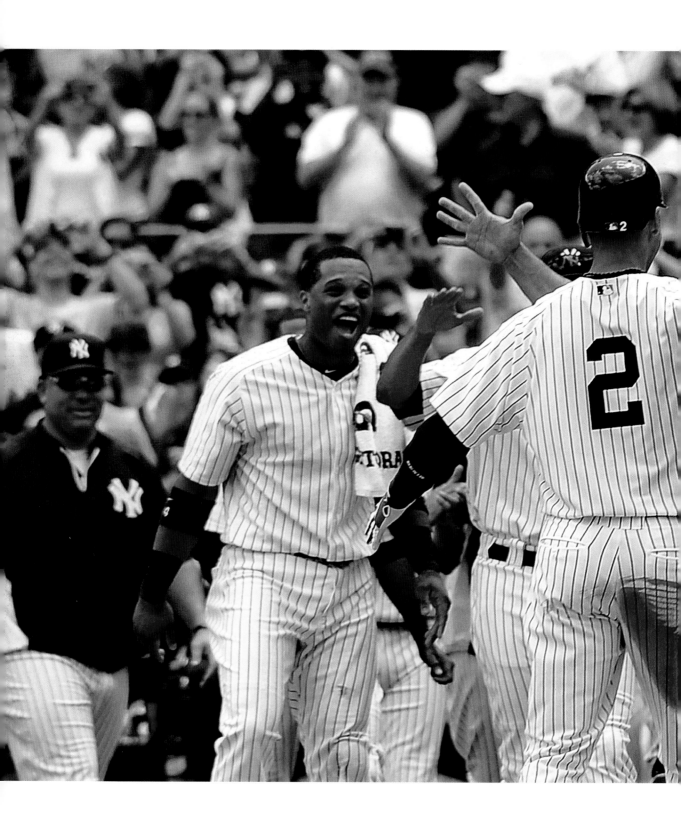

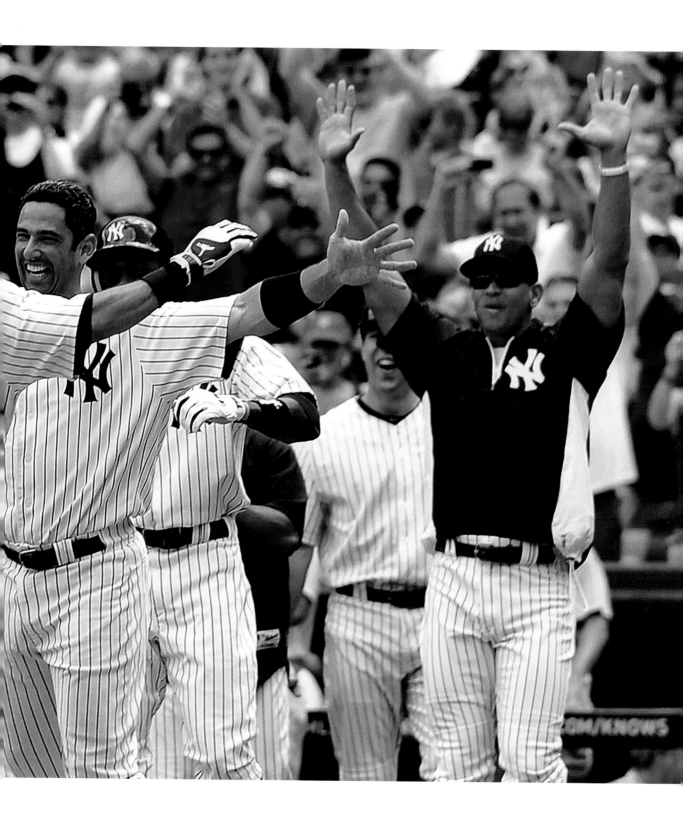

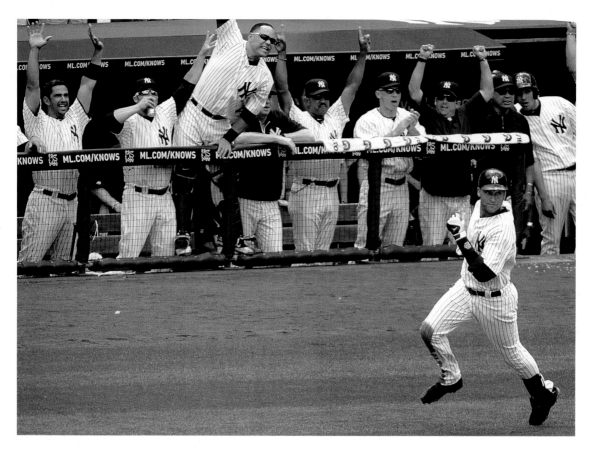

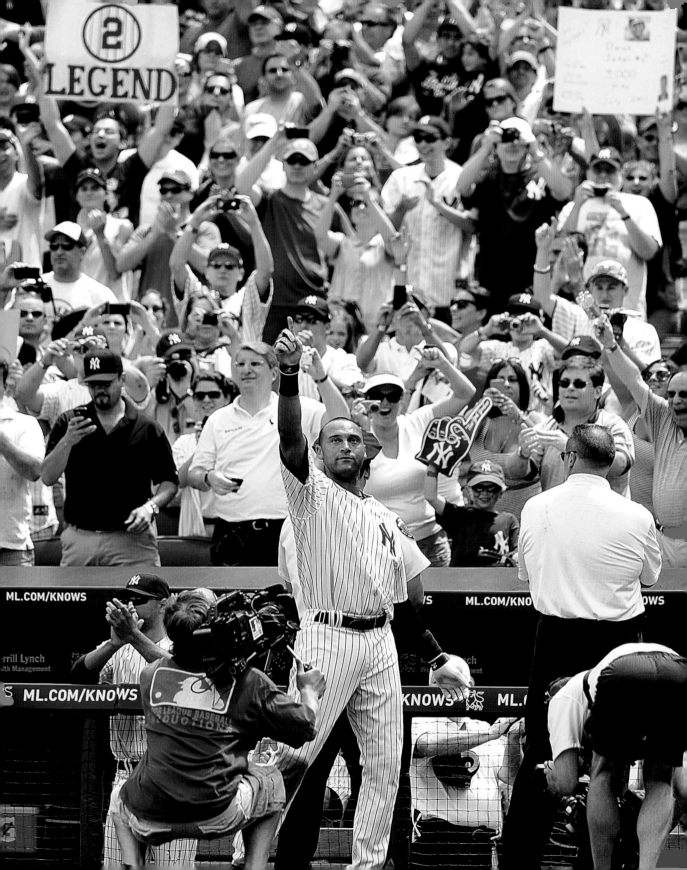

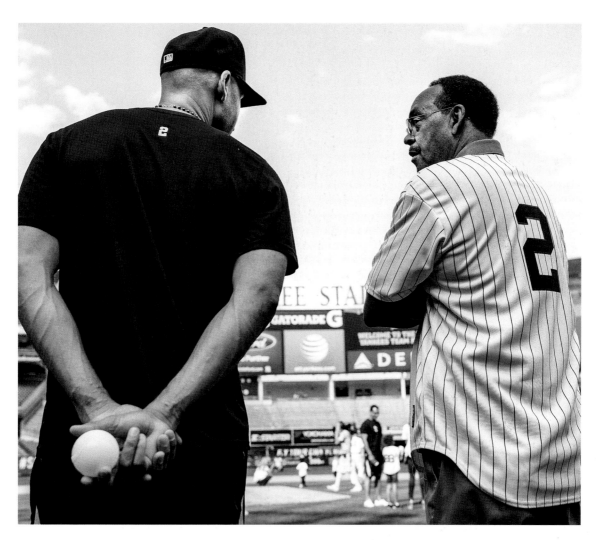

There's Always Tomorrow

Baseball is a game of ups and downs, good days and bad days. I always tell my teammates, "We've got another one tomorrow." I think it's that way with life, too. There are going to be bumps along the way, but you've got to pick yourself up and move on. That's why I like the sport most of all. My dad taught me that lesson early, as my coach and ever since. He should know, he's watched every single game of my career.

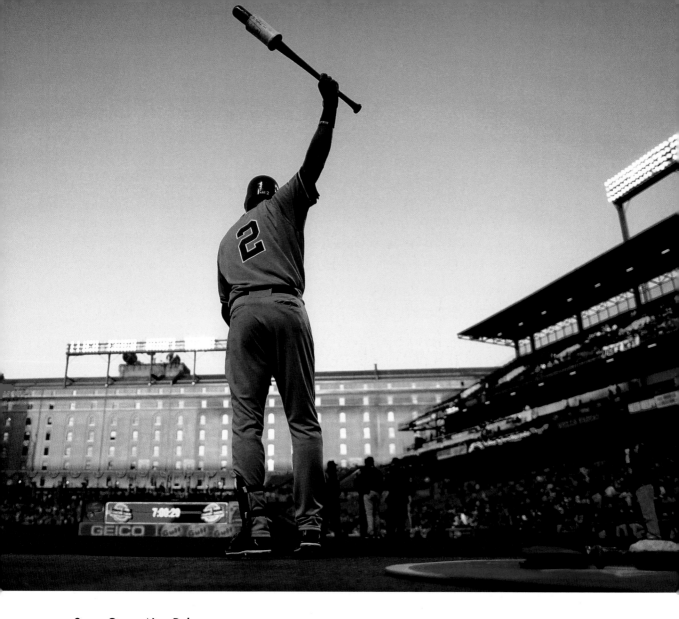

Same Game, New Rules

There's more player movement than there ever was in the past, so the camaraderie of guys playing on one team for their entire career of fifteen to twenty years is going to be few and far between from here on out. With free agency what it is, teams are constantly trading and it's all become more of a business in the past few years. I can't think of one team's roster that has had the same guys for five years, let alone ten.

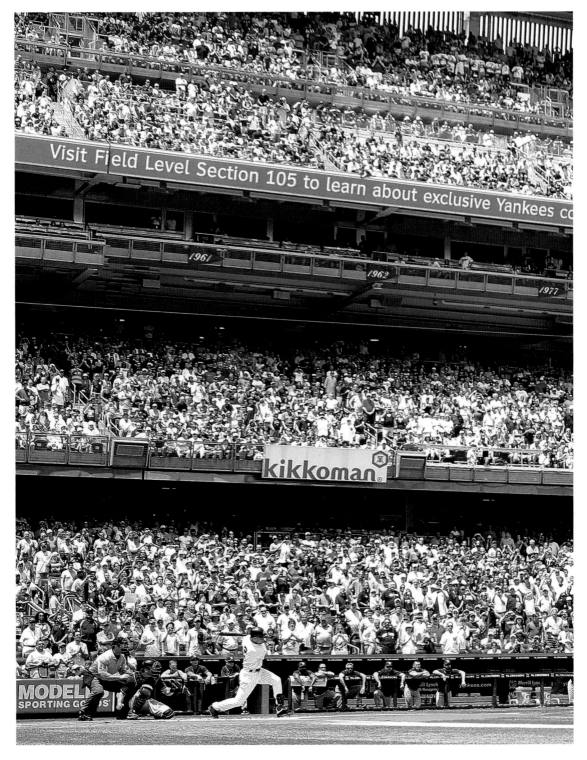

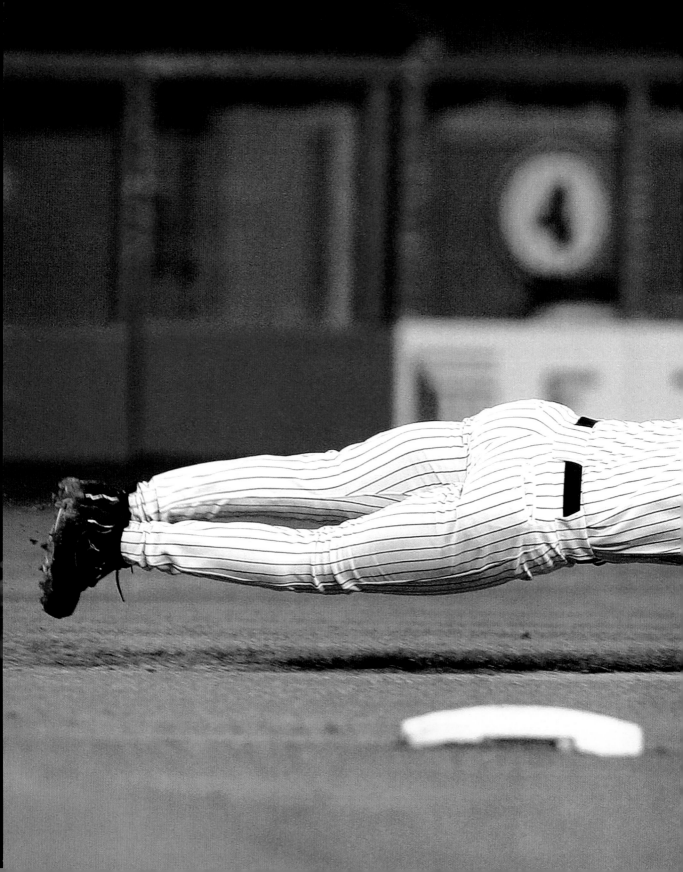

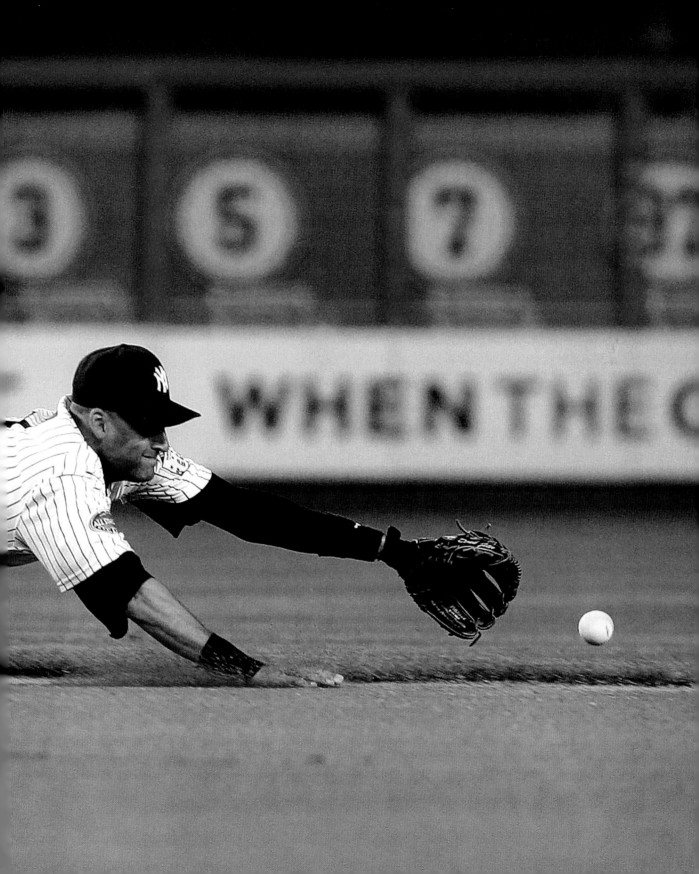

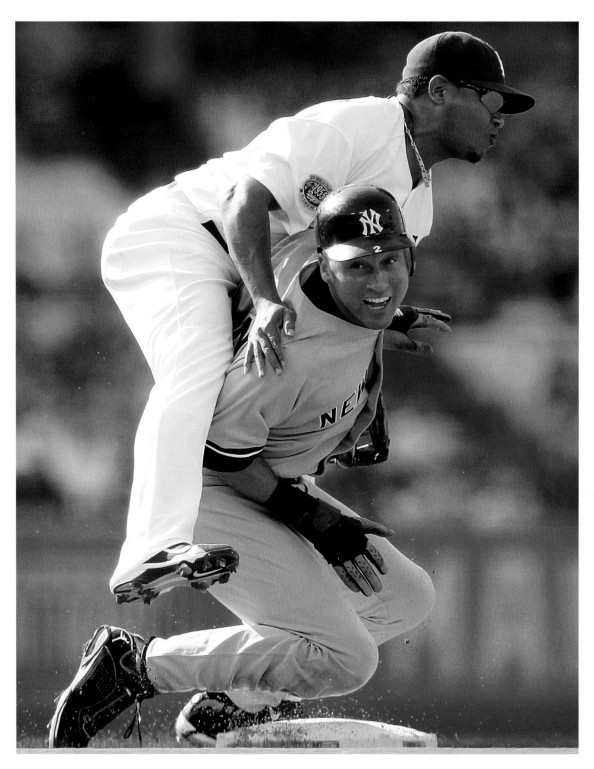

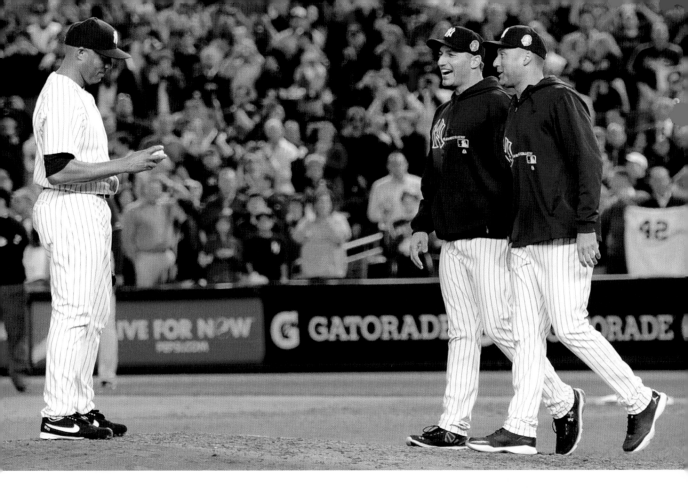

Mo Knows

Mariano Rivera is quiet but he's probably the most confident player I've ever played with. He avoided the spotlight for most of his career, until last year of course, when the attention was on him for the entire season. What you see is what you get with Mo. He took a lot of pride in doing his job—he worked hard and played hard. Although he's quiet, he has a pretty good sense of humor, which is something people might not realize about him.

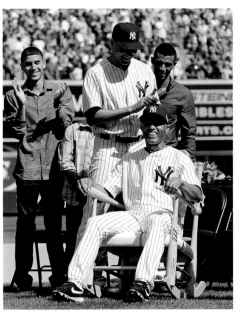

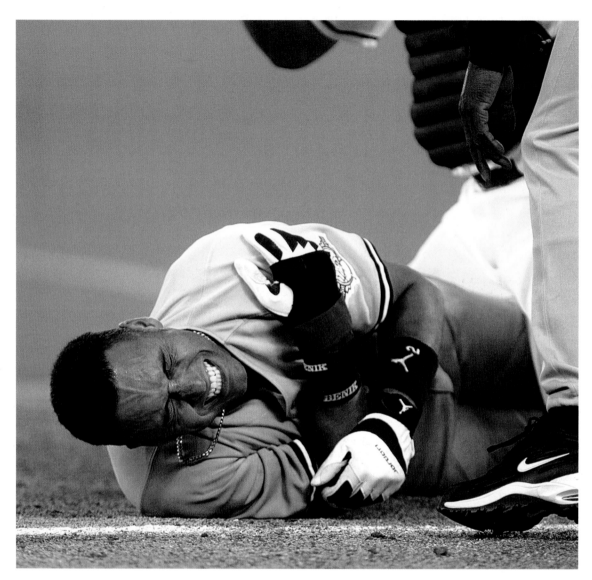

Drive

I think everyone wants to win—that's universal. But I don't think losing affects everyone the same way. Some people accept it and are fine with it. Only some are willing to make all of the sacrifices necessary to win. Some people are easily satisfied, while others continue to strive for what's next. And that desire for perfection is something else. To me, it can't be taught. You either have it or you don't.

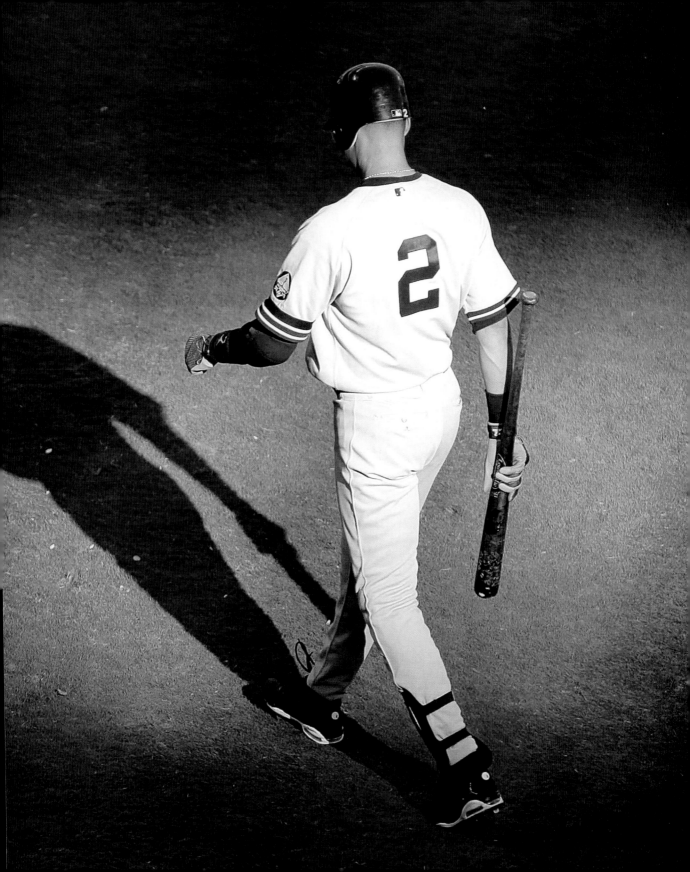

THE BIG 4-0

I've heard for men forty is the new twenty. It was like every other birthday—inside I really didn't feel any different. Then again I play a kid's game for a living. In my head I still feel like I'm young.

Surprise!

I turned forty midway through my final season. We went to dinner before my party and I thought it was just going to be my parents, my sister, my girlfriend, and my nephew. But when we showed up, all of my closest friends were there. Gifts are great, don't get me wrong, but having all of those people present meant a lot to me, even more so because I didn't expect it. Former teammates, friends, and my agent—I've got a really small group of close friends and they were all there.

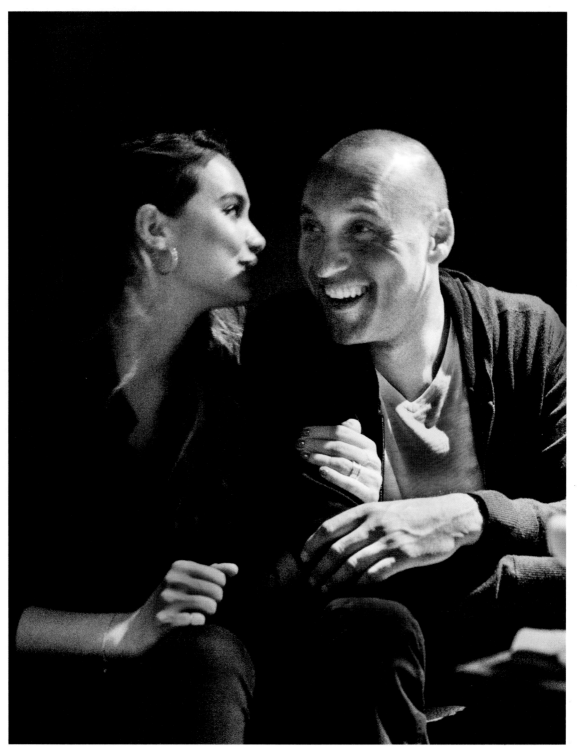

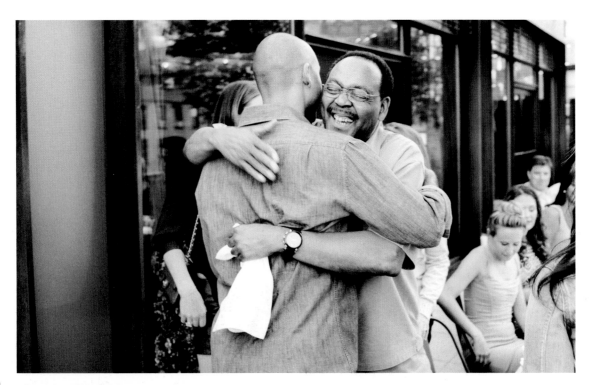

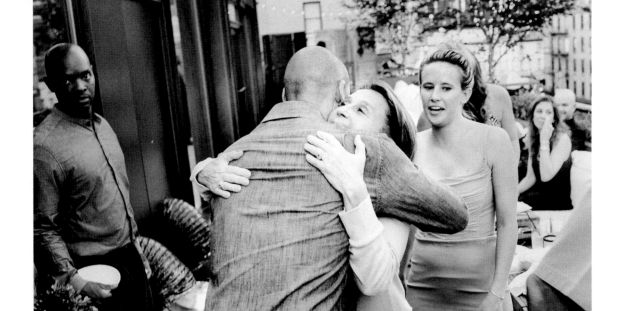

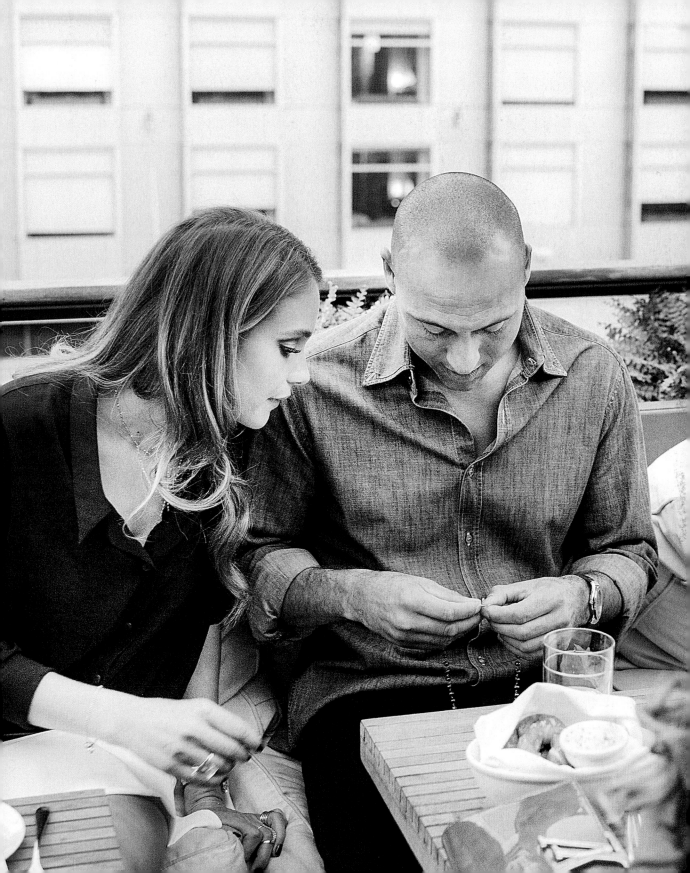

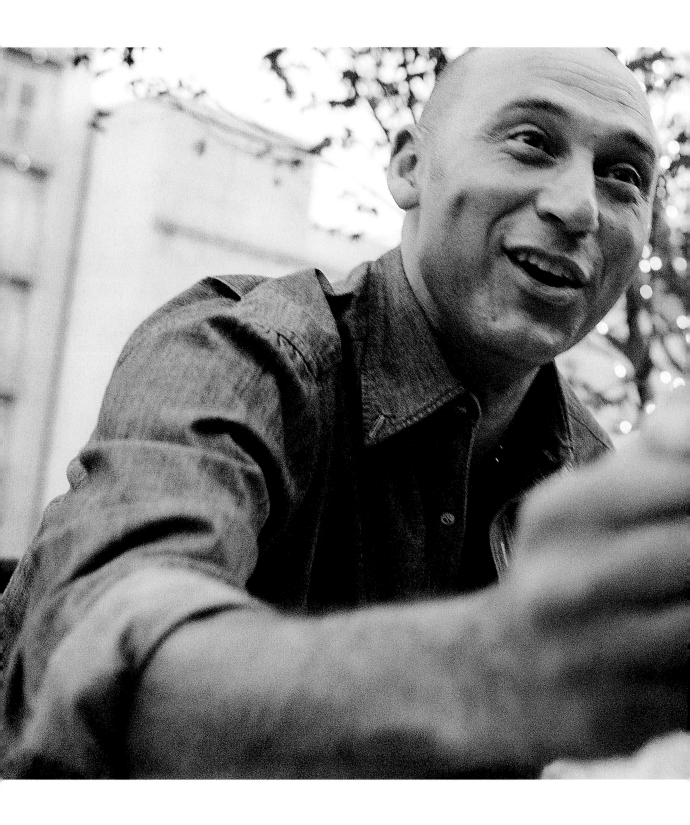

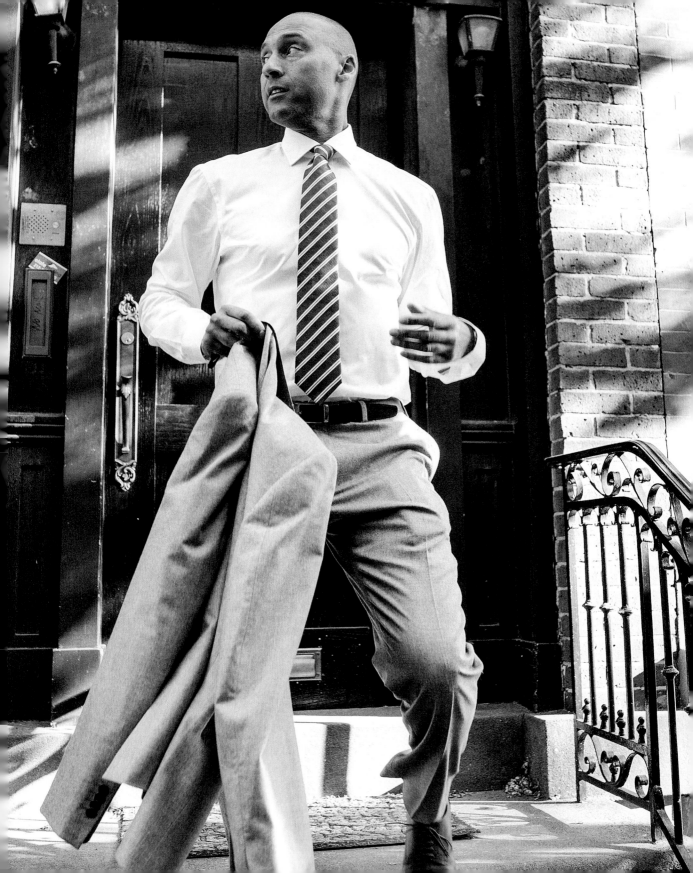

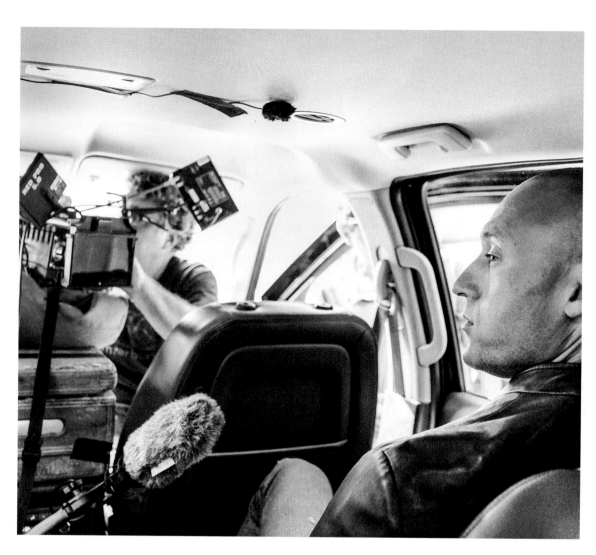

24/7

You know The Truman Show, *the Jim Carrey movie where he grows up on television? That's what my year has been like so far. The difference between baseball and other sports is that we play every day, so I've been on TV every single day. It's funny, I feel like so many people have been coming out and paying their respects, which is something I don't like to hear because it sounds like I'm going to be dying at the end of the season. Fans will say, "It was great seeing you," and I always reply, "I'm not dying, you'll be seeing me; I'm just not going to be playing baseball anymore."*

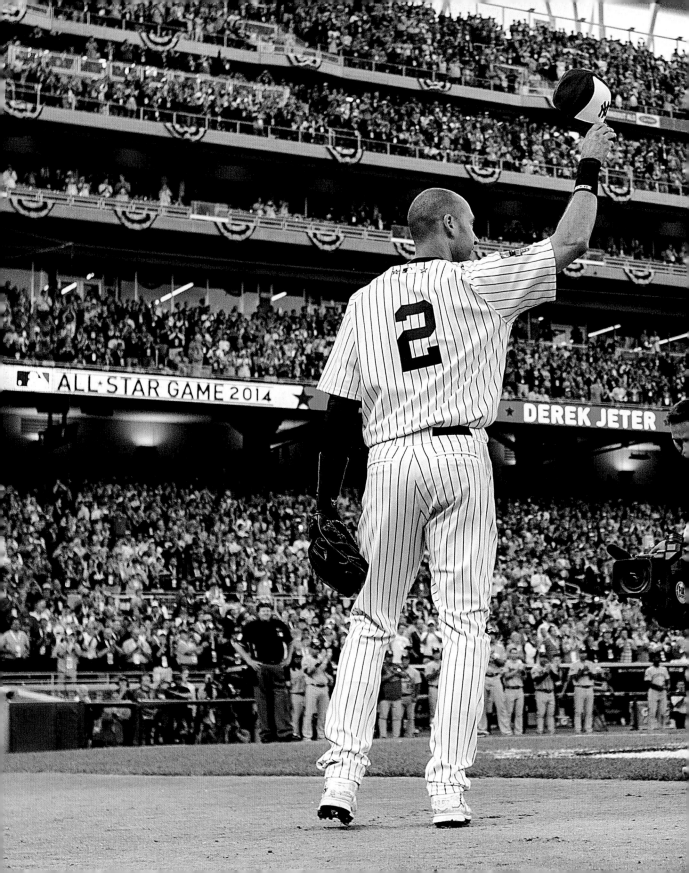

PERENNIAL ALL-STAR

I was scared to death when I played my first All-Star Game. It was 1998, I was twenty-four, and playing against guys that I grew up watching. I felt out of place and in awe. My last one was special because I knew I wouldn't get the opportunity to do that again.

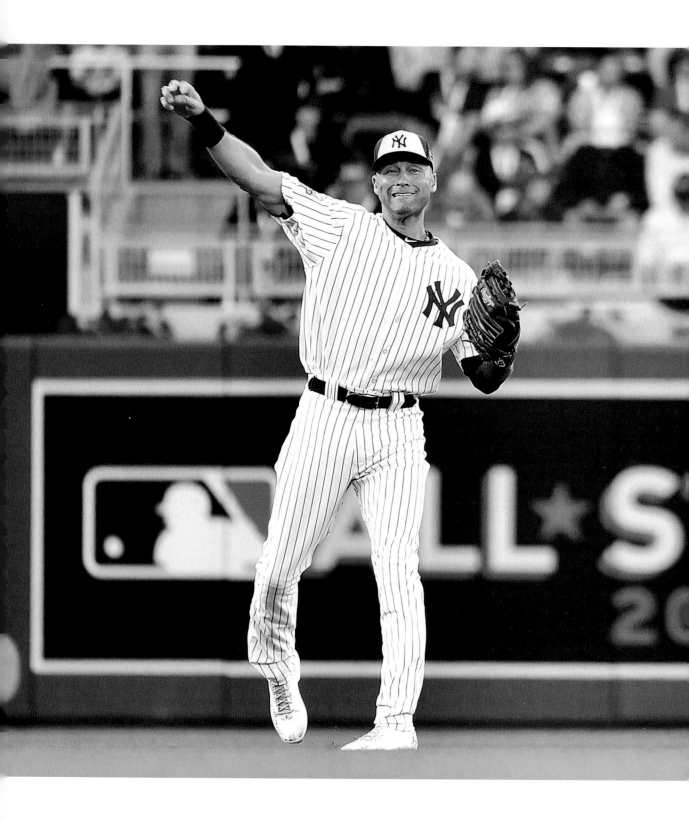

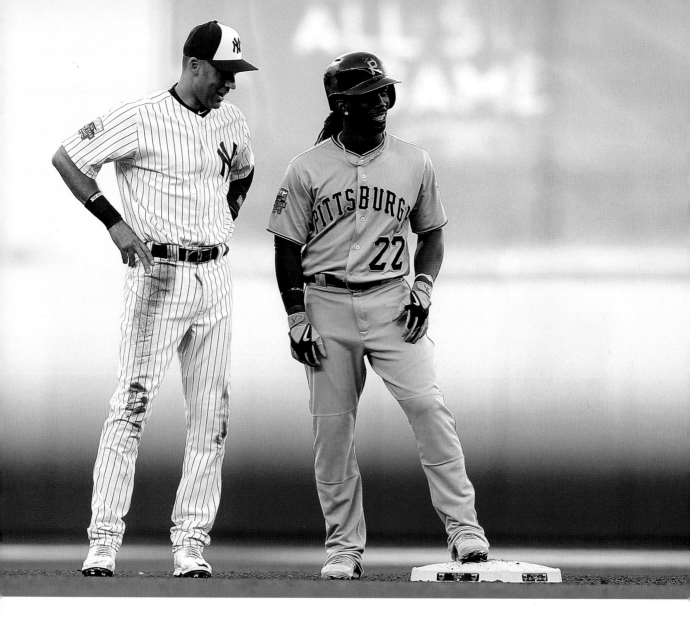

Catching Up

Everything surrounding the game is overwhelming, because from the moment we land, there are things for us to do every minute of the day. But the game itself is always really fun. There are guys you play against who you admire and respect from afar for what they do, and at the All-Star Game you get to be their teammate and get to know their personalities.

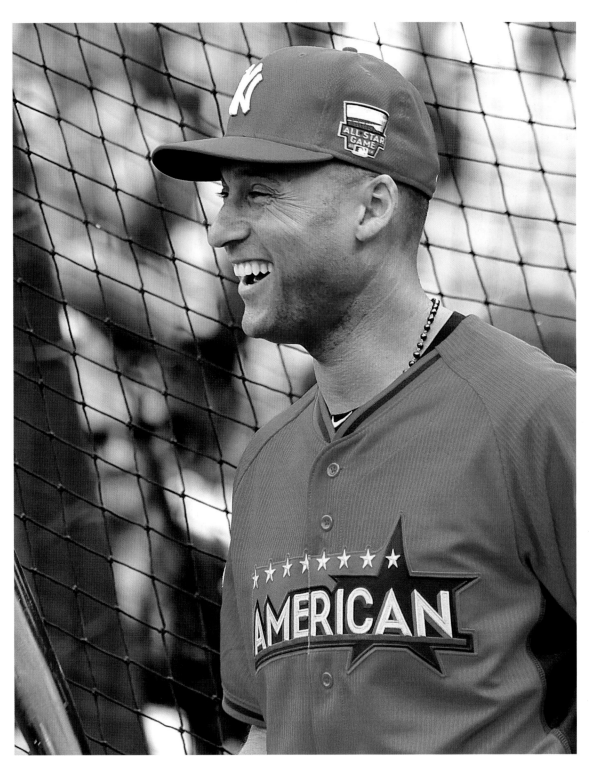

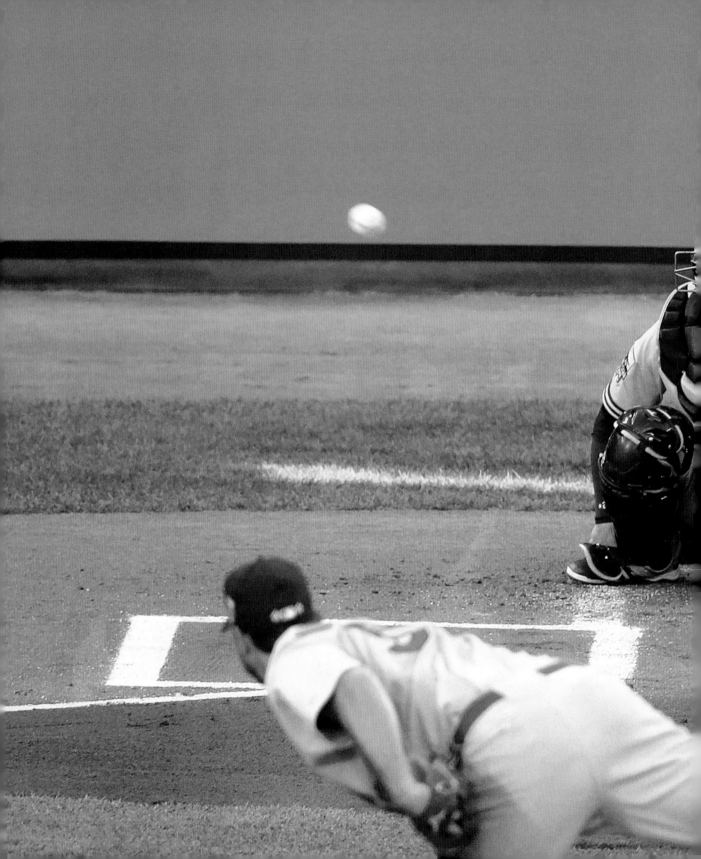

First But Not Last

I won the All-Star Game MVP award in 2000. At the time, I wasn't aware that no Yankee had ever won it, and it was an incredible honor to be the first. I'm not the only one anymore, though; Mariano Rivera won it in 2013. Playing in the All-Star Game is a treat, a chance to consider rivals as teammates just for a few days, and to compete with the best to put on a show for the fans. My parents have come to every All-Star Game I've played in, since they never took for granted that I would have the opportunity again.

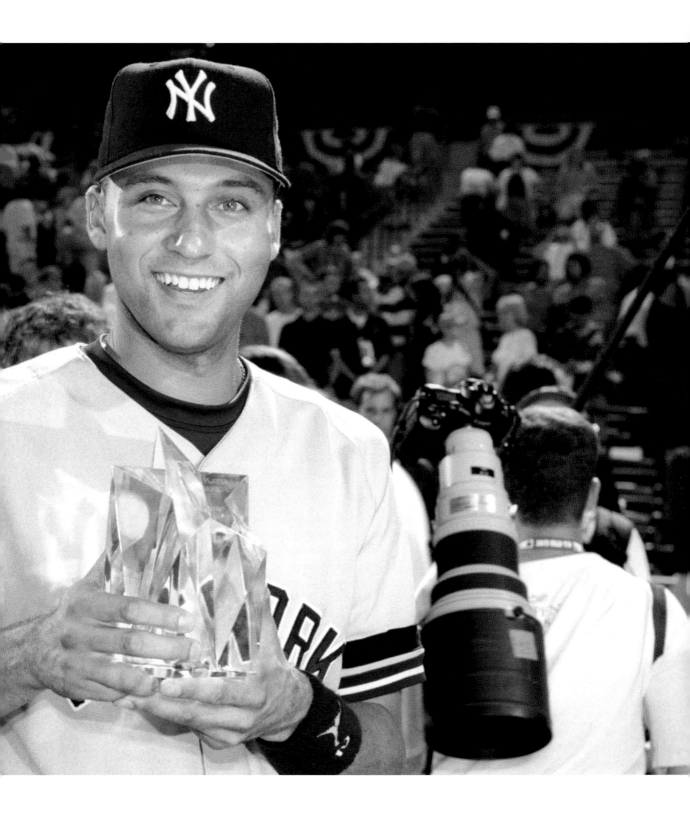

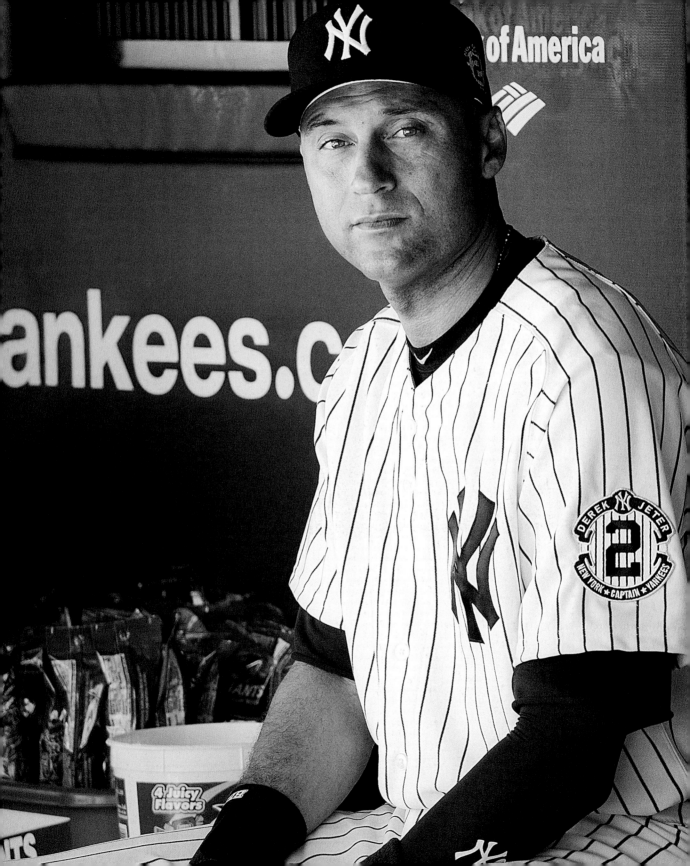

RE2PECT

My parents taught me the value of respect at a very young age and that has had a huge impact on the way I've played the game. I've tried to show respect to my managers, my teammates, fans, even opponents, and my desire to earn similar respect has influenced my decisions on and off the field. When the Yankees honored me at the stadium it was truly a special experience. They brought together more people than I expected, and I was moved by their presence and support.

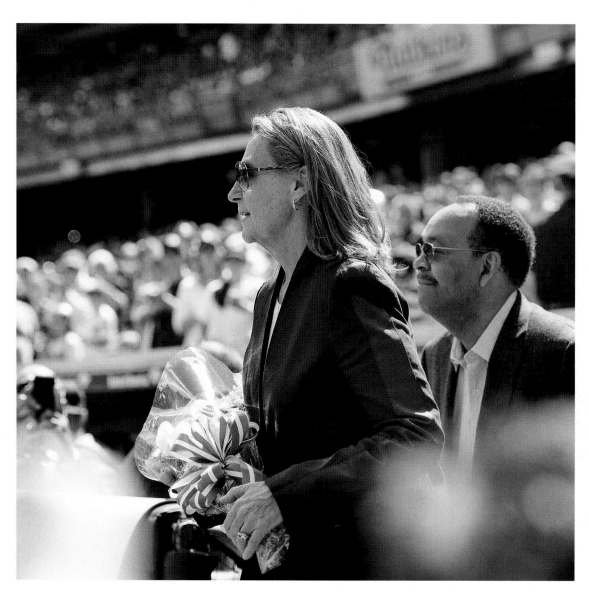

Always There for Me

My parents have been involved in my development as a baseball player and a person through every step. They've been an endless source of strength, support, and inspiration. They've encouraged me, stood up for me, challenged me, and set an example I hope to follow. If anything, I feel like this day should have been dedicated to them, as well as me.

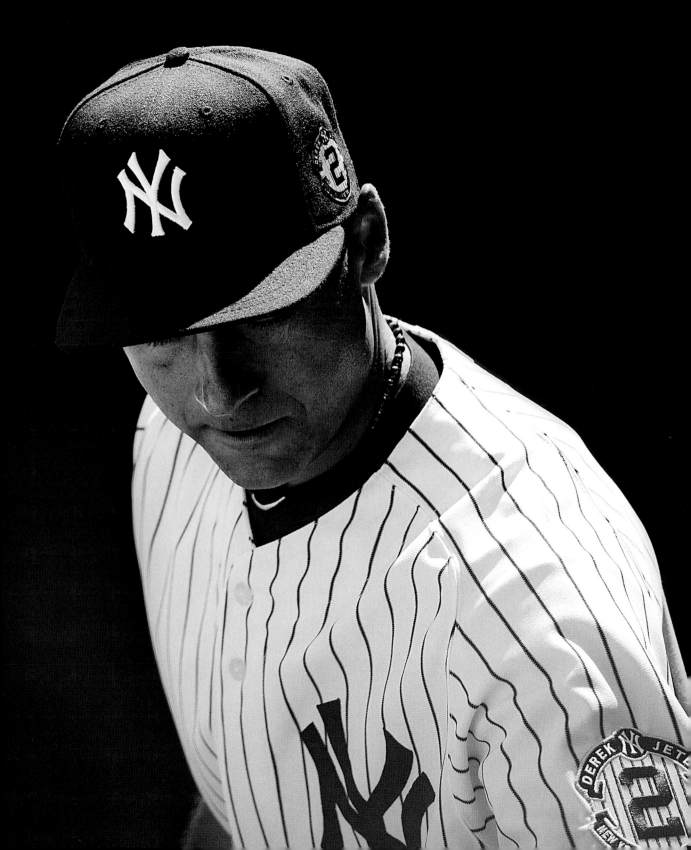

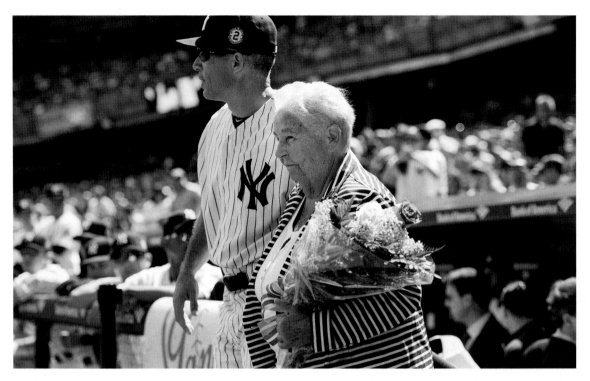

212

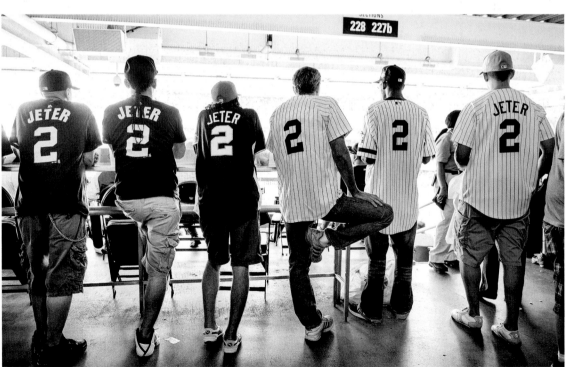

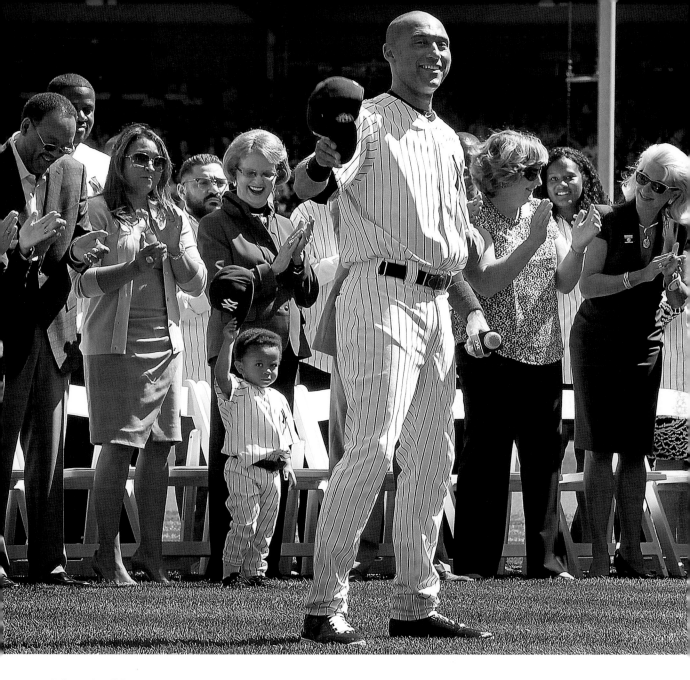

Where It All Began

What made this day at the stadium so unique was having my baseball family and my personal family together on the field. I've been fortunate to have a great support system in both. Growing up, it was my grandmother who really fostered my love of the Yankees because she was a Yankee fan. When I would visit her in New Jersey during the summer, at night we'd watch the games, just me and her. And going to a game would be a reward if I had done really well in school the previous year. She's the reason I became a Yankee fan. So to have her on the field with me was a real treat.

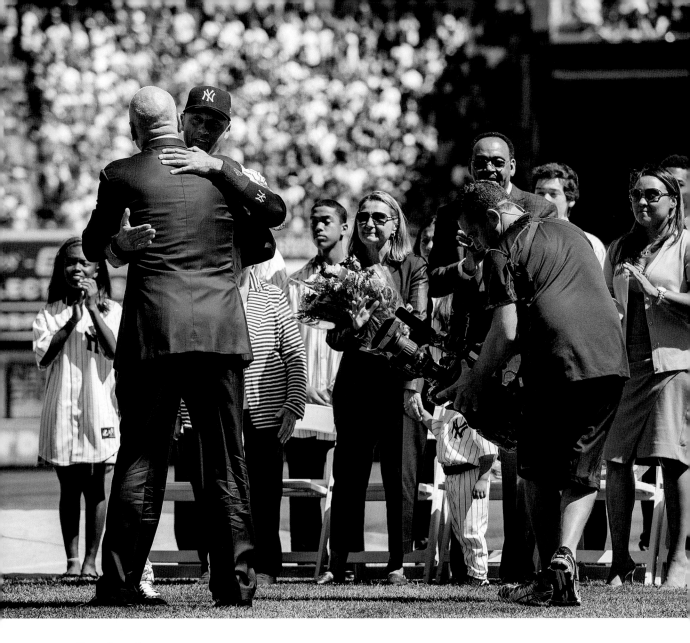

Friends and Mentors

Cal Ripken Jr. is the reason I was able to stay at shortstop because Cal was the first really big guy to play the position. When I was younger, people would tell me I was too tall to play short and my first line of defense was, "Well, Cal Ripken is doing it." I got to play against him, and after he retired I've run into him over the years. But for him to come out for my final home game, not even being a part of the Yankee organization, meant a lot. Michael Jordan, too. I competed against him when he was playing baseball in the Arizona Fall League in 1994, and I've gotten to know him well since then. He's like a brother now—a big brother who still keeps a few secrets, because I had no clue he was going to be there that day. He was a complete surprise.

215

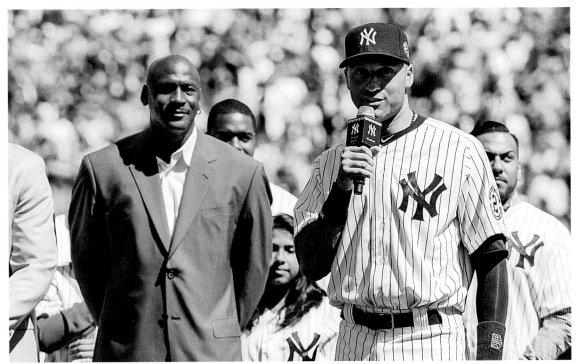

Giving Back

*The biggest honor for me that day at the
stadium was having so many members
of the Jeter's Leaders program present.
I saw this as a chance for them to get
some recognition, too. I've always felt
a strong responsibility to use my career
and visibility to do something more. I'm
very proud of what my Turn 2 Foundation
has done and continues to do for young
people, like the great ambassadors who
were with me on the field that day.*

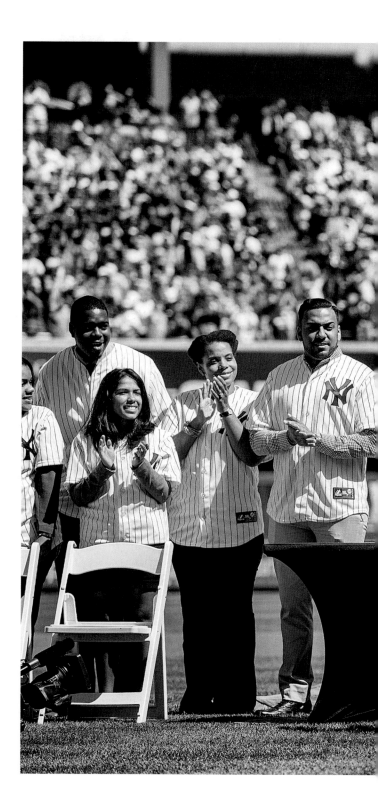

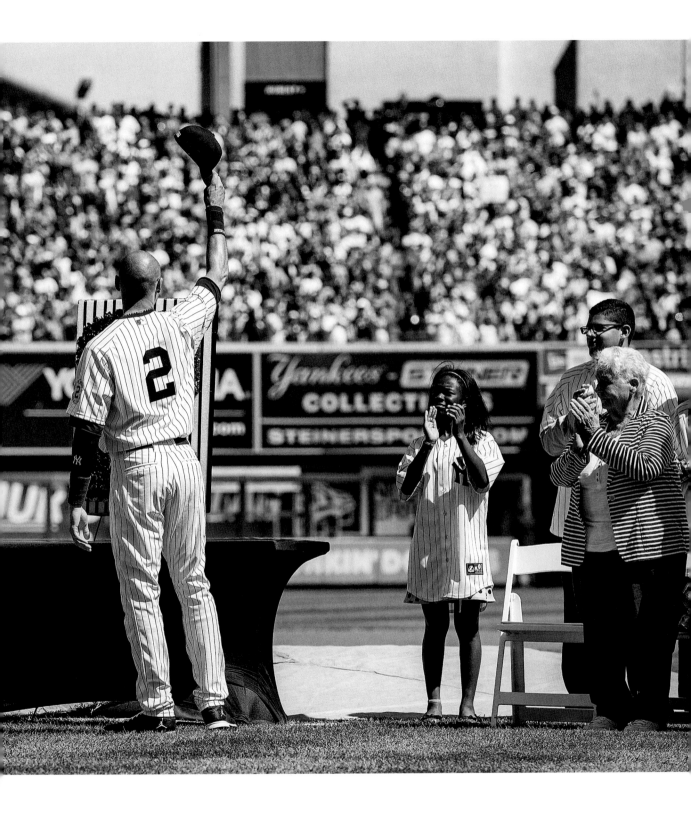

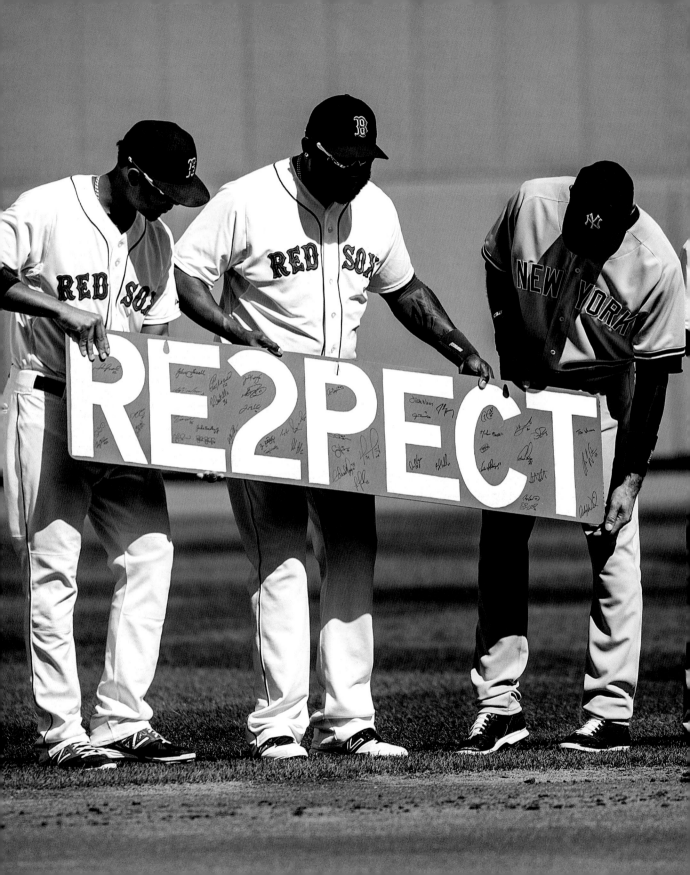

TEAM OF RIVALS

What Boston did for my final game was unbelievable. The fans were chanting for me at a place where I've heard them chant against me too many times to count. Everything that happened at Fenway that day was pretty outstanding. The entire Red Sox team came out to greet me before the game along with all of these great athletes from Carl Yastrzemski to Bobby Orr, which took a lot of time and planning. I didn't know anything about it and I didn't expect it at all. For the Red Sox organization to put forth that much effort to recognize someone who's been an enemy, for lack of a better way to put it, was something really special.

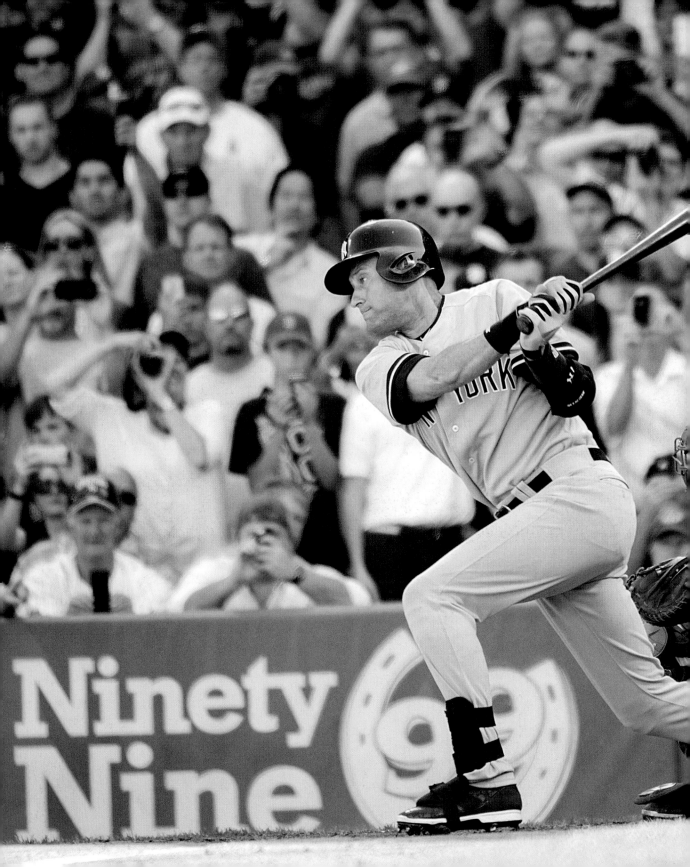

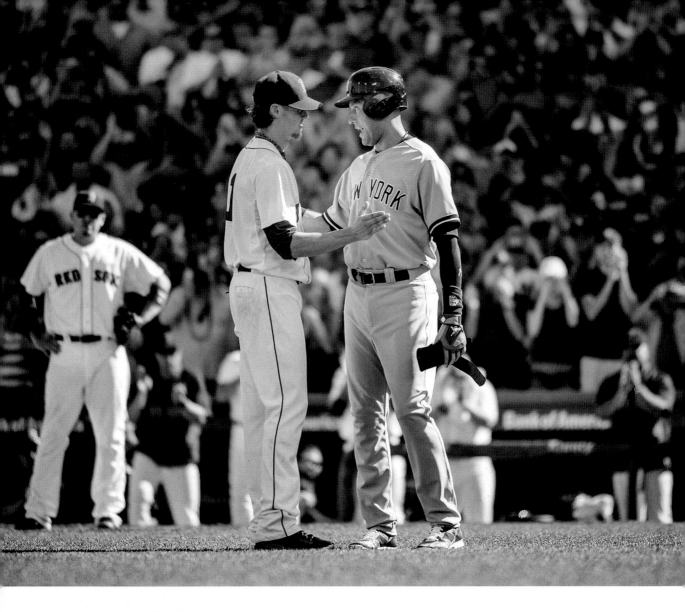

Good-bye and Good Luck

After my second at bat and my last hit, I left the game, and on the way to the dugout, I went over to Clay Buchholz, which probably seemed strange to people watching. The entire Red Sox team came out to greet me before the game, except for the pitcher and catcher because they were warming up. I got a chance to speak to the catcher when I went to the plate, but not pitcher, so I walked over and said, "I know this is odd, but I didn't get a chance to tell you before that it's been a pleasure competing against you, and good luck in your career." I didn't want to leave him out.

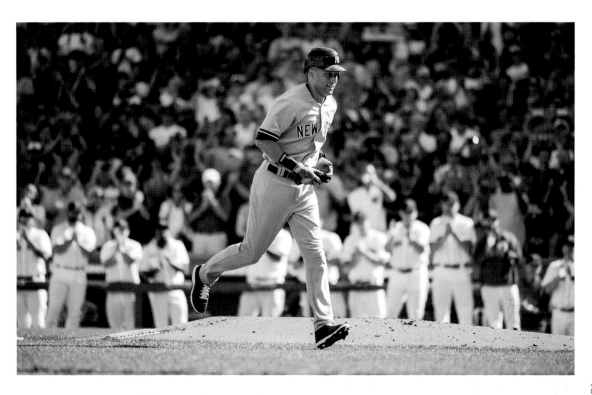

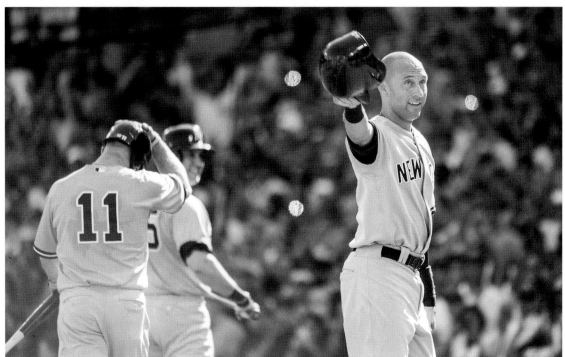

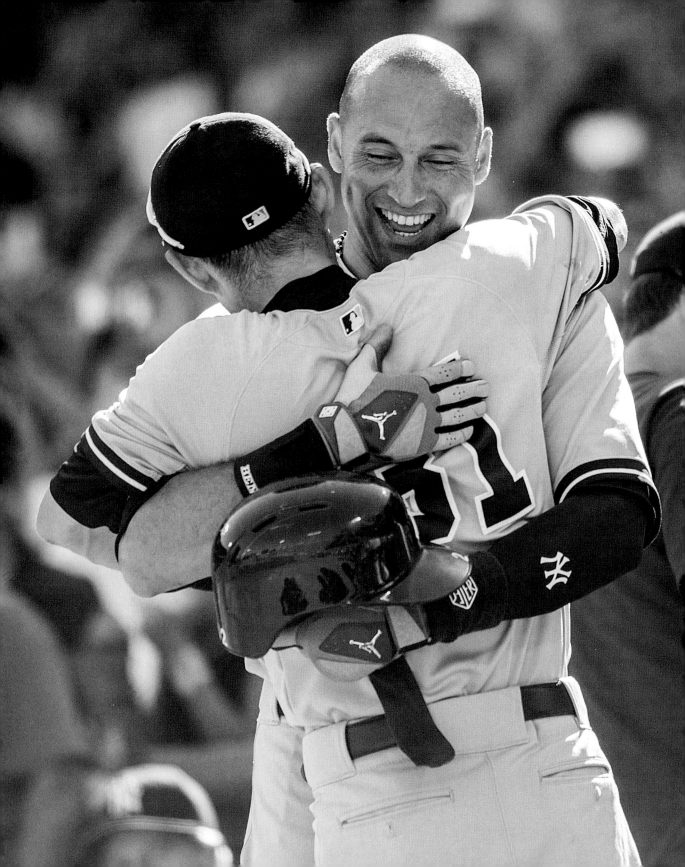

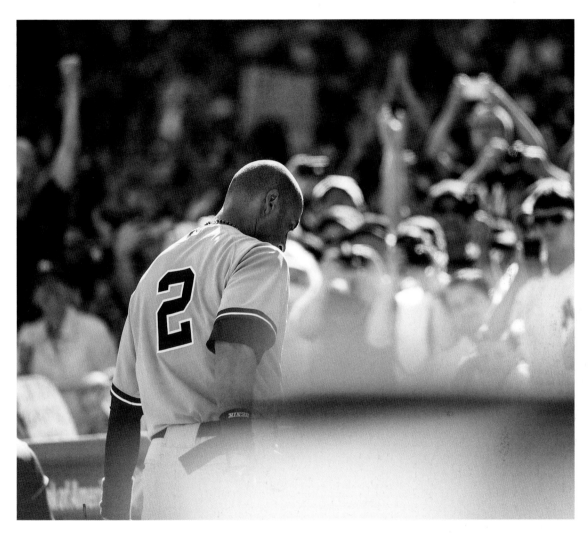

Hustle to the End

I've really enjoyed getting to know Ichiro. We're talking about a guy who has gotten over 4,000 hits. He's someone I've always admired from afar and I'm glad I got a chance to play with him. Going into that last game, I just wanted my last at bat to be a hit. I was fortunate that it was, but I almost blew out both hamstrings getting it. It was an infield chopper, so I ran it out as fast as I could. It's never taken talent to play harder and hustle, and that's how my last hit was.

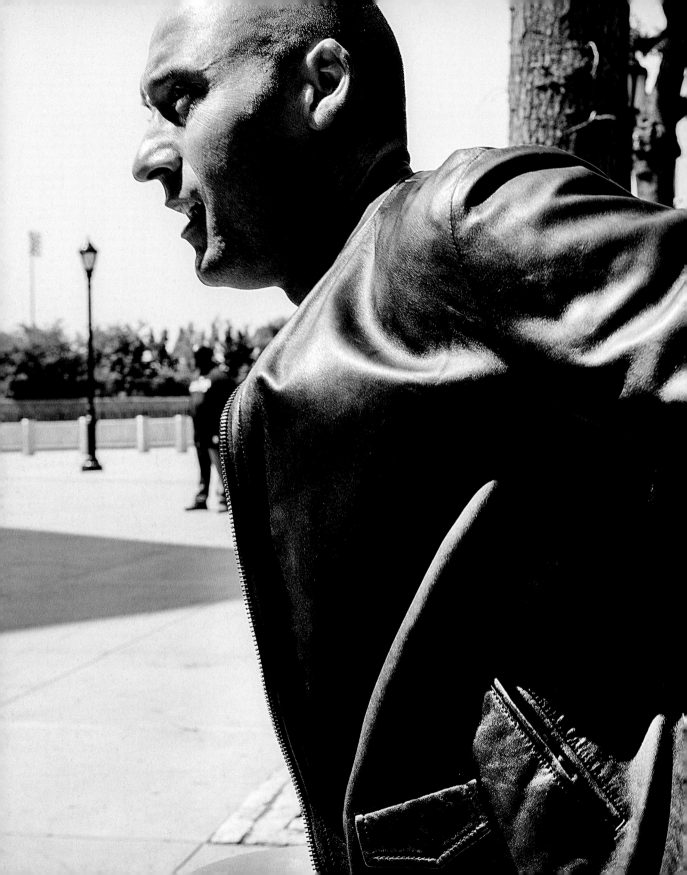

LOOKING AHEAD

After the last out in my last game, it will
be the first time since middle school
that I won't have a schedule or a routine
to follow. My life has been structured,
because it had to be for me to achieve
my dreams. That part of my life will end,
but that doesn't mean I'll start doing
a whole lot of nothing. My future will
be busy and I have big plans, most of
which probably won't fall in line with
what people expect from me. I'm looking
forward to surprising them.

New Teammates

I've always been interested in the business of sport and I think I have a fairly entrepreneurial spirit. Now I'll have the time to actually pursue some other projects and establish myself in a different way. I've spent twenty years focusing on the team and on winning. Now I'll be able to focus on things that matter to me outside of playing baseball. One thing I've always been concerned about is health and healthy living, which is why I've partnered with Luvo, a company that makes healthy, nutritious meals that also taste good.

Sticking with What Works

Even though I'm moving on from my career as a ballplayer, some things will stay the same even in retirement. I'm a creature of habit so I will still get a Red Eye from Starbucks before I go wherever it is I'm going. And I'll continue to work out with my trainer, Jason, the way we have for the past six years.

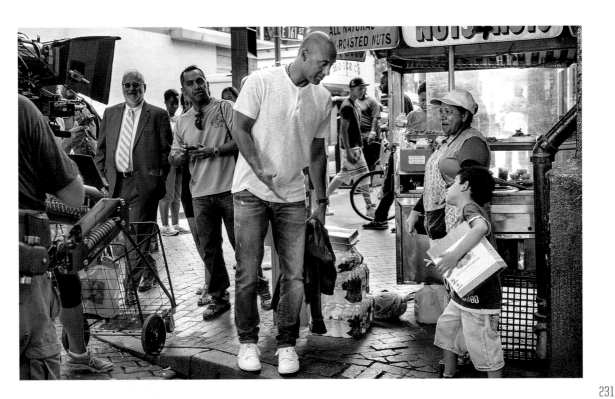

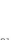

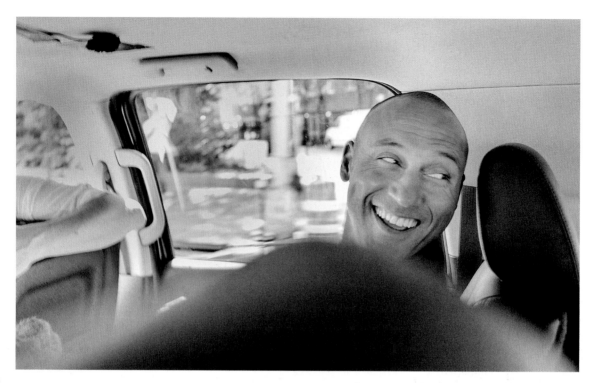

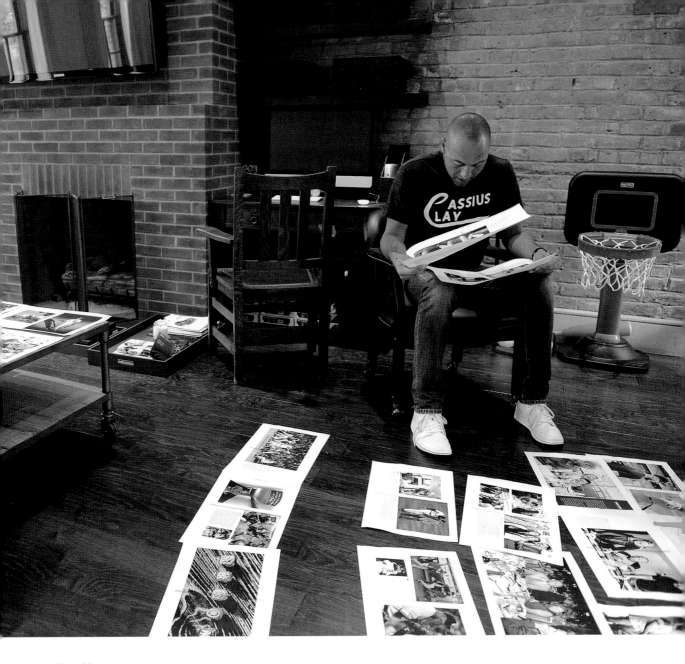

New Ventures

One of the projects I'm most excited about is Jeter Publishing, the imprint I've established with Simon & Schuster. I plan to be hands-on with every book we publish, and I intend to go after great stories and interesting subjects, and not just in sports. I want the imprint to be a place where people can tell their stories their way. And I intend to do the same with my online venture, The Players' Tribune, where athletes from all sports will be able to tell their stories, first person, exactly the way they want to. I want to provide a community where they can connect directly with their fans, no filter.

Free Time!

The greatest thing about my future is not knowing what every step will be. I have my foundation, I have my business interests and ventures, and I have my goals, like owning a team one day. But there's no schedule, there's no routine, and there's no end date. I'm looking forward to making the most of that flexibility.

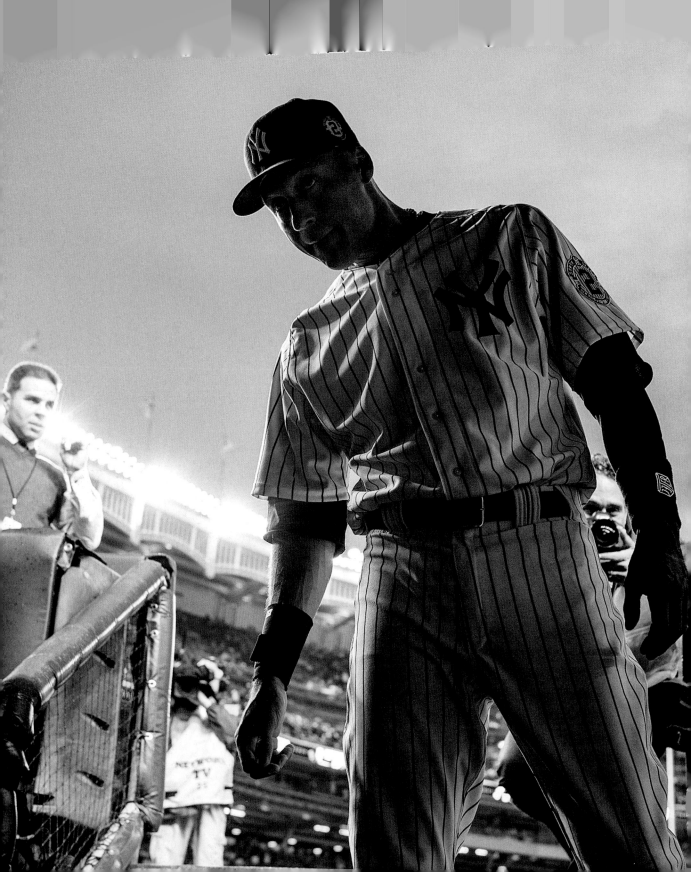

THANK YOU, NEW YORK

I don't even know where my mind was—it was all over the place, from the moment my final game at the stadium started until the moment it ended. I thought I was going to lose it by the eighth inning. I was trying to stay in control, just hoping I wouldn't get emotional out on the field. If the game had ended the way it looked like it was going to, I really would have lost it, I have no doubt about that. But then things changed, and I went from being sad to being really excited.

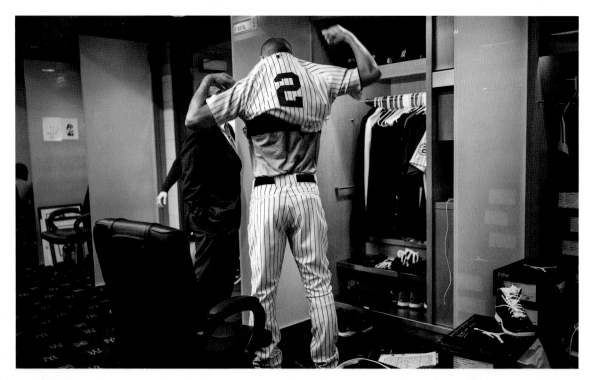

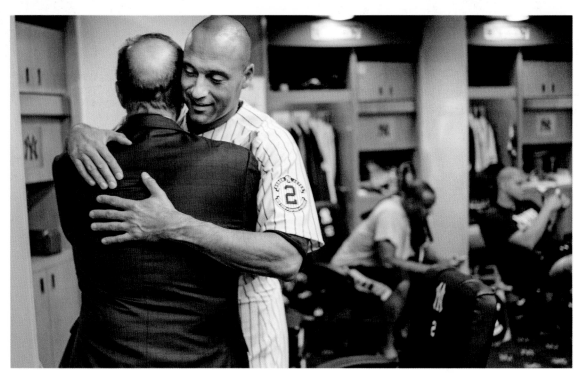

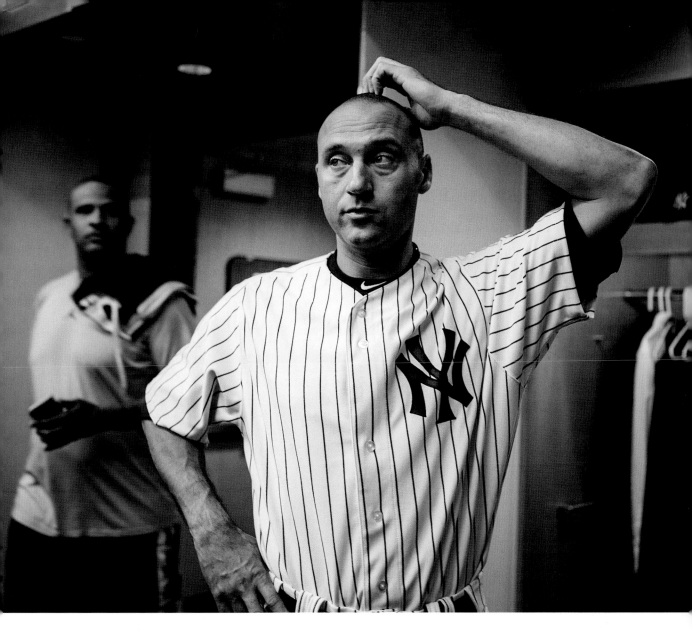

Still There for Me

*Mr. T came by before the game to wish me luck, and all of my
inner circle was there to support me. It was hard to keep my focus,
my mind was literally in a hundred places at once.*

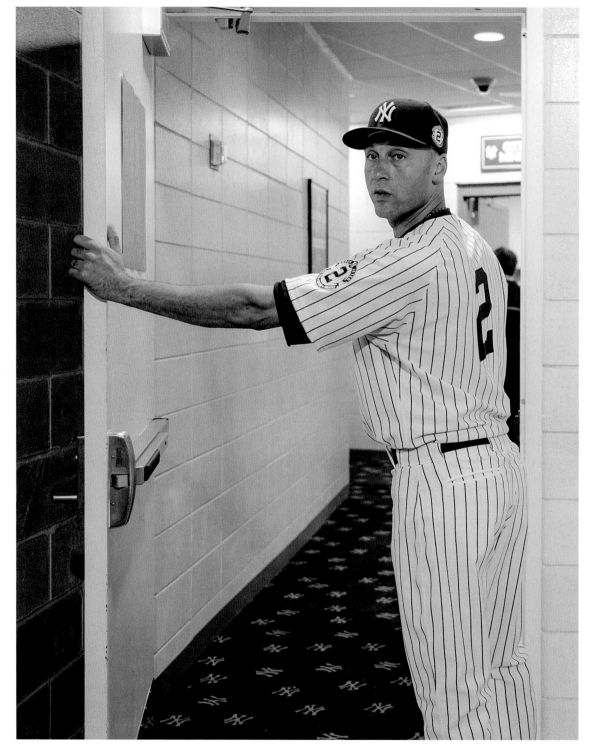

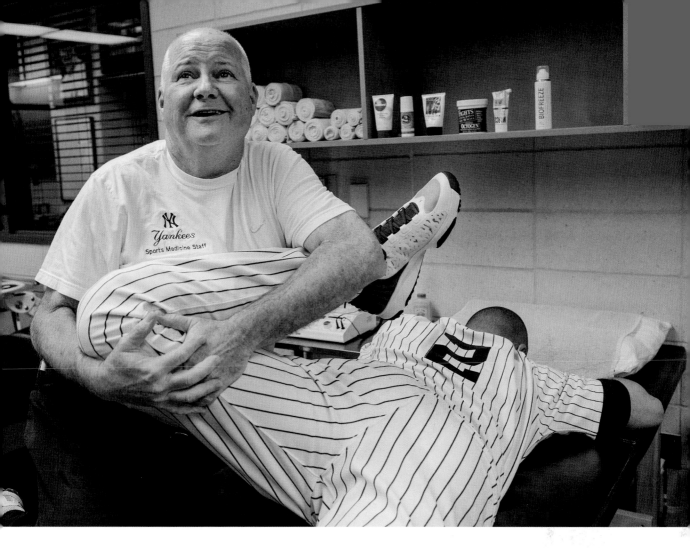

Some Things Don't Change

My trainer, Stevie [Donohue], stretched me before the game the way he's done for years and years. He has been with the organization my whole career. He began as the assistant trainer under Geno [Monahan], who was with the team for decades. Now Stevie is the head trainer. As much as I went through my routine the way I always had, I can't lie, this time it was different knowing it was my final home game, my last time doing all of those things at the stadium.

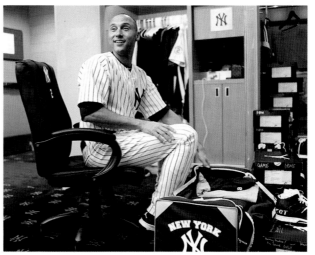

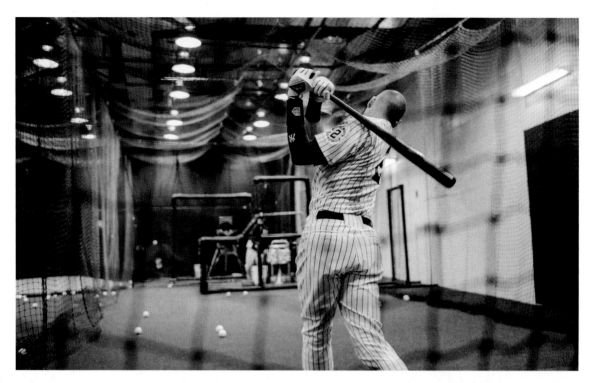

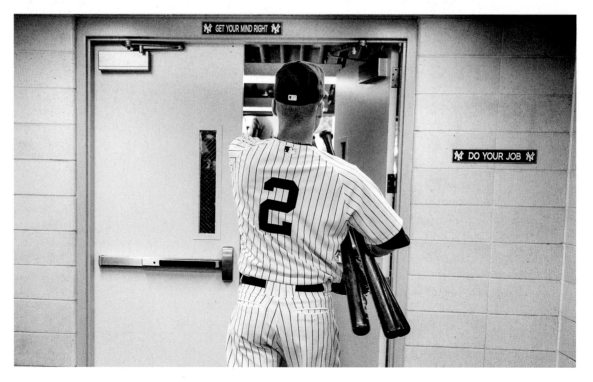

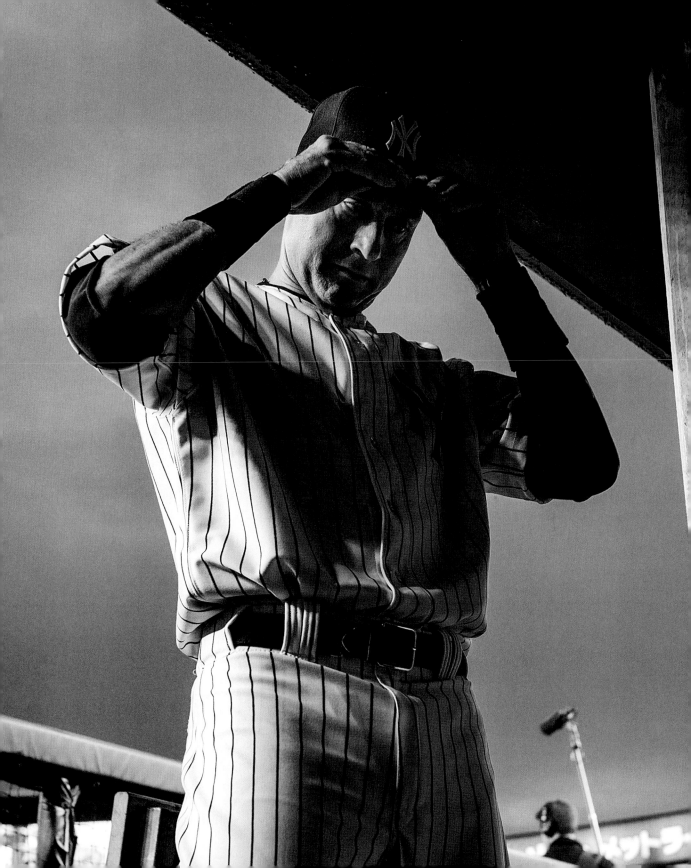

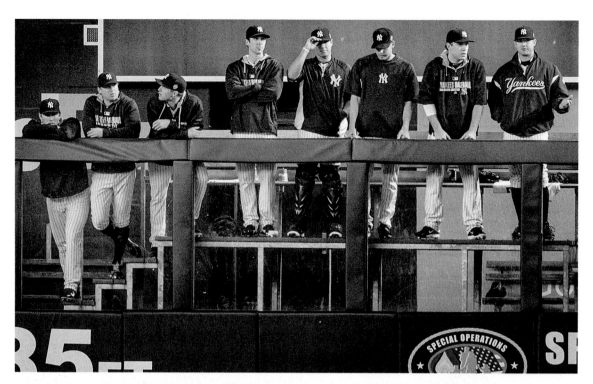

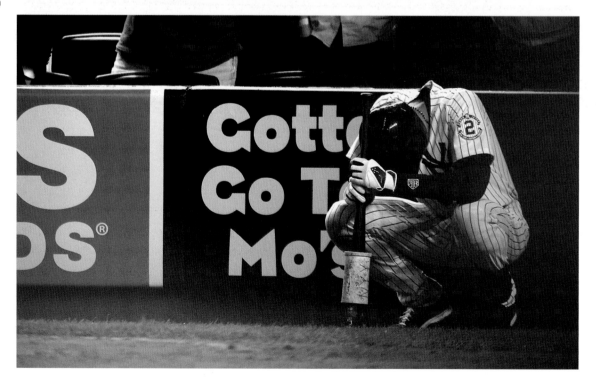

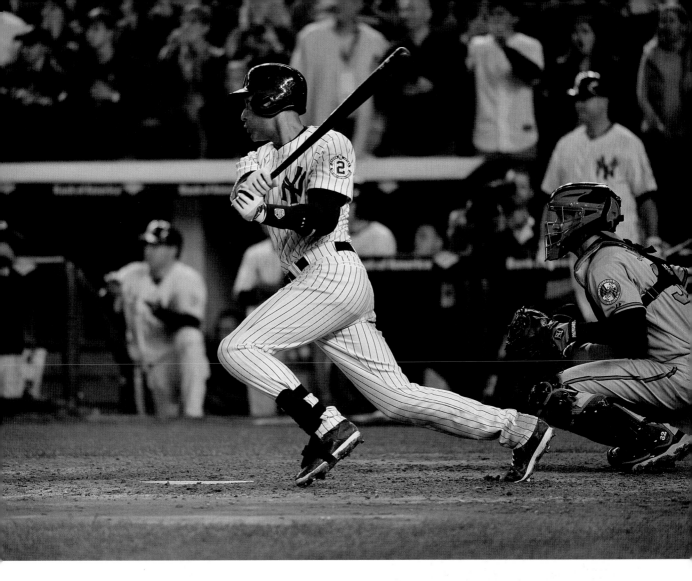

A Prayer Answered

I began to get really choked up in the eighth and ninth innings, and when the fans started chanting, "Thank You Derek," I wasn't sure I could keep my emotions under control. Then when the game was tied up I got back into it, because I wanted to win. Before I took my last at bat, I kneeled and prayed the way I always have. But this time my prayer was a little different. I said "God, if I have one more big moment in me, now is the time."

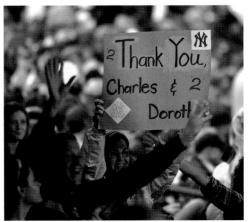

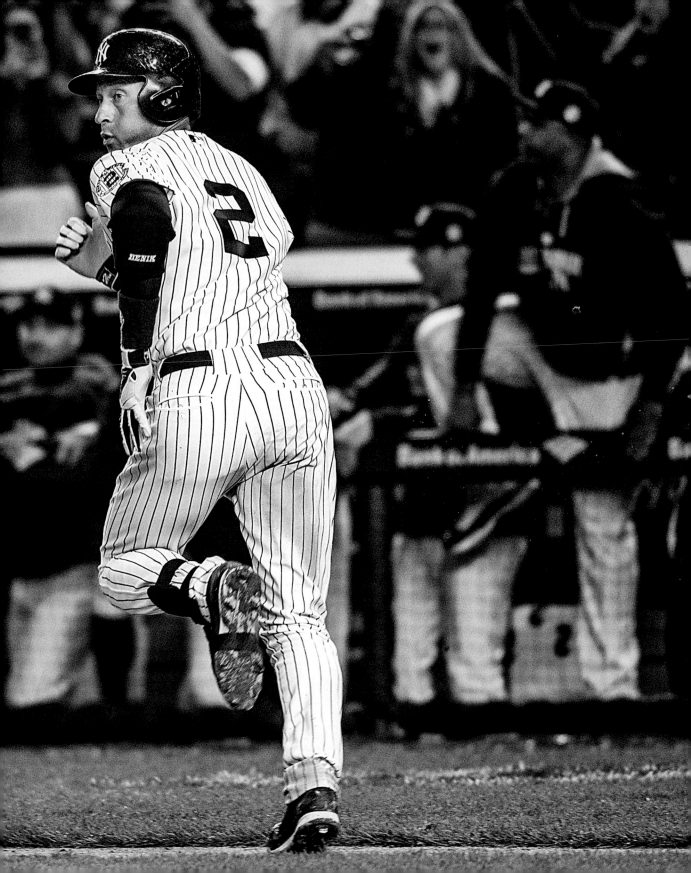

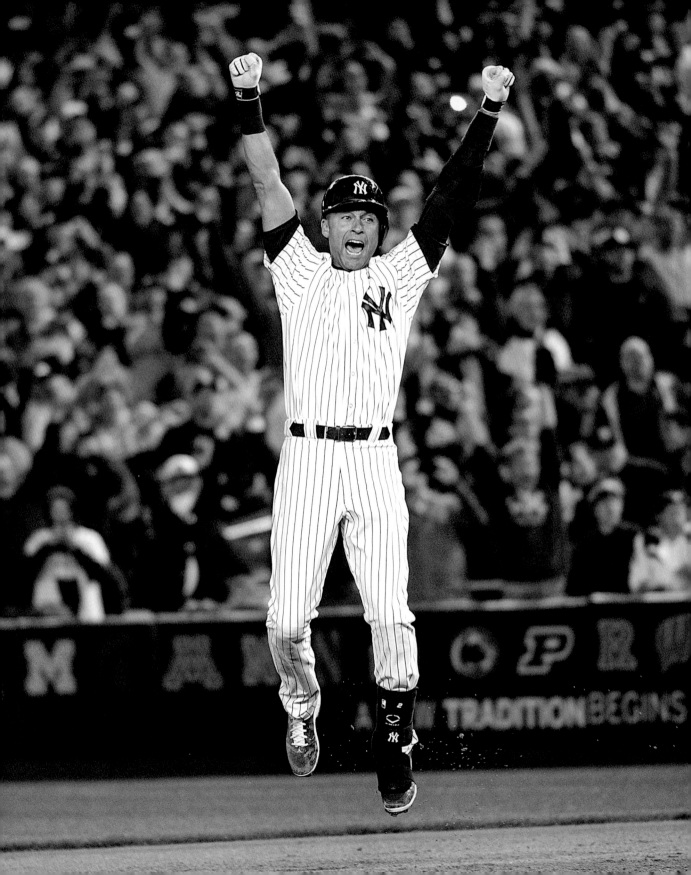

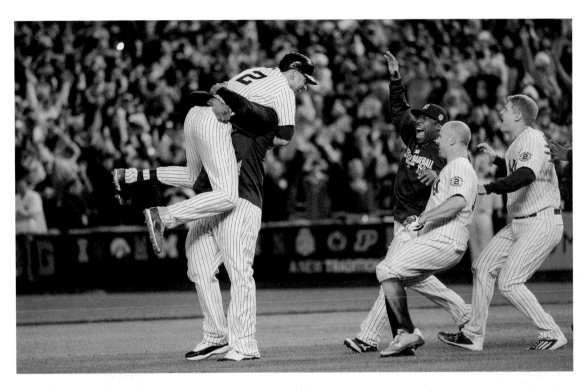

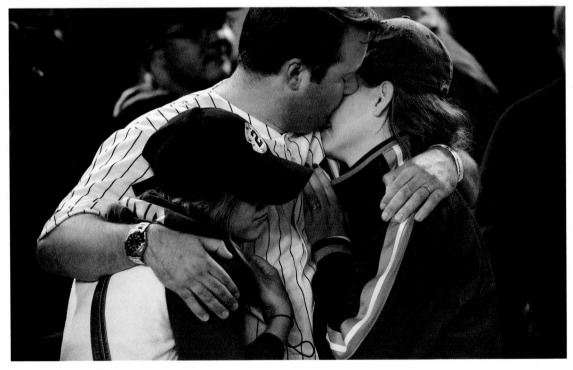

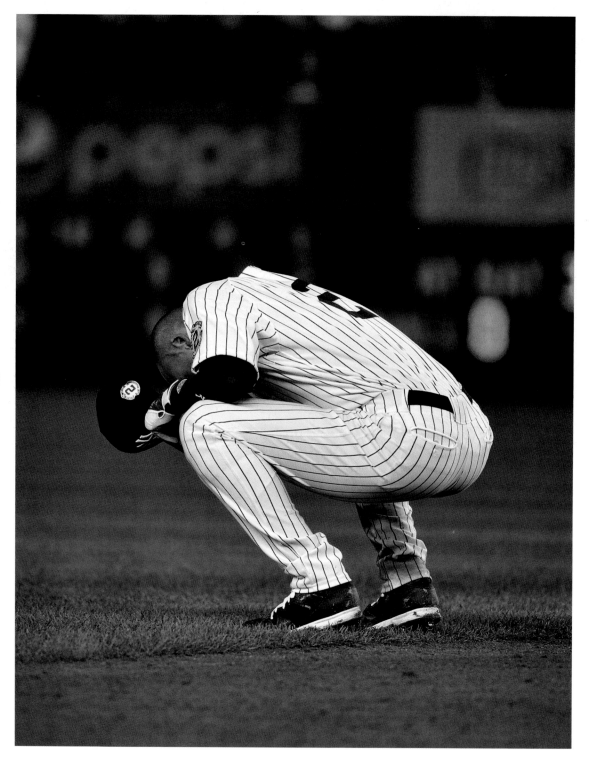

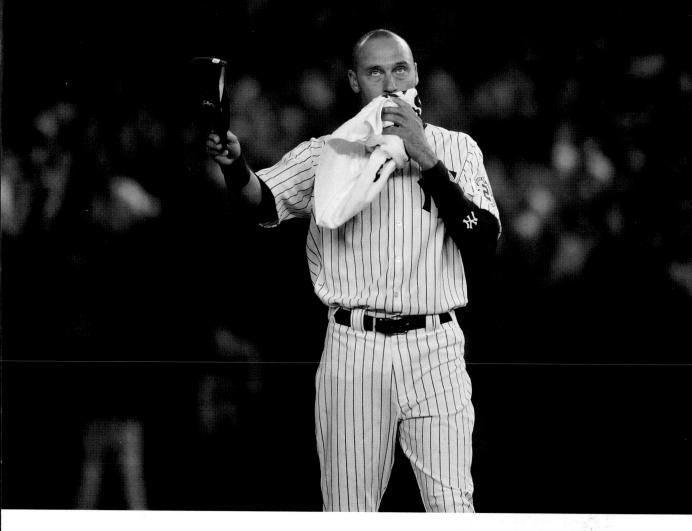

Letting Go

CC Sabathia was on the field celebrating before it was even a legitimate hit. He was the first one out of the dugout, and if our guy had been thrown out at the plate, CC would have been standing there all alone in the middle of the field. He'd just had knee surgery, but he didn't care, he was out there to celebrate. After we won, I took a moment and went to short, knelt down and said, "Thank you, God. Thank you for twenty years of me being able to live my dreams."

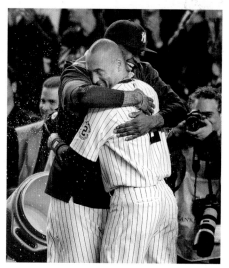

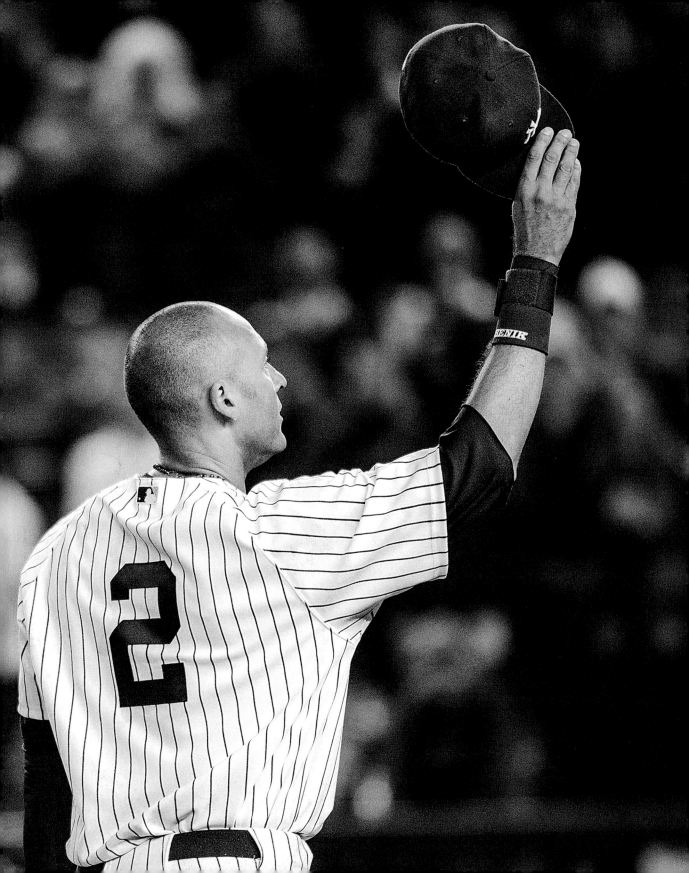

Physical Description (Build, size, agility, etc.) *Wiry Loose good Agility with good FACE @ MAKEUP - A LEADER - LARKIN TYPE*

GLASS/CONTACTS: NONE
PHYSICAL DESC: HI BUTT, LONGISH ARMS & LEGS, LEANISH TORSO, YOUNG COLT
ROOM TO FILL OUT TO 190LBS

Summation *THIS YOUNG MAN WILL HAVE AN IMPACT BOTH OFFENSIVELY AND DEFENSIVELY A BARRY LARKIN TYPE ATHLETE. TOP STUDENT FROM A HIGH CLASS FAMILY, WHERE THE MOTHER IS AN ACCOUNTANT, THE DAD A SUBSTANCE ABUSE COUNSELER WITH A PH.D. DEREK IS A MODEST, UNAFFECTED KID AND PART OF THE TEAM. WOULD LOVE TO TAKE WITH OUR FIRST PICK. WILL BE IN THE BIG LEAGUES BY* Comparable Type ML Player: *THE TIME HE'S 21.*

Summation and Signability Group: *I THIS GUY IS SPECIAL. YOU GET EXCITED JUST WATCHING HIM WARM UP. ALL-STAR POT AS SS AT ML LEVEL. RAISED OFP 7 PTS: ABILITY TO PLAY PREMIUM POS AT ML LEVEL. SIGNED W/ MICHIGAN AS A SECURITY BLANKET. WILL SIGN.*

SUMMATION: ALL THE BASIC TOOLS TO BE AN OUTSTANDING SS PROSPECT, BEST
RAW TOOLS OF ANY POSITION PLYR I'VE EVER SCOUTED, SHOULD
ONLY GET BETTER W/MATURITY & EXP, TOOLS & MAKEUP 2B A STAR

WEAKNESSES: GOT SOME HOT DOG IN HIM, TENDENCY TO COAST, BE TOO COOL,
SUSCEPTIBLE TO OFFSPEED OR CB'S BY GETTING OUT FRONT,
RECEIVES GROUNDBALLS AT TIMES IN TOO CLOSE TO HIS BODY

SPECIAL THANKS TO:

All my friends and family; Chris Anderson, Maureen Cavanagh and Gary Hoenig; Anthony Causi, Tom DiPace, Karen Carpenter and George Amores; Jason Zillo and the entire Yankees Media Relations Department.